Monet and French Landscape:
Vétheuil and Normandy

Edited by Frances Fowle

Monet and French Landscape: Vétheuil and Normandy

National Galleries of Scotland · 2006
in association with the
Visual Arts Research Institute, Edinburgh

Published by the Trustees of the National
Galleries of Scotland in association with the
Visual Arts Research Institute, Edinburgh.

Text © The Trustees of the National Galleries of
Scotland and the individual contributors, 2006

ISBN 1 903278 91 0 ISBN 978 1 903278 91 8

Designed and typeset in Minion by Dalrymple
Printed in England by Cambridge University Press

Jacket illustration:
Claude Monet, *The Cliffs at Etretat*, 1885
 Sterling and Francine Clark Art Institute,
Williamstown, Massachusetts

Preface

The conference *Monet and French Landscape,* held on 17 and 18 October 2003, accompanied the exhibition *Monet: the Seine and the Sea 1878–1883,* staged by the National Gallery of Scotland as its summer exhibition. The exhibition provided the opportunity to bring together scholars of Monet and Impressionism from Britain, France and the United States, bringing new ideas and interpretations of the artist's work into public debate in front of the paintings themselves.

The conference was organised under the auspices of the Visual Arts Research Institute, Edinburgh, a collaborative enterprise involving the University of Edinburgh, the National Galleries of Scotland, the National Museums of Scotland and Edinburgh College of Art. Since its inception in 1999 VARIE has staged a number of pioneering cross-disciplinary conferences and published their papers. One of these, *Soil & Stone: Impressionism, Urbanism, Environment,* was held in October 2001 while the work on the Monet exhibition was in train, its brief being to explore the dialogue between city and country in late nineteenth century French culture from multi-disciplinary perspectives. By contrast, *Monet and French Landscape* was specifically centred on issues related to the *Seine and the Sea* exhibition. The papers published here are from speakers of different approaches and generations, and we thank them all for their fascinating contributions.

On behalf of VARIE, I would like to thank Bonhams and the Faculty of Arts of the University of Edinburgh for sponsoring the exhibition and the National Museums of Scotland for hosting the conference. I am also grateful to John House, MaryAnne Stevens and Ségolène Le Men for their stimulating papers, Stacy Boldrick, who administered the conference, and Michael Clarke, my colleague on the 2003 Monet exhibition.

RICHARD THOMSON
Director, VARIE (1999–2004)
Watson Gordon Professor of Fine Art, University of Edinburgh

Contributors

ANNE L. COWE recently completed a PhD thesis entitled 'Community and Nation: The Representation of the Village in French Landscape Painting, 1820–1890' at the University of Edinburgh. She carried out research for, and contributed to, the catalogue of *Monet: the Seine and the Sea 1878–1883* (Edinburgh 2003) as part of an Arts and Humanities Research Board funded scholarship. She is currently working for the National Inventory Research Project.

FRANCES FOWLE holds a joint post as Lecturer / Curator of French Art at the University of Edinburgh and the National Gallery of Scotland. She has published widely on collecting and the art market and is the editor (with Richard Thomson) of *Soil & Stone: Impressionism, Urbanism, Environment* (London 2003) and (with Belinda Thomson) *Patrick Geddes: the French Connection* (Oxford 2004). She is currently writing a book on the Scottish art dealer Alexander Reid and is curating a major exhibition, *Impressionism and Scotland*, scheduled for 2008.

ANNA GRUETZNER ROBINS is a Reader in the History of Art at the University of Reading. Her recent publications include *Modern Art in Britain 1910–1914* (London 1997), *Walter Sickert: The Complete Writings on Art* (Oxford 2002) and (with Richard Thomson) *Degas, Sickert, Toulouse Lautrec: London and Paris 1870–1910* (London 2005).

ROBERT L. HERBERT is Emeritus Professor of Humanities at Mount Holyoke College. He has published widely on French art of the nineteenth and twentieth centuries, with special interest in the social history of art. Among his books are *Impressionism: Art, Leisure, and Parisian Society* (Yale 1988) and *Monet on the Normandy Coast, Tourism and Painting, 1867–1886* (Yale 1994).

RICHARD HOBBS is Director of the Centre for the Study of Visual and Literary Cultures in France at the University of Bristol, where he teaches in the Department of French. He wrote the first English-language monograph on Odilon Redon (1977), and has published widely on Symbolist artists and writers. He is the editor of *Impressions of French Modernity, art and literature in France 1850–1900* (Manchester 1998), and is currently researching artists' writings in nineteenth-century France.

RICHARD KENDALL is Curator at Large at the Clark Art Institute, Williamstown, Massachusetts, where he is currently collaborating on the first exhibition of Monet's works on paper, to be held in 2007. He has published widely on Impressionist art, including books, catalogues and articles on Monet, Cézanne, Van Gogh and Degas. As an exhibition curator, he was responsible for *Degas: Images of Women* (Liverpool 1989); *Degas Landscapes* (New York and Houston 1993); *Degas and the Little Dancer* (Omaha, Baltimore and Williamstown 1998–9); *Degas: beyond Impressionism* (London and Chicago 1996); and (with Jill DeVonyar) *Degas and the Dance* (Detroit and Philadelphia 2002).

ADRIAN LEWIS is a Senior Lecturer at De Montfort University, Leicester, and author of *The Last Days of Hilton* (Bristol 1996) and *Roger Hilton* (Aldershot 2003). He published 'Monet's Route de la ferme St-Simeon series (1864–67)' in the August 2000 issue of *Apollo* and is currently writing a book on Monet and Radicalism.

DOMINIQUE LOBSTEIN has worked as a documentation officer at the Musée d'Orsay since 1993. His main research interests include collectors and the organisation of official art exhibitions. Recent publications include the *Dictionnaire des Indépendants* (Dijon 2003) and an article on the first exhibition of the Société des Artistes indépendants for *La Revue du Musée d'Orsay* (Spring 2005). His book *Les Salons au xix^e siècle. Paris capitale des arts,* which he is currently writing, will be published by La Martinière, Paris, in October 2006.

Introduction

FRANCES FOWLE

From the move to Vétheuil in the late summer of 1878 until he settled in Giverny in 1883 Monet underwent a crucial period of transition. He rethought his earlier emphasis on modernity and developed his skills as a painter of pure landscape, culminating in the experimental works he produced on the Normandy coast in the early and mid-1880s. This collection of essays looks in depth at the political, economic, scientific, religious and art historical context for this complex and often contradictory period in Monet's life.

The essays were generated at a conference inspired by the exhibition *Monet: the Seine and the Sea 1878–1883*, held by the National Galleries of Scotland in the Royal Scottish Academy Building, Edinburgh, in the summer of 2003. The exhibition was co-curated by Michael Clarke and Professor Richard Thomson who demonstrated in both catalogue and exhibition that this relatively under-researched period in Monet's life represented a crossroads in his career. While he was living at Vétheuil, and especially around the time of the illness of his wife, Camille, Monet was forced through financial constraints to reassess his approach to landscape and return to more conventional subjects and methods of composition. As Clarke demonstrates in his catalogue essay, Monet combined Impressionist touch and increasingly innovative treatment of form and space with a more retrospective awareness of landscape conventions, as explored by predecessors such as Corot, Daubigny, Courbet and Delacroix. He relied more and more on the support of dealers, often catering to the market, rather than forging an individual path. On the other hand, as Thomson argues, stylistically he retained an originality of approach, focusing increasingly on a concern for the dialogue between form and space in the landscape motif, and adopting a more subjective response to colour and technique.

The collection of essays which precedes this volume, *Soil & Stone: Impressionism, Urbanism, Environment* (London 2003), edited by myself and Richard Thomson, was intended as a prelude to the exhibition. The city/country debate which provided the springboard for the earlier book is also profoundly relevant to the current volume. Many of the themes touched on in *Soil & Stone* – the expansion of the city and a concurrent nostalgia for the countryside; a developing taste among the bourgeoisie for landscapes of 'la France profonde'; the increasing ease of communication between city and country – are all issues that affected Monet. As the century drew on,

there was a growing sense of regionalisation and decentralisation, coinciding with the breakdown in the authority of the French Academy, the fall of Napoleon III and the rise of Republicanism. As T.J. Clark and Robert Herbert have demonstrated, Haussmannisation had the effect of driving artists out of Paris, in search of cheaper accommodation and rural subject matter. Developments in transport opened up vast areas of France that had previously been inaccessible, or accessible only with great difficulty. During the 1870s and 1880s Monet moved several times: from Argenteuil to Vétheuil and Poissy, eventually settling in Giverny. He also travelled up to the north coast, engaging in separate campaigns at Fécamp, Pourville, Etretat and Varengeville. As with the exhibition, this book focuses on Monet at Vétheuil and on the Normandy coast, but also, and inevitably, touches on Paris, Argenteuil, his campaign in the Creuse Valley and finally his move to London.

The papers delivered at the conference, eight of which are published here, revealed the ambivalent and experimental nature of Monet's approach at this time and the consequent problems of interpretation. While both Adrian Lewis and Richard Kendall suggested that an engagement with radical thought and new scientific developments informed much of Monet's work of the 1880s, John House argued that in the early 1880s Monet was comparatively conservative in approach, rejecting modern life imagery. As House pointed out, Monet turned his back on Paris and on the depiction of explicitly contemporary subjects at the very moment that Jules Grévy was appointed, marking a more liberal period in French politics, and Jules Ferry's new arts administration actively endorsed the painting of modern life subjects and of scenes that raised significant social and political issues. These ideas were developed further in House's recent book, *Impressionism: Paint and Politics*, published by Yale in 2004.

By 1880 Monet was entering a period of transition. Whether his change in approach was prompted by financial necessity or whether he had simply lost the idealism of youth, it appears that material, rather than more radical, concerns informed his paintings of the early 1880s. His choice of subject matter was often market-driven and, as Dominique Lobstein discusses in this collection of essays, he consciously looked to the example of Salon artists and predecessors such as Courbet for inspiration. On the other hand, even if he used this period for reflection and reassessment, Monet rarely emerges as an orthodox artist, either politically or technically. Prior to Clare Willsdon's recent publication, *In the Gardens of Impressionism* (2005), Monet's paintings of domestic gardens were said to signify his developing conservatism. Albert Boime's *Art and the French Commune* (1995), for example, read Monet's garden paintings in terms of their representing an 'apolitical no-risk sphere'. In this book Adrian Lewis argues that *The Artist's Garden at Vétheuil* (National Gallery of Art, Washington), one of Monet's highly marketable 'set pieces' was held back from the market for a reason, since it can be read as a blatantly Republican image, especially given Monet's links with Radicals like Geffroy and Clemenceau.

In contrast to Lewis, Anne Cowe suggests that Monet's images at Vétheuil represent a period of retrenchment and conservatism and that it is Sisley – generally

regarded as 'without politics' – who was taking the more radical stance during this period. In contrast to the stereotypical motif of the agricultural village, Sisley's intense and methodical campaign at Saint-Mammès defines the village through the community's dependency on, and devotion to, the river: a village that relied, not on the produce of the land, but on its barges and the flow of the waterways to and from Paris. Cowe discusses Sisley's pictures at Saint-Mammès in the context of the Freycinet plan, a large-scale government investment in the French waterways, and reflects the possibility that Sisley, particularly at the beginning of the 1880s, was not as apolitical in his work as was previously thought. Cowe discusses Monet's Vétheuil paintings in terms of the 'picturesque' and this concept is taken further by Robert Herbert. In his ground-breaking publication, *Monet on the Normandy Coast* (1994), Herbert discussed Monet in the context of the development of tourism in the late nineteenth century. In the current volume he looks back to the early 'tourists' of the eighteenth century and the invention of concepts such as the picturesque and the sublime, arguing that Monet, too, was working in these traditions. Like his predecessors, Monet emphasised the solitary nature of the landscape artist, giving a sense of the viewer at leisure and ostensibly alone at the site.

As Dominique Lobstein elucidates, Monet was following an increasing trend for artists to travel to and depict the landscape of Normandy. Between 1801 and 1865, when Monet first participated at the Salon, nearly 1600 landscapes of Normandy were exhibited, far more than for any other region in France. The Normandy coast was made popular during the Second Empire by Napoleon III and the Empress Eugénie, and sea-bathing became a favourite occupation of the aristocratic and bourgeois classes. Areas such as Trouville and Honfleur were made easily accessible through the expansion of the railways and tourists were enticed to these areas through vivid descriptions in travel guides of the sites Normandy had to offer, including the unusual rock formations at Etretat. In choosing to paint on the Normandy coast, Monet was following in the footsteps of artists such as Boudin and Jongkind. He was also painting the area in which he was brought up, although there is little sense in his paintings of Le Havre, Trouville and Sainte Adresse that he identifies with the indigenous fisherfolk any more than with the bourgeois tourists who stroll along the boardwalk at midday.

Monet was also one of a number of French artists (including Armand Guillaumin) who travelled to the Berry and the Creuse Valley during the Second Empire and later, creating an 'Ecole de Crozant'. In *Soil & Stone* I discussed Van Gogh's attempts to construct a Provençal identity in the native landscape of Adolphe Monticelli and Paul Cézanne. In this book Richard Hobbs focuses on Monet's relationship with the poet Maurice Rollinat, a native of Châteauroux in the Berry, arguing that Monet participated briefly in the development of a provincial school of 'berrichon' landscape painting.

One of the underlying reasons for Monet's constant search for new motifs was his desire to appeal to the market. Anne Cowe reminds us that money was a recurring issue during the late 1870s and that he was mocked by his contemporaries for

returning to the Salon. Hobbs describes Monet's work as 'idealism grounded in the material' and throughout the book one is aware of Monet's material concerns, especially the pressure to sell his work. Towards the end of the 1880s Monet's dealers looked beyond France – to Britain and the United States – for new ways of marketing his work and the last section of the book considers the reception of Monet's work initially in France and later in London.

Today Monet's paintings are among the most popular works of art in the world and yet, when they were first shown in the 1870s and 1880s, these same pictures were scorned by the press, mocked by the public and suspected of subversive intent by the establishment. This negative reception has typically been linked to his freedom of technique and its apparent disregard for the refinement of more conventional landscape practice, a view reflected in some critical reviews of the day. However, as Richard Kendall demonstrates, a more thorough examination of this criticism shows that Monet's contributions to the Impressionist exhibitions, like those of his colleagues, were also linked to liberalism, Radical politics and religious free-thinking, and with the innovations of science and technology. It is this 'mental landscape' of the late 1860s and early 1870s, and its specific echoes in Monet's landscapes of the 1880s, that forms the basis of Kendall's essay, which explores themes such as atheism, science and Darwinism.

If Monet found it difficult to establish a market in France, he was to find an even cooler reception in Britain. In the 1870s Paul Durand-Ruel attempted to sell the work of Monet and his contemporaries in London, but it was not until the 1890s that collectors began to show any significant interest, coinciding with the introduction onto the market of Monet's landscapes of the 1880s. In my own essay I have attempted to identify the first British collectors to invest in Monet, examining their motives for buying, and analysing the various strategies adopted by dealers such as Paul Durand-Ruel, Theo van Gogh, David Croal Thomson, Alexander Reid and others to create a market for Monet in Britain. But as Anna Robins demonstrates, the reception of Monet in Britain was adversely affected by a small group of critics including D.S.MacColl, George Moore and Charles Whibley. Robins argues that these critics were well trained by Whistler, who drew on recent research into physiological optics when instructing his supporters about how to look at pictures. The smooth, anonymous quality of Whistler's technique satisfied their idea of what they called abstract painting and consquently they were ill-equipped to discuss the densely worked surface of Monet's experimental pictures of the early 1890s.

If this book has an overriding theme, it is Monet's materialism and his constant awareness of the art market. In 1881 he made an informal agreement with Durand-Ruel whereby he would sell all his pictures through the dealer in return for regular financial support. This gave him a certain amount of freedom to work with new subject matter and experiment with new styles. At the same time, the romantic picturesque aspect of many of his later pictures had a strong appeal for an essentially bourgeois clientele, eager for paintings of attractive, unspoiled tourist spots. Although some still had problems with Monet's prismatic colours and fragmented

brushstrokes, by the end of the 1880s the market for his pictures was firmly established. The period of transition was over and he was able to forge ahead with his series paintings of the 1890s.

I should like to thank the Carnegie Trust for the Universities of Scotland and Bonhams whose generous support has enabled me to publish these papers. My special thanks to Richard Thomson for arranging the conference and for his constant support and enthusiasm. Many thanks also to Janis Adams and Christine Thompson at the National Galleries of Scotland for undertaking the publication of these essays. FF

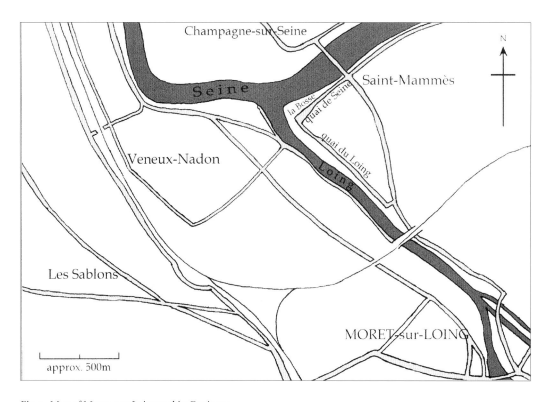

Fig. 1 · Map of Moret-sur-Loing and its Environs

1 Impressions of the Riverside Village: Monet and Sisley at Vétheuil and Saint-Mammès

ANNE L. COWE

When Claude Monet (1840–1926) went to live in Vétheuil in August 1878, it heralded a significant change in his art. Leaving the steaming engines of the Gare Saint-Lazare and the modernity of the suburbs, he began to paint rustic scenes of his new rural environment and the village where he lived. Although he maintained the stylistic tenets of his Impressionist technique, in subject matter he abandoned the strikingly contemporary for a timeless rural iconography that was widely used and recognised. The triangular form of the village in particular, with the church at its apex, was generally a popular motif and it appeared in paintings by even the most conservative of landscape painters from this time. Many of Monet's paintings during this period, for example *Vétheuil* of 1879 (plate 1), depicted what was essentially an image of traditional rural France – *la France profonde*.[1] His interpretation of this landscape beside the river Seine marked a distinct shift away from the confrontational aesthetics of Impressionism towards conventional preconceptions of a picturesque ideal. A comparison with his colleague Sisley's paintings of another French riverside village reveals the growing divergence in the Impressionist approach.

Alfred Sisley went to live in the countryside outside Paris not more than a year and a half after Monet. In January 1880, having left Sèvres, he and his family moved into a rented house in the village of Veneux-Nadon on the edge of the forest of Fontainebleau. Whereas Vétheuil was situated on the banks of the Seine about sixty-five kilometres north of Paris, Veneux-Nadon lay about seventy kilometres upriver to the south. Apart from moving house a number of times between Veneux-Nadon, Les Sablons and the town of Moret-sur-Loing, the artist would remain living and working in the area until his death in 1899 (fig.1). One of his favourite subjects during his first five years in the area was not a place where he was resident, but the neighbouring village of Saint-Mammès. Situated on the confluence of the Seine and the river Loing, it served as a busy river port for barges going to and from Paris. His numerous paintings of the village form a detailed study, not only of its appearance, but also of the life and activities of the working community which constituted its fabric. By depicting Saint-Mammès as individual and contemporary, and thus deviating in many ways from the general notion of the typical rural village, Sisley's works were more consistent with established Impressionist principles than were Monet's more idealised images of Vétheuil.

The corresponding nature of the artists' subject matter and the difference in their responses, belies the parallels in their artistic development. The circumstances under which both artists relocated to their new homes were also similar. Both were struggling to sell their works in the Paris art market and had the demands of their families to support. It is clear that what Joel Isaacson termed the 'Crisis of Impressionism' had begun, and that the cohesion of the Impressionist cause was disintegrating.[2] In this context, Monet's and Sisley's paintings were not only a reflection of their physical, personal and social environments, but also of their developing attitudes.

Monet's very first experiments in painting the village were internal views of Vétheuil's streets, which were distinctive in identifying specific buildings. Apparently familiarising himself with his new environment, he depicted detailed images of the church, his house and the road outside, as well as other parts of Vétheuil and Lavacourt (the hamlet on the opposite bank).[3] Despite this initial approach, however, his landscapes quickly became removed and distanced from the intricacies of the individual community. *Vétheuil* provides a typical demonstration of the way that Monet used the village in his paintings of the area. In general it is the composition, and the perspective from which the village is observed, that gives the imagery immediate effect. The self-contained form of the village, for example, was key in creating a focus within the rural landscape. It adds structure to both the composition and, through implication, to the resident community. In this respect, the church spire, or *clocher*, is the most important element of the motif. Its emphatic point appears as a lynchpin, fixing the community in place and around which the rest of the landscape revolves. Monet's views of Vétheuil rotate around the village with the church as a consistent reference. The other towers on the Vétheuil skyline – those of Les Tourelles, the villa on the outskirts owned by Monet's landlady – were seldom allowed to detract from the church's dominance. In most instances the artist selected views which omitted or at least sidelined this part of the village. In *Poppy Field near Vétheuil* of 1897 (plate 2), for example, the towers appear subtly amid the trees to the left-hand side, while the role of the church within the customary triangular motif remains intact. Originally built to be seen from a distance, it is perhaps not surprising that church towers were among the most recognisable facets of the village motif in many artists' paintings, and Monet's landscapes were no different. He was not a religious man – quite the contrary – and his paintings appear indifferent to the church's spiritual function. As a visual structure, however, the church was perceived as integral to rural life and therefore rural iconography. The significance of the Vétheuil imagery lay in the type of landscape it evoked, rather than the specific location. It was a structural form which affirmed the genteel rural setting and distinguished it from the city.

In Sisley's paintings of Saint-Mammès the composition and perspective are equally important in constructing an impression of the village, but are used to very different effect. His paintings make few assumptions and present a detailed exploration of the internal and external aspects of the specific location. In individual paintings, for example, both roads and rivers invite the viewer into the space.[4] Considered

together, his works reveal a methodical progression through and around the village, a process which he used throughout his career. He explained his approach to his friend, the journalist Adolphe Tavernier, in 1892: 'The subject, or theme, should always be represented in a simple and comprehensible form, which grips the spectator. The latter should be drawn – by the elimination of superfluous detail – along the road that the painter shows him and see first whatever caught the artist's eye.'[5] It is the views of the village painted from the opposite side of the Seine, of which *Saint-Mammès, Morning*, 1881 (plate 3) is one, that are often recognised as demonstrating this approach.[6] All painted around the same time in 1881, they depict the length of the village in four different segments, as if the artist was making a systematic record of his observations. Considering the rest of his Saint-Mammès landscapes, however, one finds other equally striking examples, with very small areas painted several times from different angles and distances. *Boatyard at Saint-Mammès* of 1880 (fig.2), for example, is one of a set of five paintings painted very close together around the boatyard and chestnut tree on the place de la Bosse next to the confluence of the Seine and the Loing. The artist was clearly fascinated by this spot. This group of works was among the first he painted when he moved to the area in 1880, and he returned there several times during the following five years.[7] Rather than removing himself from the village context as Monet appears to have done, it seems that Sisley enjoyed painting amid the bustle of village life, and exploring the working mechanics of his subject.

The individual identity of Saint-Mammès was founded on the boats and the river. It was not a port for loading and unloading cargo, but a stopping place for barges as they arrived at the end of the canal du Loing and embarked on the more erratic waters of the Seine, or vice versa. Whereas most of the barges coming from the south would have travelled on purpose-built canals, navigating the river would

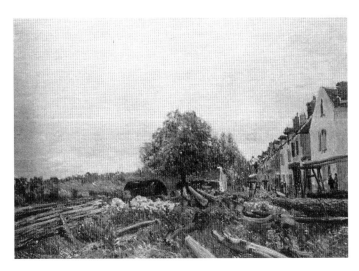

Fig.2 · Alfred Sisley, *Boatyard at Saint-Mammès*, 1880, private collection

have required more specialist skills. Boats would usually stop at Saint-Mammès to take on a *pilote*, who would be familiar with the Seine's currents and the undulations of the riverbed.[8] The local *curé*, L'Abbé Clément, wrote in 1900: 'The place lives from water transportation. Most of the men navigate, from Saint-Mammès to Paris and beyond, the boats which arrive from Montargis, Orléans and the centre of France, on the canal, "the road that moves".'[9] The village was therefore populated mostly by bargemen, or *mariniers*, and their families. A common claim was, and still is, that 'Saint-Mammès is a village of *mariniers*'.[10] As a natural stopping point, Saint-Mammès was also a centre for boat building and repairs, the hire of haulage animals such as horses, donkeys or mules and general supplies.[11] Everything in the village related to the river in some way, not least the numerous cafés which acted as business forums as well as places where the men could gain relief from their strenuous work on the river.[12]

The presence of the Seine and the canal pervades both the narrative and the iconography of nearly all Sisley's paintings of Saint-Mammès. Most of his depictions of the village focus on the streets which overlook the water: the quai du Loing on the canal with its lock, and the quai de Seine with the place de la Bosse jutting out into the confluence. Whereas in paintings such as Monet's the landscape and the community converge on the church, Sisley's have a secular structure and gravitate towards the river. The paintings of the quai de Seine, for instance *Misty Day at Saint-Mammès* of 1880 (plate 4), often show views looking along the bank – the houses to one side, the river to the other and the sloping bank connecting the two. The more distant views create a similar effect. In *Saint-Mammès, Morning*, for example, the strata of the horizontal composition combine buildings, boats and river. Although Monet also painted the Seine next to Vétheuil and Lavacourt, Sisley confirmed the link between the river and the community through his inclusion of figures. Even viewing the village from a distance, Sisley was careful to add the small brushstrokes and dots of paint which would suggest the hive of activity around the water's edge. In his close-up works too, he portrayed Saint-Mammès as an active and cohesive working community, depicting both male and female roles repeatedly. While the paintings of barges and boatyards depicted the strictly masculine working domain, others gave a view of the feminine roles in the community. In some, for example, women are shown doing laundry, again at the water's edge; and in *Farm Courtyard at Saint-Mammès* (D.544, Musée d'Orsay, Paris) they sit working within the domestic courtyard.

Allusions to functional or social activity in Monet's paintings of Vétheuil were limited. While neither Vétheuil nor Lavacourt were ports like Saint-Mammès, the Seine between them was still a busy thoroughfare for barges, steamers and other boats. Only *The Village of Lavacourt* (W.501, private collection), painted when he first moved to the area in 1878, showed the river traffic to any real extent. The majority of the Vétheuil works depict the river as an undisturbed bed of reflection on which Monet could focus his study of light. Equally, there is an increasing scarcity of figures. The early Vétheuil paintings are active with villagers featured near the fore-

ground. At the other extreme, however, some of his later paintings of the debacle seem to relish the sense of desolation.[13] Although the village inhabitants would have been mostly involved in agriculture, his paintings of the fields depict them lying fallow, as in *Poppy Field near Vétheuil*. Where he did paint cultivated fields, for instance in *Path in the Wheat* (w.676, Cleveland Museum of Art, Cleveland) from 1881, there is no allusion to the wheat or the adjacent lucerne as functional crops, or to their impending harvest. Even the significance of the church relies predominantly on allusion and the imagination of the viewer. Although Monet's motif was consistent with the common stereotype of the traditionally pious rural community, apart from his use of composition he did little to elaborate on the idea. While the form of the village does create a central focus to Monet's paintings, there is no sense of involvement in the community as in Sisley's depictions of Saint-Mammès. There is often a visual barrier between Vétheuil and the viewer, such as a large expanse of water or perhaps bushes or trees. The buildings of the village also reflect the light rather than drawing the eye in with receding space and shadows. The form of the village and the human presence it represented, progressively become amalgamated into a suggestive shape rather than a marker of the community's particular existence.

Monet's views of Vétheuil appear to have become increasingly distanced and objective, placing himself and the viewer in isolation from the community. Where he did feature figures and activity, they were not the working peasants of Vétheuil but the bourgeois members of his own family at leisure. As in his painting of the poppy field, however, they still appear separate from the village community, sectioned off by the river that bisects the composition. The extent to which Monet depicted the village as his home was also limited. Whereas early paintings such as *The Vétheuil Road in Winter* (w.510, Göteborg Konstmuseum, Gothenburg) depict his house as part of the village, in later works his home and family are treated as separate from the rest of the community. *The Artist's Garden at Vétheuil* from 1881 (plate 5), for example, gives no hint of the adjacent village and cleverly omits the road separating the garden from Monet's house. The practicalities of the artist's domestic situation may well have been a factor in this apparent quest for peace and solitude. Now that the Monets were sharing a house with the eight members of the Hoschedé family, he may have been glad to escape the distractions of his overcrowded household. Seen chronologically, it is also possible to associate Monet's retreat from the village with the event of his wife's death in September 1879. Aside from the conjecture regarding his emotional state at this time, there were a number of reasons he might have wanted to avoid other people. Since the death there had been a spate of rumours suggesting that Monet and Mme Hoschedé's relationship exceeded that of mere friendship. These, and allegations regarding his artistic integrity, had been made public in an anonymous article for *Le Gaulois* newspaper, written by his fellow artists.[14] The journalist Emile Taboureux confirmed Monet's anti-social attitude in his article for *La Vie Moderne*, which would coincide with the artist's solo exhibition in the magazine's headquarters in June of the same year. He described his arrival by river at Monet's house in Vétheuil, saying, ' … he didn't exactly throw his arms

around my neck. Monet is wary in the extreme; no doubt he's been fooled on more than one occasion.'[15]

From a more objective perspective, however, Monet's distancing from his subject also placed himself and the viewer firmly as Parisian onlookers and not as involved inhabitants. The image created was one of escapism from the modern urban sprawl of industry, overcrowding and pollution: a rural retreat for the city's bourgeoisie as opposed to a functioning place in its own right. He conveyed the tranquillity of the natural environment, reassuringly civilised by the familiar presence of the timeless village motif. In effect, he was painting a popularly recognised picturesque ideal, and consequently deviating from the realist candour of Impressionism. Sisley's paintings, in contrast, reveal a deliberate rejection of landscape tradition and the pictorial conventions of the area where he was painting. The small town of Moret conformed far more than Saint-Mammès to established ideas regarding the 'picturesque' and what was suitable subject matter for a landscape painting. It was visually and historically far more interesting, with its medieval town walls and imposing church and keep both dating back to the twelfth century. Its bridge and turreted gatehouse, as well as the church, were painted extensively over the course of the nineteenth century by landscapists such as Léon Fleury, Théodore Rousseau and Léon Lhermitte. Although these more popular views did appear in Sisley's later works, it is clear that when he first moved to the area he was purposely avoiding following standard practice. In 1882 he wrote to Monet saying that he thought Moret was 'a bit of a chocolate-box landscape'.[16] Where Sisley did paint Moret in these early years, he chose precisely the subjects that others had been careful to avoid. In 1883, for example, he turned his back on the medieval gates and painted *The Provencher Mill at Moret* (D.503, Museum Boymans-van Beuningen, Rotterdam), the imposing flour mill that dominated the centre of the adjacent bridge. It is evident that he was much more interested in painting the functional activity of the area than replicating recognised beauty spots. Sisley was not expressly seeking out the anti-picturesque, however; he was developing his own set of ideals based on the notion of the harmonious working community.

What is not evident from his often rather serene paintings of Saint-Mammès and its inhabitants was that locally the village had rather an undesirable reputation. The *mariniers* who lived on their boats were viewed as gypsy-like, and apparently were even sometimes referred to as 'shits-in-water' by those on land.[17] The village was also notorious for its large number of bars as well as the unruly nature of those who frequented them. The villagers' reputation was not aided by the low level of literacy arising from barge-life and irregular schooling, a fact bemoaned by the despairing schoolmaster M. Rausoir in his 1888 report.[18] Despite the harsh exterior of the village's population they were also described as a proud and noble people. The Abbé Clément, for example, wrote in 1900: 'This population is, in general, better than its reputation … These good people say of themselves: "We're *loudmouths* (I soften the expression) but we're not malicious!" They are perfectly right. Everywhere in the parish we receive the most cordial of welcomes.'[19] This description is perhaps more consistent with the way that Sisley portrayed the Saint-Mammès' community. Yet in

the paintings, there appears no allusion to, or admission of, the negative aspects of the village's character. For example, on seeing his works his friend, the critic Gustave Geffroy, referred to 'the peaceful Saint-Mammès'.[20] Although Sisley chose to paint the working village rather than the more popular local motifs, his interpretation of it was particularly flattering. Rather than showing what in reality might have appeared as a harsh lifestyle of hard toil and rowdy cafés, the Saint-Mammès paintings represented a comforting instance of rustic conviviality for the Parisian home. As described by the critic Jean de Nivelle at the seventh Impressionist exhibition in 1882, his paintings were ' … a moment of happy distraction for him and the visitor.'[21]

Although the Saint-Mammès paintings differed greatly from those of Vétheuil, they still conveyed the perspective of a Parisian outsider. Rather than creating a peaceful sense of rustic withdrawal as Monet had done, Sisley's works reveal the enthusiastic discoveries of a visitor new to the area. The viewer who was to follow 'the road the painter show[ed] him' was not the local Mammésien, but the genteel Parisian bourgeois exploring the place for the first time. Equally, the viewer's involvement in the scene always stops short of intimacy, an aspect particularly evident in Sisley's portrayal of figures. Although one can define at first glance the figures' class of dress, whether they are male or female, and what they are doing, the information we are given does not breach the boundary of individuality. No matter how much detail the paintings present of the different aspects of communal activity, they never become genre scenes. The figures he painted were generic Mammésiens, contributing collectively to a social unit and to the function of each landscape as a whole. Far from the passivity of Monet's paintings, however, Sisley's depiction of a productive and unified rural community appears to promote quite specific ideals. To be more precise, there are a number of elements in the Saint-Mammès paintings which suggest a distinctly modern and Republican perspective.

Sisley is generally thought to have been non-partisan. Philip Nord in his book, *Impressionists and Politics*, for example, barely mentions the artist, apart from saying 'Sisley, to all appearances had no politics at all … '.[22] Such views are perhaps encouraged by the lack of textual evidence regarding Sisley's first-hand opinions, as well as his personal distancing from the subject matter. Nevertheless, in reviewing the seventh Impressionist exhibition in 1882, which featured several of these works, Jean de Nivelle referred to Sisley as 'the man of *parti-pris*'.[23] The artist may therefore have presented a more opinionated personality than is now acknowledged. From the start the Impressionists, including Monet, had taken on a somewhat Republican ideology with their radical ideas on art and their passion for painting modern subjects. There is little to show that Sisley was not also party to this mentality. The paintings of Saint-Mammès, in particular, appear to present a highly optimistic view of the modernity and progress affected by Republican policy. At the time that Sisley first began to paint Saint-Mammès in 1880, Jules Grévy's Opportunist Republic had been in power for little more than a year. After the conservative regime of Maréchal MacMahon it was a time of great change as the new administration began to implement its plans for the nation. Dubbed by some the 'Republican's Republic', it would have been a time

of optimism for supporters of the Republican cause.[24] The positive effects of the new policies being introduced would have been clearly evident in Saint-Mammès, especially in respect of the Freycinet plan. This large-scale reform of the French communications network involved not only the modernisation of the roads and railways, but also the renovation of the French system of waterways. It would have created work for canal workers and optimism among barge communities. When Sisley first moved to the Moret area, the developments of the Freycinet plan would have been in their infancy. What is more, since Jules Ferry's appointment as minister in charge of fine arts in 1879, the State was officially encouraging the painting of modern subjects.[25] In such a context, Sisley may also have been encouraged by the fact that Republican policy appeared to endorse the depiction of such scenes on canvas.

Sisley mentioned the work being carried out on the canal in a letter to Monet in August 1881, complaining that they had cut down trees and straightened the banks.[26] While he does not appear to have found the reconstruction of the canal attractive in itself, the enthusiasm with which he viewed the activity stemming from it is clearly evident. The group of works showing the place de la Bosse, as in *Boatyard at Saint-Mammès*, depict what was the Leveau boatyard. According to a study of the area by Vanessa Manceron, it was installed on the place de la Bosse in 1880, and would therefore have been brand new when the artist painted it.[27] The standardisation of the canals under the Freycinet plan also brought about a corresponding standardisation of barges, creating a source of work for the boatyards featured in Sisley's paintings. The traditional *Berrichon* barge (27.5 × 2.62m; 55–60 tonnes) could now be replaced by a *Freycinet* (32.5 × 5.10m; 350 tonnes) which had a larger capacity but was the right size to be accommodated by all the canals in France.[28] Other late nineteenth-century river developments included the anchoring of a chain which stretched along the river bed toward Paris. It was introduced so that specially equipped steam tugs could pull themselves and a convoy of barges mechanically along a set course, avoiding the dangers that river navigation could produce. One of the tugs can be seen in *Misty Day at Saint-Mammès*. A local history by Jean-Michel Regnault, the former mayor of Veneux-Nadon, explains: 'This modernism brought a new way of life to Saint-Mammès among the *mariniers*. It was, in effect, at Saint-Mammès that the mode of haulage changed; animals on the canal, steam on the Seine.'[29]

A strong sense of optimism surrounds the village in these paintings. The light effects alone project positive connotations. The critic Arsène Alexandre, for example, described Sisley's paintings saying, 'They are all covered in a blond light, and all is gaiety, clarity, springlike festivity … '.[30] While this sense of enthusiasm may have arisen in part from the artistic opportunities which Sisley found in moving to a new area, it emerges more specifically as a distinct characteristic of this working community. Both time of day and season, for example, allude to beginnings and anticipation. Particularly in the earlier paintings of Saint-Mammès, there are also resounding allusions to aspects denoting continuity, regeneration and progress. The boatyard paintings, for example, show different stages in the process of barge construction. Similarly, in *Misty Day at Saint-Mammès*, in front of the houses, to the right hand

side, men are seen chopping down dying poplars so that they can be replaced to accord with the lush green ones behind. To the left is the river where a steam tug, some barges and a rowing boat sit in the water. In both the boats and the trees – man-made objects and nature – Sisley portrays the different stages of transition between old and new. Progress is evident, not in a strong urban and industrial sense, but in the prosperity of a modest rural community. It would be wrong to assume that these works ignored the effects of modernity simply because they do not depict an urban environment.[31] On the contrary, Sisley was purposely avoiding painting the historic sites of Moret. The steam tug in *Misty Day at Saint-Mammès*, for example, does not look out of place; neither does the railway viaduct which appears in the background of several paintings, such as *The Loing at Saint-Mammès* (D.461, Museum of Fine Arts, Boston). Sisley portrayed Saint-Mammès as a working village which was at once traditional and fully contemporary.

The secularity of Sisley's paintings would also have been a distinctive marker of a Republican outlook. Amid the new Republic's controversial drive to secularise all public institutions, it was the provincial village parishes which acted as the stronghold of Catholic conservatism.[32] Where the village church was already such an established part of rural iconography, the irrelevance of the Saint-Mammès church to Sisley's motif would have held added significance. Equally, it is possible to detect rather centralist elements in these works. This, too, would show sympathy with the Republic, which was keen to create a unified nation and quash provincial separatism. Although distanced from urban turmoil, Sisley's often still and tranquil paintings offer a reassuring reminder of the accessibility and influence of the city. Sisley's depiction of the village, for example, broke from the familiar motif of the self-contained and introspective community, to which Monet appears to have conformed. In many of the Saint-Mammès landscapes the houses continue beyond the edges of the canvas and the river flows in and out of the composition. The boats themselves indicate movement and itinerancy, alluding to other places and destinations; and the Seine, in particular, leads them to Paris and the heart of the nation. Neither is Saint-Mammès self-sufficient. Rather than being surrounded by fields of crops for its own subsistence, the village implicitly acts as part of a greater whole in having a highly specialised function. It assumes a position of significance within its contemporary context. Through its activity it is seen to benefit from Republican policy and contribute constructively to the building of the modern nation.

Given the Impressionist perspective demonstrated by Sisley's interpretation of the rural village, Monet's deviation from Impressionist principles becomes clearly apparent. As a key member of the group, and one of the most openly political and controversial, the question arises as to why Monet chose this time to change his artistic approach and distance himself from his peers. His colleagues were clearly concerned by his new direction. The article in *Le Gaulois* had been more than acrimonious regarding the suggestion that he might submit work to the State exhibition of the Paris Salon. It made a mock funeral announcement informing readers of the grievous loss of Claude Monet to the Impressionist school – it was to take place in

the Salon galleries at the Palais de l'Industrie.[33] At the seventh Impressionist exhibition in 1882 critics even spoke of the 'death of Impressionism' altogether. The critic A. Hustin wrote, for example: 'Impressionism is dying. That's what they're saying after casting a quick glance round the 7th Exhibition of Independent Artists … '[34] Changes were also apparent in Monet's stylistic tendencies. *Lavacourt* of 1880 (w.540, Dallas Museum of Art), the painting which was accepted into the Salon, demonstrates some of the concessions Monet was prepared to make. He admitted in a letter to his friend, the journalist and critic Théodore Duret, in March 1880 that he had made it 'more safe, more bourgeois'.[35] In comparing it to some of his other paintings one can appreciate immediately the tightening of his brushwork, the more 'finished' effect, as well as the increased permanence of the imagery. The fact that the subject of the painting was a tranquil view of a typical French riverside village was no coincidence. It followed many successful Salon paintings of similar locations.

Now casting himself as a rural landscapist, it appears that Monet was keen to identify himself as a solitary artist and rural inhabitant. His letter to Duret in December 1880 asking for news from Paris remarked, 'otherwise, more and more a peasant, I hardly know anything of what's new.'[36] But it was more as a marker of his isolation from Paris, rather than any active pursuit of peasant labour and being involved in a rural community, that he said this. It is possible he was trying to set himself apart from the popular artist colonies which were booming at this time, but more importantly he also seems to have been distancing himself from the original perceptions of Impressionism. In Paris, his growing isolation from the rest of the group was marked. As well as submitting to the Salon in 1880, his participation in the fourth Impressionist exhibition of 1879 had been very reluctant, and he made no submission at all to the fifth or sixth Impressionist exhibitions. Apparently unwilling to relinquish the 'Impressionist' epithet that had brought him fame, however, he reasserted, 'I still am and always will be an Impressionist.'[37] Duret, and the journalist Emile Taboureux, for example, both supported the myth that Monet painted entirely in the open air, never using a studio. To this day Monet is portrayed as the archetypal Impressionist, largely because of his direct depictions of nature.

It seems that Monet was experimenting with his marketing as much as with his art. His time at Vétheuil was the most productive of his career. Apart from exploring the artistic possibilities of the area, this high output was probably due to the severity of his financial situation at this time. Part of his original reason for moving to Vétheuil was the cheaper rent. Impressionist paintings were not selling well and he had the extra expense of his wife's medical care to deal with. He was criticised for commercialism and mass production, and even his most loyal clients complained of his works appearing unfinished.[38] He painted 232 paintings in just over three years, which included three brief excursions to the coast. Ninety-seven of these works contained either the village of Vétheuil or Lavacourt. His repetition of these motifs would not only have made his paintings quicker to produce, but it is also possible that Monet hoped such iconography would appeal to a broader audience. In comparison to his earlier works, these timeless depictions of a rustic and secluded

backwater were far from confrontational; on the contrary, he was recognising and conforming to a proverbial motif.

Monet's attempts at winning the appreciation of the Salon-going public clearly backfired, however. As well as provoking a vehement response from his fellow artists, the venue was completely unsuitable and its reluctant jury system had forced all the qualities of originality out of his work. It was through the Parisian dealers that Monet would eventually meet his market. His solo exhibition at the headquarters of *La Vie Moderne* proved to be a far more suitable forum. Just as Monet had publicised himself as a solitary artist, he now made a show of solitary strength rather than trying to assimilate himself with the sea of Salon artists. Neither was it his rustic paintings of the village that would win commendation but his more striking works, such as *The Floating Ice* (w.568, Shelburne Museum, Shelburne). And in his return to the Impressionist group in their seventh exhibition in 1883, it was the bright red of his *Poppy Field near Vétheuil* and the drama of his cliff paintings that caught the eyes of the critics. As expressed by the critic Philip Burty in 1883, 'We knew what obstacles he had to fight, and our only worry was that, as in the year before when he tried to show at the Salon, he would make too many concessions, thus sacrificing the honour of his cause.'[39]

Whereas Monet slowly began to reassert and redefine his artistic presence with more imposing iconography, Sisley's work reveals the opposite. By the mid-1880s the flaws in the Freycinet plan had become apparent, having created large amounts of debt after extravagant and ill-planned public spending. What is more, as well as investing in the waterways, it had also subsidised the railway network, the speed and reliability of which would gradually replace the barges' role in the freight industry. In Saint-Mammès, therefore, the optimism instilled by State investment would have been short-lived. It certainly seems that any political optimism conveyed in the early Saint-Mammès paintings, and inspired by the industrious barge community, was not unwavering. Sisley's success in the art market was also poor, and may have been a further source of disillusionment for the artist. During the mid-to-late 1880s there was a distinct shift in Sisley's artistic approach. Those works that he did paint of Saint-Mammès withdrew to a more neutral perspective, and were resolved in the aesthetic effects of light and reflection. He increasingly concentrated on scenes from the 'chocolate-box landscape' of Moret, and the narrative structure of the humble working community began to disappear from his work. Gone, too, were the elements of regeneration, construction and progress, which had been so vivid in the earlier paintings. Like Monet, his withdrawal from the more provocative aspects of Impressionism may have been due to commercial incentives; however, it also signified a more permanent withdrawal from the group in his personal life.[40] Eventually settling in Moret in 1889, he appears to have committed himself to his locality, shrugging off the politicism of Impressionist influence. While continuing the stylistic traditions of the group, his work lost the more opinionated elements of his earlier convictions, allowing him to be absorbed by nature and the unashamedly picturesque qualities of his setting.

NOTES AND REFERENCES
Impressions of the Riverside Village: Monet and Sisley at Vétheuil and Saint-Mammès

ANNE L. COWE

Abbreviations:
D. Daulte F., *Catalogue Raisonné de l'Oeuvre peint*, Lausanne 1959

1. For example, Richard Thomson in Thomson 1998, p.8, forms a comparison between Monet's views of Vétheuil and Henri Harpignies's views of Hérisson.

2. Joel Isaacson, *The Crisis of Impressionism, 1878–1882*, exh. cat., Michigan 1979, *passim*. See also Nord 2000, pp.7–8.

3. See, for example, w.473–5, w.495–502 and w.505–17.

4. For a discussion of this point, see Dominique Brachlianoff, 'Argenteuil, Villeneuve-la-Garenne, Louveciennes, Bougival (1870–1874)' in MaryAnne Stevens and Ann Dumas, *Alfred Sisley: poète de l'impressionnisme*, exh. cat., Lyon 2002, p.364.

5. Sisley, letter to Tavernier, January 1892, transcribed and translated in Richard Shone, *Sisley*, London 1992, pp.217–20.

6. The other three paintings are: *Vue de Saint-Mammès* (D.422, Carnegie Museum of Art, Pittsburgh); *Vue de Saint-Mammès* (D.426, Walters Art Gallery, Baltimore); and *Le pont à Saint-Mammès* (D.424, Philadelphia Museum of Art). Discussed in London, Paris and Baltimore 1992, pp.192–9.

7. The other four paintings are: *Chantier à Saint-Mammès* (D.368, Sotheby's, New York, 19 November 1967 (28); *Saint-Mammès, le matin* (D.369, Parke-Bernet, New York, 8 April 1953 (93); *Le marronier à Saint-Mammès* (D.371, Parke-Bernet, New York, 11 May 1977 (13); and *Chantier à Saint-Mammès* (D.372, Sotheby's, New York, 13 May 1992 (49).

8. See Jean-Michel Regnault, *Veneux-les-Sablons: Histoire de mon village*, Le Mée-sur-Seine 1991, p.91.

9. 'Le pays vit des transports par eau. La plupart des hommes conduisent, de Saint-Mammès à Paris et au-delà, les bateaux qui, par le canal "ce chemin qui marche", arrivent de Montargis, d'Orléans et du centre de la France.' L'Abbé Clément, *Saint-Mammès, le village et l'ancien prieuré*, Dammarie-les-Lys (1900) 1985, p.171.

10. 'Saint-Mammès, c'est un village de mariniers.' Vanessa Manceron, *Saint-Mammès, terre de mariniers, approche ethnologique d'une population et d'un territoire*, Dammarie-les-Lys 1994, p.39.

11. Ibid. p.29.

12. Ibid. pp.16 and 33.

13. See w.562–72.

14. See Anon., 'Tout Paris : Impressions of an Impressionist', 24 January 1880, translated in Stuckey 1988, pp.69–70.

15. E. Taboureux, 'Claude Monet', *La Vie Moderne*, 12 June 1880, translated in Stuckey 1988, p.89.

16. Letter from Sisley to Monet, 21 August 1881, published in 'Sisley', *Bulletin des expositions*, Galerie d'Art Braun, Paris, 30 January-18 February 1933, p.7.

17. 'Chie dans l'eau'. Archives of Daniel Bretonnet, Moret-sur-Loing (member of the Société des Amis d'Alfred Sisley whose help was invaluable in my research).

18. M. Rausoir, L'insituteur, 'Commune de Saint-Mammès … ', 1888 (unpublished), p.5.

19. 'Cette population est, dans sa généralité, meilleure que sa réputation … Ces braves gens disent d'eux mêmes: "Nous sommes *criards* (j'adoucis l'expression) mais nous ne sommes pas méchants!" C'est parfaitement exact. Nous rencontrons partout, dans la paroisse, l'accueil le plus cordial.' L'Abbé Clément 1985 (see note 9), p.172.

20. Gustave Geffroy, *La Vie Artistique*, vol.III, Paris 1894, pp.282–3.

21. ' … un moment de distraction heureux pour lui et pour le visiteur.' From Jean de Nivelle, 'Les Peintres indépendants', *Le Soleil*, 4 March 1882, pp.1–2, transcribed in Berson 1996, p.406.

22. See Nord 2000, p.23.

23. 'L'homme de parti pris'. From De Nivelle 1882 (see note 21), pp.1–2, transcribed in Berson 1996, p.406.

24. See Robert Tombs, *France, 1814–1914*, London and New York 1996, p.442.

25. For a discussion of this point, see House 2004, pp.197–8.

26. Letter from Sisley to Monet, 21 August 1881, published in 'Sisley' 1933 (see note 16), p.7.

27. Manceron 1994 (see note 10), p.23.

28. Ibid. pp.47–8 and 75–6.

29. 'Ce modernisme apporte un nouveau genre de vie à Saint-Mammès parmi les mariniers. C'est en effet à Saint-Mammès que la traction changeait; animale sur le canal, à vapeur à la Seine.' Regnault 1991 (see note 8), p.91.

30. Preface to 'Galerie Durand-Ruel, recueil d'estampes' (unpublished), cited in Caroline Durand-Ruel Godfroy, 'Paul Durand-Ruel and Alfred Sisley: 1872–1895' in London and Baltimore 1992, p.36.

31. Richard Shone has argued that Sisley deliberately avoided painting the Schneider factory which transformed the village of Champagne, on the opposite side of the Seine to Saint-Mammès. He is, however, mistaken as to the date of the factory's construction which occurred in 1901, after the artist's death. See Shone 1992 (see note 5), p.134.

32. For a discussion of this point, see James McMillan, '"Priest hits girl": On the front line in the "war of the Frances"' in

Christopher Clark and Wolfram Kaiser (eds.), *Culture Wars: Secular-Catholic conflict in nineteenth-century Europe*, Cambridge 2003, pp.77–101.

33. Anon., 'Tout Paris : Impressions of an Impressionist', *Le Gaulois*, 24 January 1880, translated in Stuckey 1988, pp.69–70.

34. 'L'impressionnisme se meurt. Voilà ce qu'on répète après avoir jeté un rapide coup d'oeil sur la septième exposition des artistes indépendants … ' A. Hustin, 'L'Exposition des impressionnistes', *Moniteur des arts*, 10 March 1882, transcribed in Berson 1996, p.395.

35. 'plus sage, plus bourgeoise'. Letter from Monet to Duret, 8 March 1880, transcribed in Wildenstein 1979, letter 173.

36. 'du reste, de plus en plus paysan, je ne sais guère rien de nouveau.' Letter from Monet to Duret, 9 December 1880, Wildenstein 1979, letter 203.

37. Taboureux 1880, translated in Stuckey 1988, pp.89–93.

38. For example, Dr George de Bellio described Monet's paintings as 'very far from completion', 17 August 1879. See Daniel Wildenstein, *Monet or the Triumph of Impressionism*, vol.1, Paris 1996, p.145.

39. Philip Burty, 'The Salon of 1880', *La République Française*, 19 June 1880, translated in Stuckey 1988, p.93.

40. For a discussion of this point, see John Rewald, *The History of Impressionism*, London (1946) 1980, p.576.

2 Reading Monet's *Garden at Vétheuil* (1881) Radically

ADRIAN LEWIS

On the whole, the 'new art history' of the last two or three decades (particularly the writings of Tucker and Boime) has produced a rather conservative reading of Monet's Impressionism.[1] It is the implicit intention of this study to criticise such conclusions by offering instead a Radical reading of *The Artist's Garden at Vétheuil*, 1881 in the National Gallery of Art, Washington (plate 5). Such a painting might seem the sort of Monet least susceptible to such an approach, given the current orthodoxy that his paintings of domestic gardens signify either a complacent, 'apolitical, no-risk sphere' beyond ideology (in Boime's words), or even a developing conservatism (in Tucker's eyes).[2] Certainly, if a Radical reading is found valid here, its relevance for Monet's oeuvre as a whole will be placed firmly on the agenda. However, the way in which certain aspects of the painting's imagery relate to broader themes and interests of bourgeois culture will need to be acknowledged from the outset. Thereafter, the particular way in which Monet approached such imagery and painting process will be shown to be inflected by Radical ideology.

I should emphasise straight away that we obviously need to separate any associations between the word 'Radicalism' with a capital 'R' and what we today think of as any left-wing radical politics descendent from socialism or Marxism. For the former we need to look at Etienne Vacherot's *La Démocratie* (1860) and *La Religion* (1869), Jules Simon's *La Politique Radicale* (1868), the letters of Allain-Targé or the early writings of Gambetta and Clemenceau. We are dealing here with what Philip Nord has called 'the struggle to realise the radical potentialities that [were] perceived within the bounds of bourgeois life itself'.[3] Katherine Auspitz provides a succinct summary of the form of bourgeois Radicalism I have in mind:

> *Radicals … remained faithful to the Declaration of the Rights of Man and the Citizen of 1789 … They believed in the free individual and the democratic nation … They were fiercely anticlerical … Ni Dieu, ni maître … These struggles were not trivial, either in conception or in achievement … Politics is often a process of self-definition, and in France this struggle reached down to the deepest levels of personal identity. The man of the Revolution was a citizen, a worker, and the father of a family. In the nineteenth century, bourgeois radicals remained true to this vision of personal wholeness. They believed that only in a society governed by republican mores was such a personality possible.[4]*

Bourgeois Radicalism, then, in this period was a political tendency upholding the values of Republicanism, freedom of expression, anti-clericalism, values articulated in Year II of the French Revolution but which, because of the political history of France's regimes, had not triumphed politically (the Second Empire being a return to a form of monarchy which sidled up to the Church and clamped down on freedom of expression). These values were only finally realised during the development of the Third Republic.[5] My aim here is not to consider the various accommodations which Radicals made with the more conservative forces of the Third Republic (a tendency that was called Opportunism), nor to analyse the contradictions of bourgeois Radical ideology or the way in which certain Impressionists came later to adopt a variety of politics. It is simply to suggest that Monet's *habitus* was Radical, and that his Radical world-view, mediated through cultural norms, affected his artistic practice and stances in some way.[6]

The general consensus within the Monet literature is that the artist must be regarded as apolitical. However, we all develop frameworks through which we conceive of the good in life and the very nature of life itself. Monet's sense of the source of morality being within the self led him to ignore certain social norms, as in the case of his two periods of co-habitation outside marriage, the second significant enough to be commented on in the Paris press.[7] At the same time, he valued family life.[8] His choices regarding marriage and burial were all positively secular, although he did make accommodations with his partners.[9] We know for certain that in philosophical terms he was a materialist atheist.[10]

In everyday life, Monet valued what he could see and experience through his senses, a stance that had Radical implications in nineteenth-century France.[11] We can be sure that Monet's artistic stance involved a stubborn assertion of his individuality in the pursuit of truth. In 1868, Monet suggested that this truth was so imbued with personal identity that it would resemble no one else's, and the difficult task of rendering what one experienced involved daring freedom.[12] Years later, he challenged a fellow-painter rather brusquely with not painting from nature because he was painting how Monet himself saw nature. There is also evidence that he associated the sense of self-actualisation through painting with personal well-being.[13] Cultural ideas about truth to experience are here being inflected with a Radical flavour of what the assertion of personal identity involved.

We can be certain that in political terms Monet was staunchly Republican.[14] Monet's stance during the Dreyfus Affair was certainly consonant with Radicalism.[15] Another clearer indication of Monet's Radicalism is his antagonistic attitude towards the State, mediated via cultural themes. In 1890, he complained about the culture minister putting 'himself up as arbiter on all questions of art'. Monet writes that 'there is no accommodation to be had with these figures; I don't need either them or their crosses'.[16] The latter remark refers to the fact that, at some earlier point, he had actually refused to be decorated with the *Légion d'honneur*. Monet was making his rejection of the role of the State as plain as he could.[17]

Finally, it is easy to point to a network of Radicals among Monet's friendships.

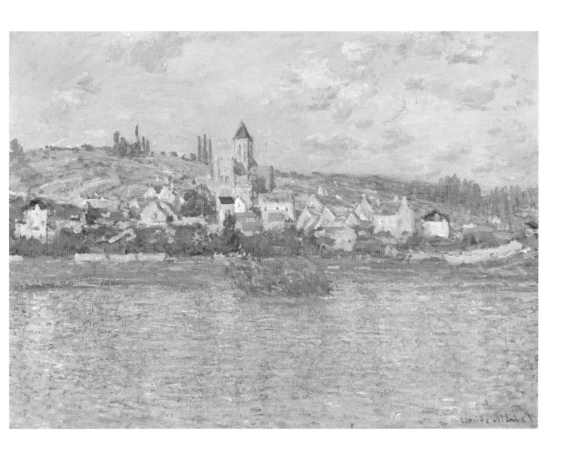

Plate 1 · Claude Monet, *Vétheuil*, 1879
Felton Bequest, 1937, National Gallery of Victoria, Melbourne, Australia

33

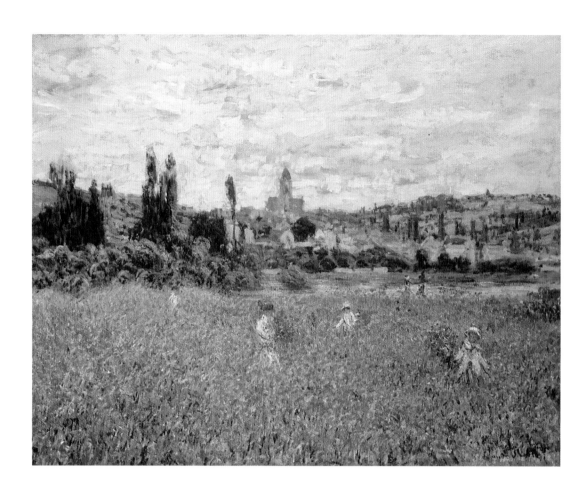

Plate 2 · Claude Monet, *Poppy Field near Vétheuil*, 1879
E. G. Bührle Foundation, Zurich

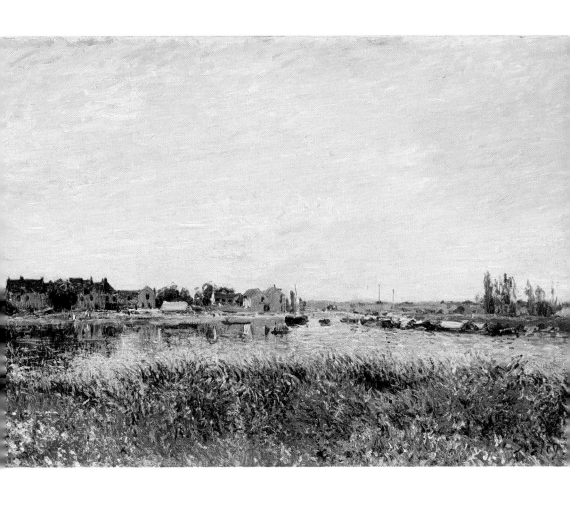

Plate 3 · Alfred Sisley, *Saint-Mammès, Morning*, 1881
Bequest of William A. Coolidge, 1993.45, Museum of Fine Arts, Boston

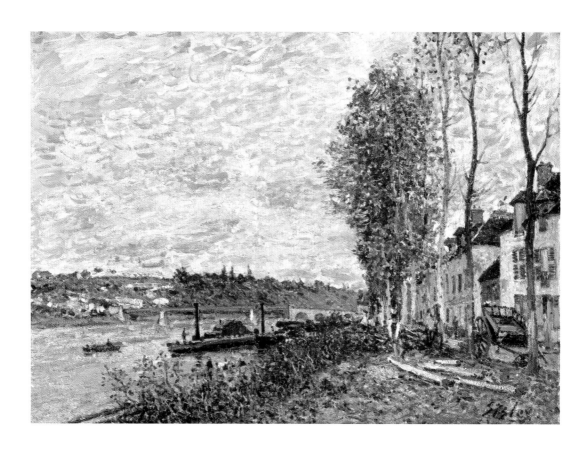

Plate 4 · Alfred Sisley, *Misty Day at Saint-Mammès*, 1880
Juliana Cheney Edwards Collection, 39.679, Museum of Fine Arts, Boston

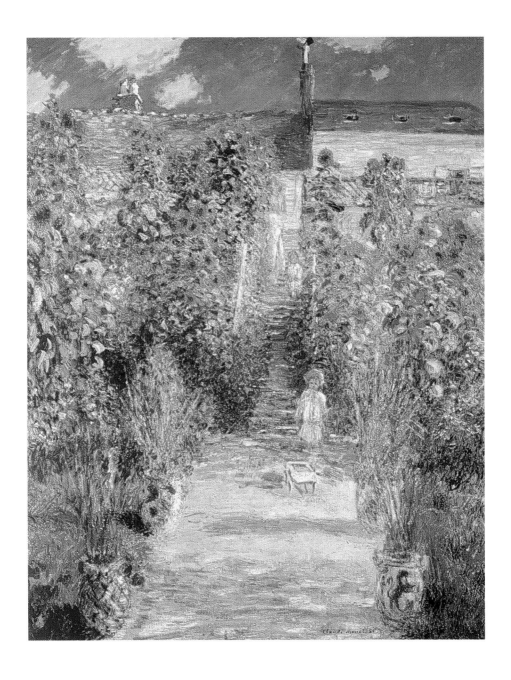

Plate 5 · Claude Monet, *The Artist's Garden at Vétheuil*, 1881
Ailsa Mellon Bruce Collection, 197.17.45, National Gallery of Art, Washington

37

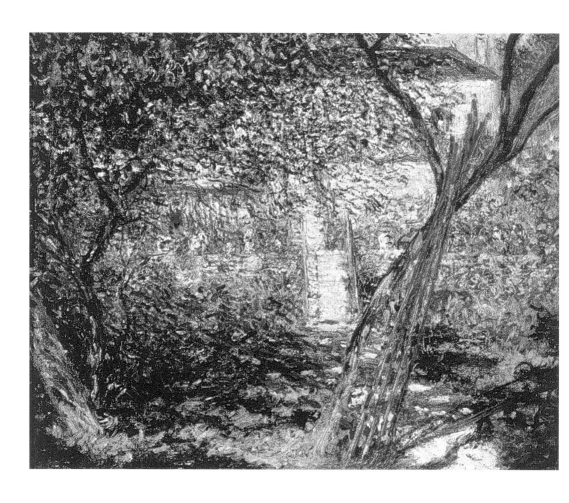

Plate 6 · Claude Monet, *The Garden at Vétheuil*, 1881
private collection

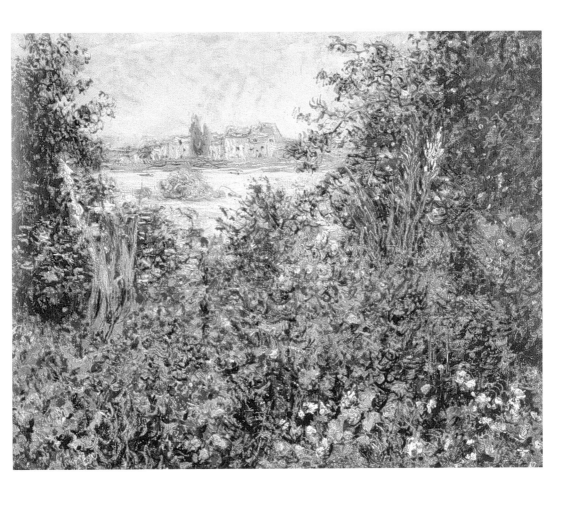

Plate 7 · Claude Monet, *Flowers at Vétheuil*, 1881
private collection

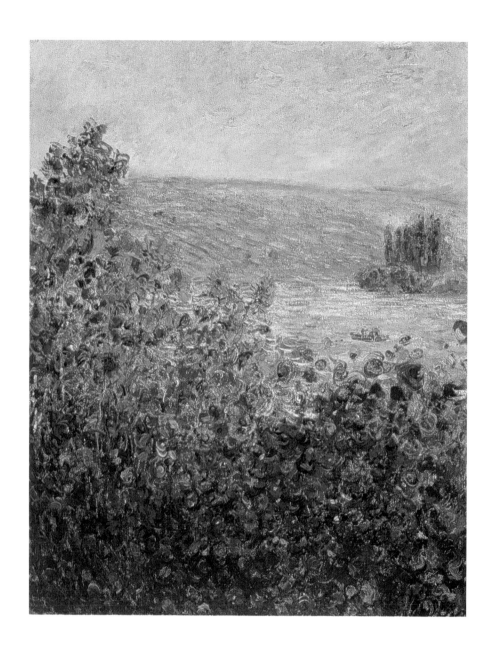

Plate 8 · Claude Monet, *Flower Beds at Vétheuil*, 1881
The John Pickering Lyman Collection. Gift of Mrs Theodora Lyman, 19.1313,
Museum of Fine Arts, Boston

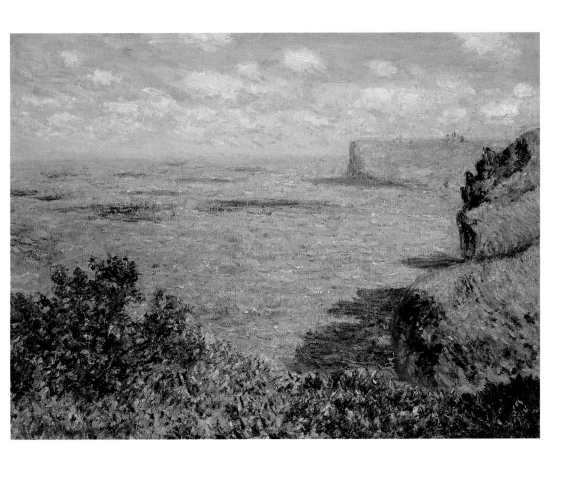

Plate 9 · Claude Monet, *View from the Grainval Cliffs*, 1881
Galerie Rosengart, Lucerne

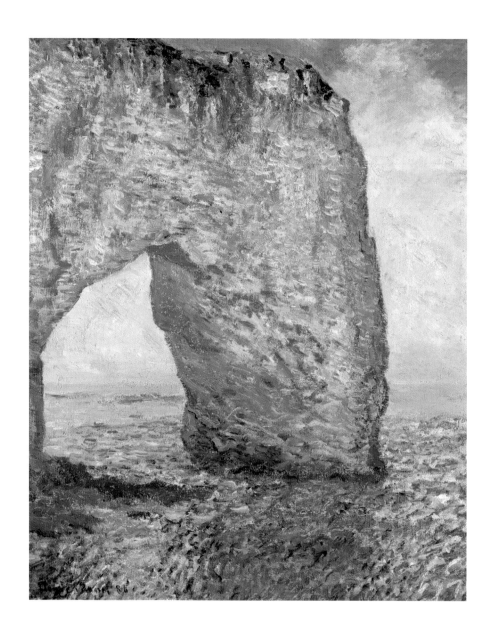

Plate 10 · Claude Monet, *The Manneporte near Etretat*, 1886
Bequest of Lillie P. Bliss, 1931, 31.67.11, The Metropolitan Museum of Art, New York

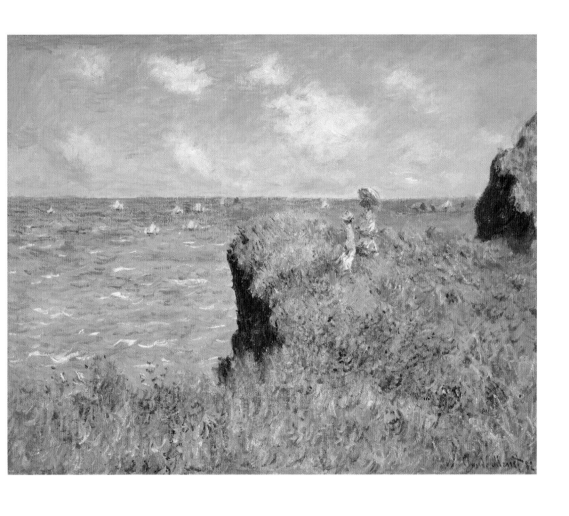

Plate 11 · Claude Monet, *On the Cliff at Pourville*, 1882
Mr and Mrs Lewis Larned Coburn Memorial Collection, 1933.443, The Art Institute of Chicago

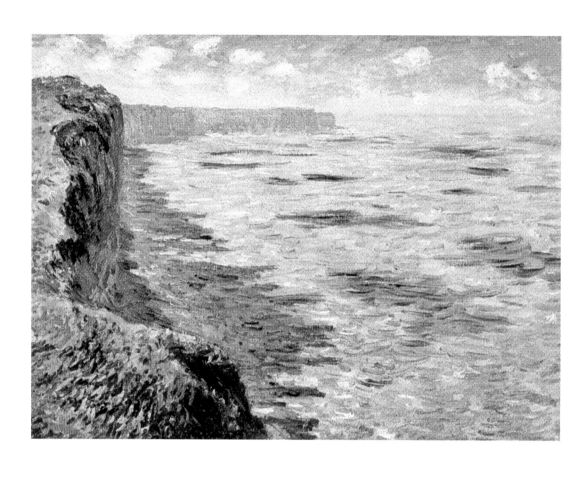

Plate 12 · Claude Monet, *The Cliff at Grainval, near Fécamp*, 1881
private collection

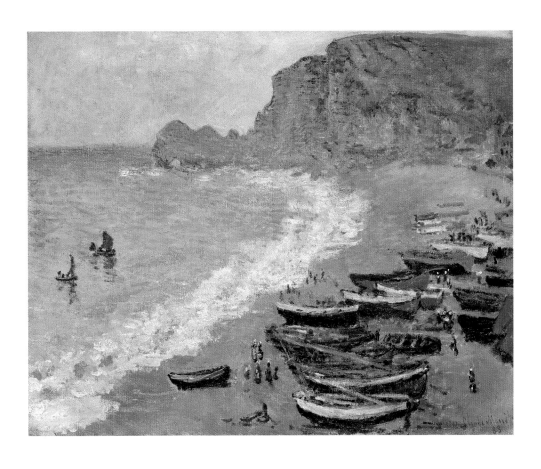

Plate 13 · Claude Monet, *The Beach at Etretat*, 1883
Musée d'Orsay, Paris

Plate 14 · Claude Monet, *Pointe de la Hève à marée basse*
Kimbell Art Museum, Fort Worth, Texas

46

Plate 15 · Claude Monet, *Embouchure de la Seine à Honfleur*
The Norton Simon Foundation

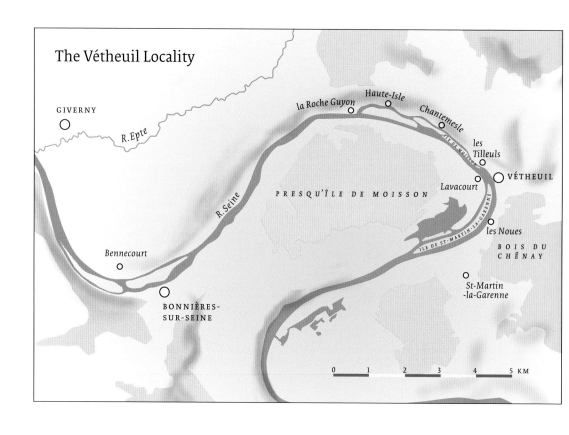

The Vétheuil Locality

GIVERNY

R.Epte

la Roche Guyon

Haute-Isle

Chantemesle

ÎLE DE MOISSON

les Tilleuls

R.Seine

PRESQU'ÎLE DE MOISSON

Lavacourt

VÉTHEUIL

Bennecourt

ÎLE DE ST-MARTIN-LA-GARENNE

les Noues

BOIS DU
CHÊNAY

BONNIÈRES-
SUR-SEINE

St-Martin
-la-Garenne

| 0 | 1 | 2 | 3 | 4 | 5 KM |

The first major monograph on Monet was written by the Radical Gustave Geffroy, a critic who felt that art helped the evolution towards greater personal freedom by representing each individual artist's witnessing of his own existence and of the surrounding universe.[18] Geffroy was permanent art critic from 1880 onwards on Clemenceau's Radical newspaper *La Justice* and Geffroy's close friend Octave Mirbeau was a significant critical promoter of Monet's work in these years. Mirbeau swiftly moved to anarchism in the late 1880s, but it was Radicalism's mind-set that launched Mirbeau in this direction.[19] Monet's great supporter in his later years was the leading Radical politician, Georges Clemenceau.[20] In his book on Monet, Clemenceau talked about his work in a materialist manner and rejected mystical readings of the late work.[21] Clemenceau discusses in explicitly Radical fashion the newly emerging ambition 'to live in society, while preserving as much as possible of our personality from constraint'.[22] Given the fact that significant Radicals such as Geffroy and Clemenceau were the prime supporters of Monet, it seems likely that his world-view chimed with their ideological outlook.[23]

The Artist's Garden at Vétheuil of 1881 was a major set-piece for the artist. Can we therefore see any ideological subtexts to critical responses to the Washington painting? The problem here is that it was not displayed at the 1882 Impressionist exhibition. A more modest version of the same image *was* exhibited (either w.683 or w.684), along with another image based on the same garden (w.681). However, the drama of the new coastal paintings at that Impressionist exhibition attracted journalists' attention away from the garden imagery. As a result, we do not have a contemporary critical response to either the Washington painting or even the related paintings, but we *can* see the critics' responses to other works at the 1882 Impressionist show. Extreme right-winger Jacques de Biez saw the painted *impression* as disdaining conventional values. He likened the effect of the various artists' submissions to a noisy dinner with free thinkers all talking at once, and even used the more violent metaphor of a bomb blast.[24] Where de Biez was disturbed by the sense of inconstancy of visual phenomena, the liberal critic Ernest Chesneau saw this positively in terms of privileging the individual's process of seeing.[25]

There is a fascinating recent discussion of a tiny area of *The Artist's Garden at Vétheuil* in James Elkins's *What Painting Is.*[26] Elkins talks about the sheer endless difference of Monet's brushwork when studied close to, and points to a jittery, out-of-control quality in Monet's handling. Elkins's approach is designed to point out the inadequacy of recent semiotics-derived methods of engaging with paintings. However, such handling could be seen as connoting impatience to give up fixed inherited forms and to open oneself to a wider world of sensuous experiences than had previously been allowed. Monet's combination of control and deliberate abdication of determinateness at some partial level could be seen as a desire to transform brushstrokes into the sense of a visual field in flux. The Radical Clemenceau talked these sorts of qualities through in terms of Monet embodying in painted action the material universe in flux, which becomes aware of itself in developed individual consciousness.[27]

In *The Artist's Garden at Vétheuil*, a centralised axis is created by the centrally placed steps and path ushered in by pots, which we view straight on but slightly to the right, so that the right-hand railing reads vertically and points up to the chimney. The first pair of pots creates a sense of the spectator being at that spot just beyond the picture's bottom edge. The tallest chimney acts as a rough focal point for the receding diagonals, yet their spatial thrust is compromised by the ascending steps and blocked by the architecture. The distinction between path and steps is elided by the light-and-shade pattern. The result is that the spatial illusion of Albertian orthogonals is transmogrified into a tense triangular form on the picture surface. The top of this triangle can be found where one chimney hits the upper edge of the painting. Indeed, this triangular surface division acts to create a reverse compositional direction downwards from the top of the painting, like a reverse visual cone that sweeps past the figures and takes in the implied beholder on the threshold of the picture. This effect is accentuated by the frontal poses of the three figures. They seem to return our gaze and complete the sense of involvement in perceptual terms.

There was a certain body of academic genre paintings representing gardens produced during this era, usually showing bourgeois females either on their own meditating or smelling flowers, or with friends and family. One such example is Marie-François Firmin-Girard's *First Kisses* (fig.3), shown at the 1875 Salon, the year after this artist had won a second-class medal. There is an ongoing debate about histories of early modern painting and its relation to academicism, and much writing has suggested dismantling such a contrast. However, in many ways today we need, instead, to deepen our historical understanding of the differences between such practices. The way in which the Impressionists' images were painted raised questions then about professionalism and control, but also issues about the individual's relation to society, the source of truth and the ends of life.

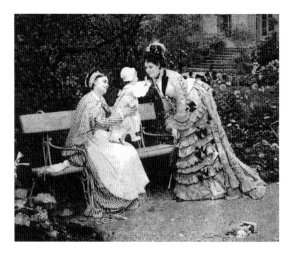

Fig 3 · Wood engraving after Marie-François Firmin-Girard, *First Kisses*, exhibited at the 1875 Salon

We need to compare the differing modes of apprehension constructed by *The Artist's Garden at Vetheuil* and Firmin-Girard's painting if we are going to get beyond broad thematics to a specific world view. Firmin-Girard's painting is known today only through a print, but it would clearly have been smooth in finish, with a chain of emotive figure-interaction within the very centre of the canvas. It shows a moment of 'timeless' mothering rendered in modern circumstances but fixed for contemplation from without. Monet's picture, by contrast, uses the sort of address by figures from within the picture to an implied spectator that one finds in eighteenth-century conversation pieces, but given an imposing vertical and axial format, all of which add to the painting's sense of facing and incorporating the viewer. Our sense that the painting involves some process of abrupt marking of a perceptual fullness (requiring the 'effacing' of the features of those topmost figures and the further omission of the feet of the nearest child) engages our feeling of visual involvement, of being right there in time as well as space. The painting envelops us and seems to make art-viewing as well as art-making contingent. Such a sense of contingency seems to make us acutely aware of our own individual moment of being. Works like Firmin-Girard's image, by contrast, allow us to gaze from the outside on the typicality of human circumstances, where we do not confront our own selves and where instead life scripts are written in advance.

Monet's Washington canvas *seems* to represent some sort of domicile and its garden, with two children and a female figure. The whole form of the painting and flight of steps suggest a certain grandeur. Echoes of Renaissance villas on a sloping terrain with terraces and gardens slung from that high vantage point come to mind. Yet that aristocratic *topos* is here 'bourgeoisified', made more modestly available. Indeed, the image itself involved a certain cunning editing. Firstly, although the roof is run together colouristically through the blue shadows falling across the red roof, it consists clearly of two levels. Thus the 'domicile' at the top comprises two houses, in the right-hand one of which Monet lived. Secondly, the garden was not continuous with the houses, but separated by a main road, and the evidence of another painting (*The Garden at Vétheuil*, w.666, plate 6) shows that what looks like one grand staircase is actually two lesser sets of steps which run visually together, probably with Monet's pots rearranged for the purpose of adding to a vista often associated with images of property. Such a sweeping view is here made vertical, rather than laid out in deep space.[28] Thirdly, the house did not belong to Monet, but was rented from a Mme Elliott, a widow whose money came from big industrial wealth and who owned a genuinely grand mansion called Les Tourelles, situated just behind and to the right of Monet's modest dwelling and dwarfing it dramatically.[29] Reduced today to one shortened turret, Les Tourelles originally had two five-storey turrets of distinctly historicist style, often conflated in Monet's Vétheuil paintings with the church behind. If Monet had depicted his garden steps at a slight angle to the left, he would have had to show a section of this grand house, which he has chosen not to do. In opposition to the big money and high status signified by the mansion of his *propriétaire*, he chose instead to assert his own investment of personal identity in his present make-shift situation.

Radicals invariably saw themselves as 'workers who have property' and yet who are, in the words of Ferdinand Buisson, 'nearer the working class than the great … capitalists and the great ones privileged by wealth'.[30] Radicals came from the social strata of small businessmen (Monet's own background) and petty producers, though it was the professional classes who tended to represent their interests politically. Most *petit-bourgeois* had to sell their labour or the products thereof, as did Monet with his painting (unlike Manet or Cézanne), though he certainly started getting substantial earnings from his paintings as early as the 1870s. Many *petit-bourgeois* owned some land, but not all, determining their commitment to the idea of private property at the same time as they tended to be antagonistic towards big business and high finance. Crucially here, it is often forgotten that Monet did not actually own land until he was able to purchase the house at Giverny in 1890, approximately the time that Monet had himself photographed by Theodore Robinson as a clog-wearing gardener, whose individual assertiveness was grounded in being a socially modest stakeholder.[31] Prior to that, Monet had always rented houses and gardens, as he was doing at Vétheuil and went on to do at Giverny in 1883. Even at Giverny, the house he finally bought was not at all like the grander houses of other contemporary successful cultural figures, however impressive it might seem to us today, after all Monet's work on the garden and studios. Thus Monet's handling of the image of his rented Vétheuil house to suggest a settled property-stake was part of a certain Radical wishful thinking.[32]

There is, of course, a longer-standing, underlying liberal/bourgeois notion of property here: Locke's notion that the foundation of property lies in the individual being 'master of himself and proprietor of his own person and the actions or labour of it', his bodily labour mixing with the earth to determine one's own sufficient plot of land.[33] However, we do well to remember that Radicals put their own ideological spin on this tradition. We might remember that a Radical commentator, Sigismond Lacroix, made the following call in 1872: 'universalise power and property. That is the programme of the future.'[34] In other words, it was necessary for self-realisation to have the social opportunity offered by property. For Radicals, the owning of property was the basis of political freedom and citizenship. For the Radical-Socialist Pierre Malardier in 1870, every citizen ought to own property and that guaranteed freedom, fostering 'the uniqueness of the personality' which was at the basis of all activity.[35]

A coda is needed on this discussion of property and politics. Despite the grand effect conjured by Monet's image, it should probably be titled *A Corner of the Garden at Vétheuil*, the title of the related work which Monet exhibited at the 1882 Impressionist exhibition. An even more modest, geographically neutral title *Corner of a Garden* was devised when one of the related works was bought by Durand-Ruel in 1882. The title the Washington painting goes by today, *The Artist's Garden at Vétheuil*, thus performs a significant act of misrepresentation. For Monet, dreaming of one's own plot of land to work, was aspiring to full self-realisation, the basis for asserting one's full identity. The unnecessary reference to the artist in Washington's present-day title militates against the painting being a sign of Monet's identity and

instead signifies self-congratulatory ownership of a Monet 'masterpiece' imbued with 'special' biographical significance, by the national gallery of the world's most powerful nation.

The emphasis on home and garden has long been recognised as a central feature of an emerging bourgeois culture. Gardens were seen as being democratised. Royal gardens were now publicly owned and, in the words of Baron Ernouf, 'today the humblest abodes claim the right to be adorned [with a garden]', a garden which might be superior to an aristocratic one, he adds, in the same way that a good easel-painting might be superior to a mediocre Salon-sized *machine*.[36] Small gardens were the topic of much debate, as in Moléri's 1866 book *Les Petits Jardins*. Moléri makes great play of the fact that he is not writing about exotic gardens from other times and cultures, or gardens for producing food, but bourgeois gardens for enjoying looking at and being in, the *jardin fleuriste* or *jardin d'agrément*.[37]

This era saw the appearance of the first broad histories of gardens and discussion of their cultural significance. Gardens came loaded with social connotations, especially around formality and aristocratic culture, informality and bourgeois culture. Writing on the eve of the liberal phase of the Second Empire, Ernouf compared the fashionable mixing of formal and informal elements in garden design to the blending of monarchical and democratic modes of government,[38] while Mangin, writing after the triumph of Republicanism in the 1880s, related the vogue for the informal *jardin paysager* to the 'undisciplined character of modern societies', the desire to govern oneself freely, and liberal and progressive tendencies generally.[39] The bold massing of sunflowers in the Washington painting has to be taken, to some extent, as 'given' in the property being rented, rather than as Monet's handiwork, but the way in which Monet's representation of these sunflowers is made to bounce the spectator's eye around the top half of this sunlit image would have suggested the undisciplined burgeoning of life in free formation.[40]

In terms of the broader resonances of garden imagery in Western culture, we know that Monet deliberately indexed his taste and outlook to the rococo 'garden of love', or at least to a more mythically developed version of that, Watteau's *Le Pèlerinage à l'Ile de Cythère* of 1717. Monet declared to Clemenceau in conversation that this painting was his favourite in the Musée du Louvre, Paris.[41] In so doing, he would also have associated his outlook with certain traditions of gardens in Western culture, while suggesting a distance from others. He would doubtless have felt positive about the garden of courtly love and the humanist garden of ordered harmony, but less so about the idea (if not the image) of the *hortus conclusus*, an allegorical figure of thought, medieval and monastic in formation. This image of enclosure, of spiritual perfection associated with the Madonna, was predicated upon separation from the world and interior meditation.[42] Monet's Washington canvas seems to overturn any such separation of garden from our viewing presence. Moreover, what we see and experience is the sum content of experience and knowledge in Monet's world view.

The 1884 papal encyclical *Humanum Genus* talked about a battle between contempt for self and love of self. Amongst the 'allurements of pleasure' associated with

the latter is the fact that 'designs for works of art are shamelessly sought in the laws of a so-called realism'.[43] For the Church and cultural conservatives generally, the highest form of art was seen as celebrating timeless spiritual truth, the idea of a higher authority and triumph over human vileness. The starting point of Catholic faith was the acceptance of original sin, and the image of its emergence in history is the Fall and Expulsion of Adam and Eve from the Garden of Eden. The 1884 encyclical spoke of the Fall producing an unending struggle between those on earth championing either the kingdom of God or the kingdom of Satan. In a contemporary representation of this theme, Alexandre Cabanel's *Paradise Lost* (fig.4), a glistening sword suggests the directional power of light in exposing carnal sin, associated with woman. To modern eyes the projection of carnality onto woman is a patriarchal construction deeply embedded in Christian thought-patterns, and that sword of authority bespeaks male phallic power while rhyming with the serpent it purports to expunge.

Cabanel, a member of the Institut and professor at the Ecole des Beaux-Arts, represented academic art perhaps better than any other artist. *Paradise Lost,* typically, was awarded the *Croix de chevalier de première classe de l'Ordre du Mérite de Saint Michel de Bevière.*[44] Artistically, the authority of such work resided in tight outline and smooth surface, the power of light and dark pattern to produce a sense of emotional conflict. Monet's light, by contrast, does not act as metaphor, not even of the revolutionary light of reason sweeping away darkness. Surfaces break into marks that bespeak the individual's fresh attempts to make sense of visual experience in the

Fig. 4. Alexandre Cabanel, *Paradise Lost*, 1867, exhibited at the *Exposition Universelle*
Formerly collection of the Maximilianum, Munich (destroyed 1945)

absence of pre-given cultural solutions. Painting reality as wholly shifting and contingent makes the individual artist/observer the arbiter of truthfulness, which undercuts the idea of authority in general. *The Artist's Garden at Vétheuil* does not model a truth elsewhere but engages us in a sense of presentness. There is no conflict over the pursuit of pleasure for the self, and no authority with a gleaming sword to gainsay its pursuit.

Back in 1857, the liberal-republican critic Jules-Antoine Castagnary had discussed the relationship of culture and ideology in a way that deploys with some pertinence the image of a secular paradise garden:

> *Art is ... [today] above all the expression of the human self brought forth by the exterior world ... According to biblical legend, when God, creator and sustainer of all things, came across man in the flagrant offence of disobedience, He chased him from the Garden of Eden, placing at the door, to stop him ever entering, an archangel holding a flaming sword in his hand. Mankind has wreaked its long-term and startling revenge on this ancient formulation ... [saying] to replace the divine Eden from which mankind was expelled, I will construct a new Eden which I will people with my own kind. At the entrance I will place Progress, invisible sentinel; I will place the flaming sword in his hand and he will say to God: 'You shall not enter!' ... Man as he has grown has broken through these terrible walls [of mystical collectivity operated by the religious spirit, and of political collectivity], and individualism has escaped through all the gaps. Thus does Humanity continue the process of negation of religion and traditional authority, and affirmation and progressive emancipation of the human personality.*[45]

This humanist position connects progressivism with anti-Christianism in a way that was central to Radicalism. Etienne Vacherot, for example, associated Catholicism and despotism, and by contrast linked Radical Republicanism to an absolute, unqualified freedom based upon reason itself,[46] whereas for Catholics thinkers and authorities, original sin tended to mean the more authority and social pressure reining in human license the better.

Radicals took on board reason and science as given starting points for knowledge. Christian culture's loaded image of paradise lost, by contrast, was associated with eating the fruit of knowledge. While the idea of positive knowledge through observation of the world – testing and reasoning – was gaining pace throughout this period, contemporary Catholic culture regarded mankind's attitude towards attaining truth as deeply problematic.[47] The 1884 papal encyclical *Humanum Genus* challenged the idea that there ought to be a reason to obey any authority. It opposed the idea of natural freedom, freedom of conscience and opinion, equality of human rights, the very principle of democracy that 'power is held by the command or permission of the people'. The Catholic Church then set itself firmly against the legacy of the French Revolution and the 1789 *Déclarations des Droits De L'Homme et du Citoyen* until very late in the nineteenth century.[48] It was in this context that Gambetta in 1877 attacked the Church as 'the enemy' of the Republican way of life.[49]

The area of greatest political contestation between triumphant Republicans and

the Catholic Church during this era was education, the focal point for reproduction of values or change of mind-sets.[50] Not all Radicals were atheists, but many were, and all Radicals felt it important to chase religion out of education. A belief in secular values was connected to the idea that the demise of religion would lead to a morality of proper human values and that human beings would now combine in social circles on the basis of equality. Upbringing, especially in resistance against religious formation, was a key theme of Radical texts, connected with new values of self-realisation in opposition to traditional moral enculturation.[51] Here we have a piece of crucial evidence from Wildenstein that, while living at Argenteuil, Monet chose to send his son Jean to a private school run by some sort of Radical Republican. The eponymous teacher of the Pension Fayette has been documented as 'fierce' in his Republicanism. There is also some evidence for François Fayette being interested in Monet's work because, in lieu of a fees debt, he happily accepted three paintings by the artist in 1877.[52]

At the same time the language of self-realisation was obviously beginning to be more widely deployed as part of bourgeois culture. Connected to that trend was a general shift towards a valorisation of the child. While these new cultural themes were not exclusive to Radicalism, one wants to know whether there was any relationship between different theoretical outlooks on child-rearing and different ideological positions. Certainly the position of conservatives was still to associate parenting with hierarchy, discipline and the transmission of traditional moral/social values. We find this line of argument in Théodore Barrau's *Amour Filial* (1862). Here Barrau tells us that there is in our parents something sacred, and that young people should listen to their parents' moral guidance with the appropriate attitude of reverence.[53] More radical opinion rejected the emphasis both on parental authority and on original sin. Not all liberals or Radicals *in practice* took up a position different from conservatives. However, if we consider views rather than practice, where a difference *can* be detected, it was the former who tended to hold those newer ideals. Views on childhood were enmeshed in wider beliefs about morality, society and metaphysics. Reverence for authority on the conservative side was matched with valorisation of individual independence on the Radical side. For example, one 'advanced' text by Angely Feutré was significantly entitled (in translation) *Against Present-Day Marriage: Thoroughly in Favour of Children*,[54] a distinctly subversive title to conservative ears. By contrast, a cleric such as Bishop Dupanloup may have insisted on the need for parents to attend to the nature and individuality of the child, but in the end he lamented lack of parental control and attacked independence in the child as a vice.[55]

Contextualised within such discourses, Monet's various representations of mother/children relationships in the 1870s all construct an image of the child as an autonomous individual,[56] whereas ideologically conservative academic artists usually made the child dependent on the parent-figure. Firmin-Girard's *First Kisses* (see fig.3), for example, shows the intertwining of nurse, baby and mother. The child is being lifted and supported to interact with the mother, and the focus is on bonding. The child may be given a special, almost sacral emphasis, but ways in which child and

mother are intertwined in academic paintings always suggest the dependency of the former and the role of the latter in protecting and guiding the child. What is most dramatic in painting after painting by Monet is how he depicts the child as separate from the mother.

The imagery of *The Artist's Garden at Vétheuil* suggests some nuclear family embedded in its small town existence, where the garden has become the blissful context for life and maturation. The linking of differently aged figures and steps may vaguely evoke *degrés des âges* imagery, with a rise and fall of steps indicating a process of maturation and decline.[57] The link, though, is loose, as the two boys ascend in age as they descend the steps. The implication also of a pre-given pattern of life is worked against as our eye is stopped, by the boy in the foreground, at a privileged moment of emergent personality.[58] The imaginary aspect of this family unity is underlined when we recall that those modelling this family scene came from two families devastated by death (Camille Monet) and separation (Alice from Ernest Hoschedé. The model for the female figure is not known, and may even (from her height) be one of Alice Hoschedé's daughters, but the foreground child, whom we might assume to be Monet's older son Jean, was in fact modelled by Alice's child Jean-Pierre, with Michel Monet behind.[59] The financial difficulties of the Monets and Hoschedés had led them to pool their resources, while the bankrupt Hoschedé *père* tried to bring in some money by working in Paris, before going into temporary financial exile. Monet's wife Camille died in 1879, and Monet at some unknown point fell in love with Mme Alice Hoschedé, though they did not marry until 1892. In addition to the two remaining adults and two staff in the Vétheuil house after Camille died, there were eight children, all in three bedrooms, plus ground-floor rooms and a painting attic. Monet's set-up was not the unproblematic nuclear family that the image seems to suggest, but, instead, a complicated and socially unseemly household; a widower's family sharing with that of a separated woman.[60]

This information about Monet's home life underlines the degree of dreamwork going on within the project of phenomenal realism here. A sense of longing is hinted at by the 'oriental' pots. In fact, they are probably not oriental at all but European imitations, picked up years before and part of the moveable Monet furniture, popping up in the Argenteuil garden pictures and, as we see from plate 6, possibly realigned from their place along the first terrace specially for the Washington picture. We need to understand that during this era their oriental look would trigger associations of a primitively simple Arcadia,[61] chiming with the privileged theme of childhood, as we shall now see.

In *The Artist's Garden at Vétheuil*, the notional painter/observer is placed within some sort of family unity identified with the garden of a rural house. Indeed, arguably the presence of stairs suggests a conflation of inside and outside, as stairs are usually associated with indoors. We are enveloped within a garden as corridor-like space, with overarching plants and pockets of shadow. It is not too fanciful to suggest that the cloud hovering above the second chimney carries subliminal associations with the smoke of a warm hearth. Read from this point of view, the garden

offers a picture of the child's imaginary world. Our gaze fixes on the barely indicated stare of the nearest child, located directly below the main chimney and alongside the funnel created by the fusion of path and staircase. He is woven into the pattern of light and shadow, his toy cart before him in the full morning sunlight. The location of the path's vanishing point, not far above his head, makes us feel as if we are roughly on his level. Sunflowers in various cultures have been associated with sunlight and the mystery of life. Here, both the size of the child's round head and the green tint of his hat seem to rhyme with the flowers and foliage on either side. The child is placed within nature and is associated in his growing individuation with the natural burgeoning of sunflowers. Child-rearing involving play and sunlight evokes Rousseauesque notions of upbringing, notions that the process of individuation is practically organic.

The question here is whether we can tie such progressive elements of bourgeois thinking generally to a more Radical outlook. Certainly, the Republican Jules Ferry legislated that all rural schools must have an enclosed garden for the children to play in.[62] There must then be some discursive concatenations between the idea of the secular school, gardens and Republicanism. Let us turn to the writings of Jules Michelet, a staunch hero of Radical Republicanism, whose work deeply interested Monet.[63] In 1860, Michelet talks about the first duty of giving a child sunlight, which penetrates the central mass of the brain as well as the optic nerves.[64] Even a four-year old, according to Michelet, is still a blank slate (horror of horrors in conservative religious eyes) and the role of education was to channel the child's mobility and sensibility. The child needed to be introduced to the love of nature and also creative play. Here Michelet draws on the idea of the kindergarten introduced by Friedrich Froebel.[65] Ten years later, Michelet picks up on what he sees as the key lesson of the Enlightenment, 'the will', 'the living force which gives man his power', and 'in the will, that which makes it powerful and efficacious, freedom'.[66] It is the creative power of man that is crucial, and therefore acting, producing, creating are central to education.[67] 'To create, that is education', and the child should learn to play with regular elements, learning to combine them, to make small constructions.[68] This creative play gives the greatest pleasure to a child and develops the child most dramatically, before the play of history (at least for boys) is introduced.

These ideas of the 'child-garden' place us firmly in the area of Radicalism, with its sensationalist philosophical background, its denial of original sin, its open-ended approach to the development of the individual. Indeed, we can pin down Monet here even more closely. In the *The Luncheon* of 1873 (w.285, Musée d'Orsay, Paris), Monet's son is playing on his own beneath the table in a garden, which is circulating with air and sunshine, as Michelet wanted. Clare Willsdon has also pointed out that Monet's son is manipulating basic wooden elements exactly as progressive educational theory of this era encouraged.[69] The child, in other words, is learning to interact, to create, to become a free, self-determining individual capable of recreating society in humanity's own desired image, at least in the eyes of Radicals.

What is most Radical in outlook in Monet's Washington canvas, then, is the sheer

separateness of the figures, the sense of the individual identity and development of each child. The painting is constructed dramatically for us to identify with the nearest child who is significantly separated from the other two, and is himself separated from the cart he is playing with. This child is being allowed Radical free space for individual formation, with the sunlit enclosed garden as his playpen and a toy for interaction, exactly as Michelet encouraged. Even more Radical here is the general emphasis upon the contingency of truth, both in the temporal flux of observed reality and in the spectator's relationship with what we feel we experience through the painting. Yet, paradoxically perhaps, such a work was done on a nearly five-foot canvas of specially constructed dimensions. Begun right at the end of his Vétheuil stay on 1 October 1881,[70] it remained in Monet's second studio at Giverny, although the fact that it was signed suggests that it did go on the market in Monet's last years. However, its entry into the market may have been delayed because, as one of those summative pieces of work which Monet periodically did as reputation-capping paintings, he wanted to keep it back for a while in order to be able to use it in some way to reinforce his artistic contribution and stature. He certainly kept it as part of the mini-retrospective of his works for visitors to study in the second studio at Giverny.[71] Thus my argument is that it was done in some sense for art history rather than simply for market consumption.

Yet there is another, even more deeply Radical impetus within Monet, and that is to dismantle the very basis of the 'masterpiece' and replace it within a series of interactions with nature, emphasising individual viewpoint in time and space. *The Garden at Vétheuil* (plate 6) may be *La Maison de Campagne* bought by Durand-Ruel in April 1881.[72] If so, this painting may date to earlier than the other garden paintings to be discussed below. Thus, Monet began his exploration of this garden area by painting a distant view of it from far down the path, to its left and standing under the trees, looking to the north-west. Two identically sized works (on standard size 25 canvases) bought in December 1881 by Durand-Ruel show a figure beneath those lower trees (w.680–1). A different time is implied by means of the differing lighting and floral growth. Monet also twice painted the gate at the end of the garden, which gave directly onto the river, a west-south-westerly view (w.690–1). This view is done on a standard size 20 canvas, but oriented differently in each case. The vertical image (w.691) suggests that Monet stood to the left of the gate, while the horizontal one (w.690) implies a position centred on the gate and further back.

Thus Monet tries out both temporal shifts within a static viewpoint, and also shifts of viewpoint. He pursued relative shifts of position in two more views from the garden, right down in its bottom corner. *Flowers at Vétheuil* of 1881 (plate 7), roughly the same size as the last two, has a glimpse of Lavacourt across the river, looking roughly south-west. The larger *Flower Beds at Vétheuil* (plate 8), done on a standard size 30 canvas and bought by Durand-Ruel in December 1881, shifts our view to the left from the same sort of position. It misses out any houses but includes a rowing boat as its sole human indicator, and fills half the canvas area with flowers and foliage.

There is no evidence of the order in which these last six paintings were executed

over the middle and late summer of 1881. However, any commentator is drawn to say that (taking Wildenstein's arbitrary choice of ordering here for convenience) Monet looked first of all in a north-westerly direction (w.680–1) and turned anti-clockwise to take in the gate (w.690–1), then the glimpse from the left towards Lavacourt and subsequently the view further southwards down the Seine. While clearly Monet did not turn around to do the next painting as one would take a snapshot, I would describe his painting activity in the Vétheuil garden in 1881 as serial – that is, systematic in the process of shifting positions and directions of viewing/painting, varying painting format and orientation, and of necessity representing views in different moments of time.[73] It is thus a systematic exploration of the key elements of variation in the relationship between the human perceiving subject and the world observed through the process of painting.

However, the impetus to establish a position within art history through occasional summative works is a contrary one operating simultaneously in Monet. (It is not a question of privileging one motivation over the other, but of giving full due to contrary impetuses.) So Monet took the motif of *The Garden at Vétheuil* (plate 6) and homed in on the steps (w.682). He then did two larger oils in which he introduced, firstly, the imagery of two boys on the steps (w.684), and then clouds (w.683), reverting to a lateral morning light, before finally (plate 5) shifting to an even larger scale and replicating the cloud-patterns and lighting of w.683, while adding a third figure on the steps and making the older boy the focal point of the whole painting. This suggests a process of going from plein-air work (w.682) through some less definable combination of outdoor and indoor work (w.683–4) to what might be considerably, or even completely, a studio work (w.685).[74]

Monet's garden images at Vétheuil embody an intensely self-possessive stance towards the world, both in their painted imagery and in the process of open-ended interactions between self and visual world. This serialism had been operating in practice from the start of Monet's career, but he could not conceptualise it until later.[75] What is Radical about that serialism (and not connected with market repetition) is the model of consciousness it suggests, a model in which truth is not given in advance or seen as existing somewhere else, but is what is produced by an individual's questioning exploration of experience in all its human contingency. A contemporary right-wing critic, Jacques de Biez, reviewing Monet's work at the 1882 Impressionist exhibition, for example, felt uncomfortable that he was seeing related motifs that seemed to suggest a short interval of time between them, as if an emphasis upon representation of the temporally structured nature of experience was itself subversive.[76]

The very emphasis upon the sense of time's momentum and the implied provisional nature of truth was ideologically unsettling. For Monet, the truth of the case (for the painter, what the world looks like) needs to be accumulatively discovered by piecemeal investigation, tested out by the individual through variant investigative strategies. Cabanel's *Paradise Lost*, by contrast, was so finalised that it was subject to replication by the artist himself twice, whereas each serially related, but different,

image of Monet's adds something to a cumulative sense of reality, based in the contingent flux of experience. The grand statement about truth that is the 'masterpiece' (exemplified by works like Cabanel's *Paradise Lost*) is undermined by this notion that truthfulness will always be partial and provisional. Thus, those books or exhibitions entitled something like 'Masterpieces of Impressionism' contribute to the erasure of one historical meaning of such work, the undermining of those presuppositions upholding the 'masterpiece'.

Even those unwilling to take a broader view of culture and ideology are willing to acknowledge today the politicised nature of cultural debate during the mid-1870s' 'moral order' regime, which saw the staging of the first Impressionist exhibitions. However, there is a danger today of thinking, from the friendly words of cultural ministers, that the triumph of Opportunist Republicanism during 1879–80 meant the rapidly ensuing approval of Monet's Impressionism.[77] Official Third Republic policy towards Impressionism certainly softened as the 1880s and 1890s wore on, as shown by works included in the 1889 and 1900 Expositions Universelles.[78] However, when it came to the Republic's official consensual face in the form of public decorations, Monet's candidature to do a landscape scene as decoration for Paris's Hôtel de Ville was firmly rejected as late as 1892.[79] In practice, then, Monet was still operating at a distance from official Republican aesthetics until relatively quite late. It also took until 1907 for Monet's work to be bought by the State.[80]

To see Monet's painting practice as informed by a strong Radical outlook is difficult for us today, given the later history of Radicalism. While such Radicalism had its progressive moment in its opposition to State power, and to expedient attempts to maintain bourgeois socio-economic gains at the expense of liberal-humanist ideals, ultimately such an outlook proved only too amenable to increasing State power and the entrenchment of class relations. This contradiction is demonstrated only too well in the later career of Clemenceau, who ended breaking strikes, running the State machine during the First World War, and twisting Monet's arm to complete his contract with the State by delaying no further the completion and delivery of the Waterlilies decorations.[81] Impressionist painting itself was recuperated to the point where it could either be lauded as transcendent pleasure or else ahistorically criticised by recent academic leftists as conservative bourgeois vision. However, a dialectical historical reading should insist not just on the process of ideological recuperation, but also on the moment of critical vividness of ideological values. Monet's work through this period achieves a more extreme form for a culturally mediated Radical-bourgeois vision than had yet been artistically achieved elsewhere.

Reading Monet's *Garden at Vétheuil* (1881) Radically

ADRIAN LEWIS

Ongoing reference is made in the footnotes to Wildenstein I–V. w. numbers refer to catalogued paintings, WL. numbers to catalogued letters.

1. P. Tucker argues in 'The First Impressionist Exhibition and Monet's *Impression, Sunrise*: A Tale of Timing, Commerce and Patriotism', *Art History*, December 1984, pp.465–76, that Monet after 1870 was answering his society's *post-bellum* call for a patriotic art celebrating the country's potential new dawn. In Tucker 1989, pp.37 and 251, he talks about Monet's work affirming principles of 'order and permanence', celebrating the 'essential values of the French countryside' based upon a lifetime's nationalistic 'devotion to painting *la France*'. Albert Boime in *Art and the French Commune: Imagining Paris after War and Revolution*, Princeton 1995, pictures it as essentially doing the conservative dream work of a bourgeoisie politically frightened by the Commune.

2. Boime 1995, p.98. In stating that Impressionist painted gardens constituted 'material values', Boime is eliding the everyday pejorative connotations of the term 'materialistic' with materialism as a philosophical position. Boime does fleetingly refer to the possibilities of 'self-definition' offered by representation of one's own garden, but he does not develop this. For Tucker, Monet's painted gardens represent 'self-containment and sentimentality opposed to worldliness and dispassionate inquisitiveness' (Tucker 1982, pp.163 and 149). The garden is made to function here within a semiotic binary contrast with the city/suburb to deliver a verdict about Monet's increasing rejection of 'involvement with modern life'. However, Monet had painted gardens from

the start of his career (w.67–69) and painted nearly as many images of his own garden in the first half of his years at Argenteuil as in the second half, something you would never guess from the structure of argument in Tucker's book.

3. P. Nord, 'Manet and Radical Politics', *Journal of Interdisciplinary History*, Winter 1989, pp.447 and 448, n.2.

4. K. Auspitz, *The Radical Bourgeoisie*, Cambridge 1982, pp.3–4 and 19.

5. See F. Furet, *Revolutionary France, 1770–1880*, Oxford 1995. For example, a fuller freedom of expression was legislated for in 1881. A totally secular and compulsory free education was enacted by Ferry after he came to office in 1879. (The restriction of the Church's direct role in the polity was to come later with the Radical separation of Church and State in 1905).

6. Nord in Nord 2000 gives reasonably full data on biographical connections with politics, but he focuses only on a cultural politics that, in the 1860s-1870s, became interlocked with Republicanism. We never quite see the art amid all the cultural politics, apart from taking some explicitly political images. John House (House 2004) sees the general Impressionist stance of rejecting pre-ordained values as being 'a political position' in the mid-1870s era of moral order, but he avoids the problem of relating culture and ideology in a structural rather than conjunctional way. See A. Lewis, 'Painting with Attitude', *Art History*, 2005, 28, 4, pp.559–61.

7. Anon. [Tout Paris], 'La Journée parisienne, impression d'un impressioniste', *Le Gaulois*, 24 January 1880.

8. He represented family members in his landscapes not simply because they were convenient models but also perhaps

because it was a means of being with them and simultaneously pursuing his own goals as a painter. His portraits of family children certainly attest to his fatherly interests, as these were records of love unconnected to market sales.

9. His first marriage, after years of living with Camille-Léonie Doncieux, was civil, and witnessed by militant atheists Gustave Courbet, Paul Dubois and Antonin Lafont. His second wife was divorced, and thus, despite her Catholic faith, a civil marriage was required, but again Monet was not bothered about regularising his union until well after it had caused social concern (see note 7). He accommodated Alice Hoschedé's wish for a priestly visit to the house when Camille lay dying and for Camille to have last rites, and also for the baptism of Michel. Alice may have been the prime mover in the religious union which Camille underwent with Monet seven days before she died. Monet also accommodated Camille's earlier wishes over the baptising of Jean when he had his arm twisted by his friend Bazille. These would not, however, have been Monet's own choices.

10. J.-E. Blanche, who had known Monet personally for decades, described him clearly as 'incroyant' (*Propos de peintre III: De Gauguin à la Revue Néègre*, Paris 1928, p.30). Alice Hoschedé-Monet's second daughter Blanche confirmed that he wanted a civil burial (J.-P. Hoschedé, *Claude Monet: ce mal connu*, Geneva 1960, vol.I, p.164: 'il avait toujours dit qu'il voulait être enterré civilement car il ne pratiquait pas'). The fact that the final ceremony was civil was studiously ignored by press reports apart from an approving local Republican paper (Anon., 'Claude

Monet est mort', *Républicain de Vernon*, 11 December 1926, cited in Wildenstein IV, p.142, n.1327).

11. Monet described his artistic project to Geffroy thus: 'je fais ce que je peux pour rendre ce que j'éprouve … pour fixer mes sensations' (7 June 1912, WL.2015). To sign up to a sensationalist view of knowledge was, in the words of Jan Goldstein, to identify with a 'doctrine associated with the [French] Revolution itself: it was regularly invoked by radicals in subsequent decades of the nineteenth century, and its suggestion of human malleability was consonant with the call of radicals for social and political change' (J. Goldstein, 'Saying "I"', in M. Roth, *Rediscovering History*, Stanford 1994, p.322).

12. Letter to Bazille, December 1868 (WL.44): 'on est trop préoccupé de ce que l'on entend à Paris … et ce que je ferai ici a au moins le mérite de ne ressembler à personne, du moins je le crois, parce que ce sera simplement l'expression de ce que j'aurai ressenti, moi personellement … Plus je vais, plus je m'aperçois que jamais on n'ose exprimer franchement ce que l'on éprouve.'

13. See T. Robinson, 'Diary', 25 April 1894, p.59 (Frick Art Reference Library, New York) and W. Low, *A Chronicle of Friendships, 1873–1900*, London 1908, p.450, for the charge of copying Monet's vision. His discussion with Mirbeau in the early 1890s about Van Gogh's personal misery shows us that he associated the sense of self-realization through the activity of painting with a feeling of well-being (L. Daudet, 'Un Prince de lumière : Claude Monet', *L'Action Française*, 8 December 1926, p.1).

14. For Monet's opposition to the actions of the non-republican Versailles government

in 1871, see WL.56. Monet's straightfor-
wardly positive Radical Republican stance
on the consolidation of the Third Republic
in 1878 can be seen in w.469–70. On
Monet's political awareness in 1888–9 of
the dangers of the overthrow of the Third
Republic (the Boulanger affair), see WL.878
and 908. Monet's reading included
Mirbeau, Geffroy and Clemenceau (see
note 10, Hoschedé 1960, vol. I, p.76). We
also have a clue as to what newspaper
Monet read. The 1868–9 painting *Le
Déjeuner* Frankfurt Art Gallery) depicts a
folded newspaper laid upon his own
breakfast table. The letters LE and P(?)
appear at the top of the newspaper, and the
only papers which could fit that bill would
be the leftist-republican *Le Petit National*
or *Le Petit Journal*. The only other
alternative is the less likely far-left journal
Le Peuple.

15. Monet wrote no less than three short
letters supporting Zola's stance on behalf
of Dreyfus (Wildenstein III, 1979). He also
signed the pro-Dreyfus *Manifeste des
Intellectuels*, published in *L'Aurore*, 18
January 1898. Monet finally donated an
1889 Creuse painting, *Study of Rocks*
(w.1228, referred to familiarly as *Le Bloc*),
to Clemenceau in recognition of his part in
the Dreyfus Affair. One cannot help
thinking of both Monet and Clemenceau
connecting the bald strength of this motif
with ideas about his friend's integrity and
staying power in the Radical fight for truth.

16. Wildenstein III, 1979, pp.252–3, WL.1023.
Octave Mirbeau wrote to Monet in an
undated letter that the culture ministry
would be annoyed if Monet was offered the
Légion d'Honneur and refused it. Having
clearly refused it himself, Mirbeau wrote
that Monet had already refused the cross
and was not likely to accept it on a second
offer (O. Mirbeau, 'Lettres à Claude Monet',
Cahiers d'aujourd'hui, 5, 29 November
1922, p.165).

17. Even more dramatically, when Monet
finally donated his Waterlilies decorations
to the State, he insisted on their being
glued to the wall, so that the State could
not dispose of them at some later date, and
he contracted with the State that this sign
of his identity would never be undermined
by any break-up of the donation or
presence of artworks by others in the same
space (C. Stuckey, 'Blossoms and Blunders:
Monet and the State II', *Art in America*,
September 1979, pp.115–16.). Of course, the
donation itself was a sort of accommoda-
tion with the State, but my point is not
what *happened* to Radicalism in practice
but what its originating impulse involved.
As *quid pro quo* for his donation of the
Waterlilies decorations, Monet forced the
State in 1921 to buy *Women in the Garden*
(w.67, 1866, Wildenstein IV, 1985, p.93 and
WL.2335). That Monet should force the
State to eat humble pie by buying the first
work of his that the Salon rejected in 1867
is proof of the operation of a truculent
Radicalism antagonistic towards the State.

18. 'L'homme est témoin de sa propre
existence et de l'univers qui l'entoure'
(G. Geffroy, *La Vie Artistique*, Paris 1894,
vol.III, p.ix). Geoffroy's critical discussion
of Monet begins in 1883 and culminates in
his monograph *Claude Monet, sa vie, son
temps, son œuvre*, Paris 1922. Many pieces
discussing Monet appear reprinted from
the newspapers in his eight-volume *La Vie
Artistique*, Paris 1892–1903.

19. For Monet's major showing with Rodin at
the Galerie Georges Petit in 1889, Mirbeau
wrote a catalogue essay in which he
emphasised that Monet's work was
grounded in a notion of the movement of
the human spirit and a refusal to hold up
any previous artists or principles as sacred.
He remained a close friend thereafter, as
their extensive correspondence reveals
(P. Michel and J-F. Muet (eds.),
Correspondance avec Claude Monet, Tusson
1990).

20. Clemenceau began writing articles on
Monet in 1895. He encouraged and
facilitated the production and final
installation of the Nymphéas decorations
at the Orangerie. On this relationship with

Clemenceau, see A.Wormser, 'Clemenceau et Claude Monet: une singulière amitié' in J. Rewald and F. Weitzenhoffer, *Aspects of Monet*, New York 1984, pp.190–217, reprinted in Réunion des Musées Nationaux, *Georges Clemenceau à son ami Claude Monet, Correspondance*, Paris 1993, pp.27–59.

21. G. Clemenceau, *Claude Monet: Les Nymphéas*, Paris 1928 ; trans. *The Waterlilies*, New York, 1930. Clemenceau was criticising Louis Gillet's anti-materialist reading of Monet's work when he wrote that 'there is no possible reconciliation between this metaphysics of the unknown and the spontaneous impulse of Monet … to sacrifice all to the expression of *that which is* … [welding together] all the fragments of man's sensory experience' (pp.163 and 6–7).

22. Ibid., pp.5–6. He also emphasized Monet's self-possessive, wilful motivation, most succinctly summed up in his explanation of his love for Monet, 'because you are you' ('je vous aime parce que vous êtes vous'), letter to Monet, 17 April 1922 (*Georges Clemenceau à son ami Claude Monet*, Paris 1993, p.101).

23. Other Radicals not mentioned here, with whom Monet was friendly, included Paul Dubois, Antonin Lafont, and the radical-socialist Baron D'Estournelles de Constant, whose correspondence with Monet has recently been unearthed (A. Distel, 'Un ami de Claude Monet, le baron d'Estournelles de Constant, 1852–1924, Prix Nobel de la Paix' in *Monet: Atti del convegno*, Conegliano 2003, pp.249–56).

24. J. de Biez, 'Les Petits Salons : Les Indépendants', *Paris*, 8 March 1882, p.2, in Berson 1996, pp.380–1: 'tout est sacrifié à l'effet, en haine absolue de ces valeurs conventionnels, sans lesquelles un tableau ne paraît jamais terminé … Lorsqu'on quitte cette exposition des indépendants il semble qu'on sort d'un dîner de libres penseurs, où tout le monde a discuté à la fois … Cette école … restera longtemps encore l'école du pétard.' For de Biez's

remarks on the disturbing sense of time, see note 76.

25. E. Chesneau, 'Groupes sympathiques: Les Peintres impressionistes', *Paris-Journal*, 7 March 1882, p.102, in Berson 1996, p.385: 'ces phénomènes sont essentiellement inconstants … Le Peintre est forcé de les saisir dans les rapides moments de leur durée … s'attachant à traduire … la nature *comme elle nous apparaît*'. Even though *Paris-Journal* was a conservative paper, Chesneau was given some rein with more liberal opinions here.

26. J. Elkins, *What Painting Is*, London 1999, pp.9–19. For my commentary on Elkins's contribution generally, see *Art Bulletin*, vol.LXXXIV, no.4, 2002, pp.698–9, and for general comments on art historical decoding of painterliness which runs partially counter to Elkins's thrust, see *The Art Book*, September 2001, pp.21–3.

27. Clemenceau 1930, pp.23 and 72–4.

28. The steps are illustrated in D. Joel, *Monet at Vétheuil and on the Norman Coast, 1878–1883*, Woodbridge 2002, p.37, and early photographs of the house and road are in Wildenstein I, 1974, p.102.

29. Wildenstein I, 1974, pp.93 and 102. The situation of Les Tourelles can be seen in the site-photograph in Joel 2002 (see note 28), p.37, and also in w.510.

30. F. Buisson, 'La politique radicale socialiste', *Revue Hebdomadaire*, 12 February 1910, pp.159–81.

31. A colour reproduction of Robinson's original cyanotype can now be found in S. Mayer, *First Exposure: The Sketchbooks and Photographs of Theodore Robinson*, Giverny 2000, p.29.

32. That is why I cannot agree with Richard Thomson's suggestion that Monet treated the experience of living in Vétheuil 'as if he were in a semi-permanent state of *villégiature*' (Edinburgh 2003, pp.18–19), a term signifying the extended stay in the countryside in rented accommodation which well-off townspeople made during the summer months. Monet had been permanently settled in small towns outside

Paris since December 1871 (and was so for the rest of his life). His decision to live in the country town, at a certain degree of distance from local life, should not be confused with some notion that he was, in his mind, on semi-permanent vacation.

33. J. Locke, *Two Treatises of Government* (1690) 1969, Hafner ed., New York, chapter 5, sections 27, 32 and 44, of second treatise.

34. *La Révolution Française*, 19 March 1879, quoted in L. Loubère, 'The French Left-Wing Radicals', *American Journal of Economics and Sociology*, April 1967, p.191.

35. P. Malardier, *République et Socialisme*, Paris 1870, pp.7–10.

36. Le Baron Ernouf, *L'Art des jardins*, Paris 1868, vol.2, p.6.

37. Moléri, *Petite Bibliothèque du Jardin Amateur VII : Les Petits Jardins*, Paris 1866, pp.i–v, 44–50.

38. Ernouf 1868 (see note 36), vol.2, pp.114–15.

39. A. Mangin, *Histoire des jardins anciens et modernes*, Tours 1887, p.18. I am indebted to J. House, 'Monet's Gladioli', *Bulletin of the Detroit Institute of Arts*, vol.77, 2003, pp.8–17, for drawing my attention to these discursive patterns.

40. Sunflowers have carried a general association with the sun in many cultures, and with whatever the sun signified. However, nineteenth-century studies of flower symbolism suggest problems with the contemporary vividness of such symbolism, or at least a creeping syncretistic vagueness, which makes me worried about the attempts by Clare Willsdon (Willsdon 2004) to read certain paintings in terms of some revitalisation of flower emblematics (pp.80–2, 139). For the sake of my argument here, I would have loved to make play with her discussion of the sun as traditional republican emblem, and especially with the cartoon identification of the radical Gambetta with the sunflower in Alfred Le Petit's *Le Soleil*, 1871, published in *L'Eclipse*, ill. Willsdon 2004, p.184, but the methodological issue of teasing symbolic readings out of an anti-symbolist artistic project such as

Impressionism seems to me too problematic.

41. Clemenceau 1928, pp.92–3 (English edition, p.96).

42. See, for example, *Sur la terre comme au ciel*, Cluny Museum, Paris 2002, pp.23–4.

43. See www.papalencyclicals.net.

44. *Paradise Lost* was destroyed during the Second World War at the Maximilianum, Munich. Three sketches survive (one in Versailles, two at the Musée Fabre) and two other versions, one of which, a reduced version, was exhibited as part of an anonymous private collection at the Bruce Museum's *Elegance and Opulence: Art of the Gilded Age*, Greenwich, Connecticut 1999.

45. J. Castagnary, *Philosophie du Salon de 1857*, Paris 1857, reprinted in J. Castagnary, *Salons*, 2 vols., Paris 1892, vol.1, pp.5–7: 'l'art est donc avant tout une expression du moi humain sollicité par le monde extérieur … Aux termes de la légende sacrée, lorsque Dieu, créateur et conservateur de toutes choses, eût surpris l'homme en flagrant délit de révolte, il le chassa du Jardin de délices, en plaçant à la porte, pour lui en défendre à jamais l'entrée, un archange tenant en main une epée flamboyante. L'homme a pris une longue et éclatante revanche de cette prescription ancienne … Il s'est dit … à coté de l'Eden divin d'où l'on m'a chassé, je me construirai un Eden nouveau que je peuplerai de ma personne. Je placerai a l'entrée le Progrès, sentinelle invisible ; je lui mettrai en main l'epée flamboyante et il dira à Dieu : -"Tu n'entrera pas !" … L'homme en grandissant a fait éclater ces terrible murailles [les collectivités mystiques opérées par l'esprit religieux, les collectivités politiques], et l'individualisme s'est echappé par toutes les fissures. Donc, dans l'humanité, négation continue de la religion et de l'autorité traditionnelle, affirmation et affranchisement progressif de la personnalité humaine.'

46. In *La Démocratie*, Paris 1860, Vacherot called for 'total freedom, without

restriction or reserve', based upon reason itself, the history of freedom being the very essence of universal history. For Vacherot, respect for other free individuals, rather than some way of organizing politics, lay at the basis for democracy. Similarly, for Allain-Targé, radical republicanism had to be rooted in an idea of equality of human dignity (H. Allain-Targé, *La Republique sous l'Empire, Lettres (1864–1870)*, Paris 1939).

47. *De Fide Catholica* (1870) condemned those 'conclusions of science' that seemed 'contrary to the doctrine of faith'. The 1878 encyclical *Quod Apostolici Muneris* talked about a deadly war that had been waged for the last three centuries against 'revelation' on behalf of 'the hallucinations of reason alone'. 'The ardent desire of happiness has been limited to the bounds of the present', it argued. The 1864 encyclical *Syllabus of Errors* had also condemned the exercise of 'human reason, without any reference whatsoever to God' when presented as 'the sole arbiter of truth and falsehood'. As late as 1888, the papal encyclical *Libertas* condemned liberals for licensing 'every perversity of opinion' and suggesting 'that every man is a law to himself'.

48. The revolutionary legacy was seen by Chevé, for example, as setting up a cult of man as worldly animal, a religion of the flesh and vile appetites (C. Chevé, 'L'Armée Antichrétienne', *L'Echo de la France*, vol.V, Montreal 1867, pp.399–407.) De Ségur called the Revolution quite simply 'the perfect reign of Satan on the earth' (Mgr de Ségur, *La Révolution expliquée aux jeunes gens*, Paris 1862, reprinted 1997, p.15).

49. L. Gambetta, *Discours dans la chambre à propos de l'agitation cléricale*, Paris 1877, publication of a speech given on 4 May 1877.

50. The political upshot of this clash can be read about in E. Acomb, *The French Laic Laws, 1879–1889*, London 1941, and M. Ozouf, *L'Ecole, l'Eglise et la République, 1871–1914*, Paris 1963. I should add here that

Radical fears about women's domination by the Church led them to rather qualify their commitment to legal equality and educational possibilities for women when it came to the suffrage. See Auspitz 1982, pp.38–46, and C. Ford, *Divided Houses*, Cornell 2005.

51. Gambetta's 1869 Belleville programme and Clemenceau's 1876 election programme, for example, both made an explicit commitment to the secularisation of education. The Radical-Socialist Pierre Malardier argued in *République et Socialisme*, Paris 1870, that any nation that delivered its children to clerical education was lost, and a full-blown diet of scientific, secular, civic and rationalist education was necessary to turn out Republican citizens. Concerning Radical claims to produce individual realisation and social mobility through education, it should be noted that various historians have shown how education continued to reproduce social class to a considerable extent.

52. Wildenstein I, 1974, p.83, n.592. Wildenstein calls him 'farouche' but does not give any further evidence, apart from mentioning a bill of payment from 31 September 1876, and a mention of the school in Argenteuil's *Annuaire du Commerce*. The paintings were w.1, w.239, and w.333.

53. For example, T. Barreau, 'Quelques Conseils' in T. Barreau, *Amour Filial: Récits à la Jeunesse*, Paris 1862, admonished young people to listen to those who dispense morality, parents pre-eminently, who have the best right to dispense moral guidance because they gave life to the child involved (p.374).

54. A. Feutré, *Contre le Mariage actuel: tout en faveur des enfants*, Paris 1882.

55. Bishop F. Dupanloup, *L'Enfant*, Paris 1869.

56. For example, w.280, 282, 284–5, 379, 381–2. In the *The Luncheon* 1873, (Musée d'Orsay, Paris), for example, the young boy plays alone with basic constructional elements beneath a table, with female figures at a considerable distance.

57. See an example of such imagery illustrated in *French Popular Imagery*, Arts Council, London 1974, p.41, ill.244.

58. Another way to look at the imagery of steps is as secularist troping of religious ideas about special places being high (eg. Solomon 9:8 and Revelation 21:2.), and steps being an ascension to them, as in the image of Jacob's Ladder (Genesis 28:10–22). This ladder was depicted as a staircase in both Raphael's 1516 vault from the Stanza of Heliodorus in the Vatican and in Gustave Doré's illustrations for *Le Sainte Bible*, 2 vols, Tours 1866. If we were to accept the suggestion of the trope of ascension being secularized here, we have not a process of spiritual ascension pre-visioned in dream but an image of figures descending a mundane set of steps, an image also suggesting real-life maturation.

59. Hoschedé 1960, vol.1, p.65.

60. See note 7 for evidence that this caused some comment. It has even been suggested by Jean-Pierre Hoschedé that he was Monet's son from a liaison during Monet's 1876 stay at Rottembourg, though Wildenstein I, 1974, p.83, disputes this.

61. The pots in the Washington painting also appear in w.202, w.282, w.284, w.365, and w.366. We also see possibly one of the same pots in a photograph taken at Giverny (A. Forge and C. Joyes, *Monet at Giverny*, London 1975, pp.50–1). Monet may have bought them in Holland in 1871. See *Monet in Holland*, Rijksmuseum Vincent Van Gogh, Amsterdam 1987, p.43, which identifies them as oriental-looking Cologne pots. To understand the suggestion of such pots, we need to remember how the sophisticated culture of Japan was constructed by late nineteenth-century French culture as primitive or a child-like Golden Age, one which had escaped sophisticated decadence through isolation (E.Evett, 'The Late Nineteenth-Century European Critical Response to Japanese Art: Primitivist Leanings', *Art History*, March 1983, pp.82–106).

62. Willsdon 2004, p.55.

63. On Monet's interest in Michelet, the doyen of Republican historians, an opponent of the Second Empire and outspoken anticlerical, see WL.1267 and 1281. Monet's reading included Michelet's 17–volume *L'Histoire de France*, Paris 1867, according to Hoschedé 1960, vol. I, p.76. I am indebted to Willsdon 2004, pp.54–5, 82–3 and 142–6 for her discussions of Michelet and Froebel.

64. J. Michelet, *La Femme*, Paris 1860, p.74, in a chapter entitled 'Le Soleil, L'Air et La Lumière'.

65. Ibid., pp.102–3, 89, 128.

66. J. Michelet, *Nos Fils*, Paris 1870, p.192.

67. Ibid., p.245. Michelet discusses the ideas of Pestalozzi here.

68. Ibid., p.248.

69. Willsdon 2004, p.145.

70. Wildenstein I, 1974, WL.223, p.443. The date of 1880 on the canvas is therefore a later misdating.

71. Roger-Viollet's photograph from *c.*1920 showing the picture in his second Giverny studio is illustrated in House 1986, p.149. See too C. Joyes, *Monet at Giverny,* London 1975, p.64, for another arrangement of pictures in the same space. The picture was definitely exhibited after his death at Durand-Ruel's 1928 Monet show, but Washington's National Gallery of Art now has evidence that Galerie Bernheim bought it in 1910.

72. Wildenstein I, 1974, p.400.

73. C. Hug and M. Leonhardt in 'Claude Monet the Gardener' in Kunsthaus, Zurich, *Monet's Garden*, Ostfildern-Ruit 2004, p.123 and p.156, n.47, manage to doubly misrepresent my position by suggesting I believe that Monet's serialism began at this precise point and is to be found in the four variants of the Washington image (w.682–5), when w.682–4 operate more traditionally like oil-sketches for the final Washington canvas.

74. My sequencing of these pictures differs from Wildenstein, who places w.683 before w.684 because it lacks figures. By contrast, I

see w.683 as the determinate *ébauche* for the Washington *tableau* in all aspects except for the need to make the figures more effective as image than they had been in w.684, which therefore comes before w.683.

75. For a fuller account of this argument, see A. Lewis, 'Monet's *Route de la ferme St.-Siméon* series (1864–67)', *Apollo*, August 2000, pp.39–47. This analysis challenges that of leading Monet scholars (Tucker 1989, pp.28–9; House 1986, pp.194–7) that Monet's serialism dates from a late point in his career. Richard Thomson has recently argued for Vétheuil as being the start of Monet's serialism (Edinburgh 2003, pp.34–5). This seems equally arbitrary, given the serial relatedness of Monet's earliest mature work in the 1860s. While making fleeting reference to the production of originality, Thomson claims that such serial connectedness of works 'simply made sense to re-use a satisfying and marketable subject'. My reading of the impulse towards seriality in Monet, however, is that it is not symmetrical as such with market productivity and has other sources in Radical individualism.

76. J. de Biez, 'Les Petits Salons : Les Indépendants', Paris, 8 March, p.2, in Berson 1986, pp.380–1: 'la progression lumineuse des marines … sont toutes des répétitions … Et c'est à peine si la marche du soleil marque une heure d'intervalle entre chacune d'elles.'

77. For example, Jules Ferry, under the new Opportunist government of 1879, stated that there would no longer be any imposing of aesthetic ideas but a fostering of artistic individualism and freedom. Alongside the restoration of a grand style, he said, there was the development of a new plein-air school which the State would somehow 'assist' (J. Ferry, 'Discours prononcé à la distribution de récompenses aux artistes exposants du Salon de 1879', in *Explication des ouvrages de peinture, sculpture, architecture, gravure et lithographie des artistes vivants, 1880*, Paris 1880.

78. Impressionist works were included in small numbers (one Monet, for example) in the 1889 *Exposition Universelle*. At the 1900 *Exposition Universelle*, there was a far more impressive room of Impressionist works.

79. His candidature was proposed by Rodin and Bracquemond (Wildenstein III, 1979, pp.48–9). Pierre Lagarde was finally commissioned to do *Vue du grande lac du Bois de Bologne* for the north Tourelle Gallery after Jules Breton pulled out. The commission was definitely for a landscape decoration, so Monet's rejection is all the more pointed.

80. Monet's first French State museum purchase was one of the Rouen Cathedral works (*The Portal, Harmony in Brown*, w.1319), bought in 1907 for the Luxembourg. Of course, this was not the first Monet work to enter a French museum, which had come about in 1896 as a result of the acceptance of the Caillebotte bequest.

81. Letter from Clemenceau to Monet, 8 October 1924, in *Georges Clemenceau à son ami Claude Monet*, Paris 1993, p.158: 'sur votre demande un contrat est intervenu entre vous et la France ou l'Etat a tenu tous ses engagements … Il faut donc aboutir artistiquement et honorablement car il n'y a pas de si dans les engagements que vous avez pris.'

3 Monet's Neo-Romantic Seascapes 1881–1886

ROBERT L. HERBERT

I have always been struck by the strong feelings that emanate from so many of Monet's cliff-top views of the Normandy and Brittany coasts in the 1880s. These pictures seem to recover the expressive energy of the Romantic era, both in their subjects and in the way they were painted. Although Monet's brushwork now strikes us as 'natural,' it insists on itself so much that we look, not just at the representation of dramatic sites remote from cities, but also at the painter's work as it embeds his emotions. In earlier publications I called Monet's work of the 1880s his neo-Romantic decade,[1] and in this paper I want to explore the usefulness of considering key concepts of Romanticism: the sublime and the picturesque.

THE SUBLIME

With his pages on 'the modern sublime' in *Monet: the Seine and the Sea*, Richard Thomson has facilitated my task, for I will now be able to comment upon a subject newly made familiar.[2] Furthermore, I found in the National Gallery's publicity this welcome injunction: 'Get swept away by sublime seascapes, great cliffs and vast beaches.' With the appearance of these publications, I thought that the sublime must be an acknowledged aspect of Monet's work of the 1880s. However, there are many observers who are unwilling to grant Monet's pictures any subjective meanings. Judged by the review of the exhibition in *The Spectator* in August 2003, the formalist view of Monet still dominates. We read that 'The curator's bid to present [Monet's] Normandy paintings as stabs at a "modern sublime" is unconvincing. However rough his seas or precipitous his cliffs, Monet's struggle is not so much with the elements as with the raw materials of his art. There's no attempt to illumine deeper meanings about the world and our position in it.'[3]

Formalism still dominates much writing about Monet. Critics have perpetuated the early defense of abstraction, which said that representational subject matter does not count, and that we need concern ourselves only with art's formal components, or with a disembodied kind of perception that emphasises colour and light independent of representational and social substance. This view has been superimposed over nineteenth-century art, with the result that its subjective and social meanings have all too often disappeared, even though Monet's letters give abundant evidence that he was fully aware of his own feelings. He lived through a decidedly sublime

moment at Etretat in 1885. In search of what he called the 'furious sea,' he miscalculated the tides and was almost swept away by the rising surf, leaving him with nightmares. And at Belle-Isle in 1886, his letters are full of phrases that could have been written fifty years earlier: the sea is 'sinister, diabolical,' at another time, 'sinister, tragic,' and 'the lugubrious has no need of sunshine.'[4]

If Monet was fully aware of his subjective responses to the sea, it is not far-fetched to find the sublime in many of his paintings. However, critics of the 1880s usually wrote about his colour, technique and perception, and only rarely used phrases that reveal their awareness of the emotional content of his art. This same emphasis upon the formal marked the writings of William Seitz and others in the 1960s, following the rehabilitation of Monet under the impact of abstract expressionism. In his marvellous exhibition at the Museum of Modern Art in 1960, Seitz included ten paintings of the Normandy cliffs and Belle-Isle but, a true modernist, his text concentrated on the later 'series'. He gave only a few words to the paintings of the 1880s, among them this sentence: 'Regarded in the light of the landscapes of Van Gogh, Soutine, or the German expressionists, one marvels at Monet's ability to preserve the purity of his impressions from emotional deformation.'[5]

In recent years, a few historians have been willing to acknowledge the 'emotional deformations' in Monet's views of the Normandy and Brittany coasts, including Steven Levine, Virginia Spate, Paul Tucker, myself, and now Richard Thomson.[6] The concept of the sublime itself was not invoked until 1985 when Steven Levine wrote an article, 'Seascapes of the Sublime: Vernet, Monet, and the Oceanic Feeling,' devoted to the paintings at Belle-Isle in 1886. It was later revised as a chapter in his book of 1994, *Monet, Narcissus, and Self-Reflection*.[7] In that book another chapter is entitled 'Etretat and Death by the Sea,' revealing Levine's central concern with a Freudian interpretation of Monet's art. It is a brilliant account, but the sublime finds its place within a study of the personal and the psychological. This pulls Monet into the twentieth century, instead of linking him with the earlier Romantic era, except by implication.

When we look at Monet's cliff-top vantage points for many paintings of the Normandy coast from 1881 to 1886 (plate 9) we see how thoroughly he eliminated not only the nearby villages and ports but also the ground beneath our feet. He deliberately created an unstable view, as though we were seabirds hovering above the cliff. His energetic brushstrokes call attention to themselves, and call upon us to share the powerful emotions that inspired him. He cuts out all signs of tourism and takes us back decades to the era of 'discovery,' the Romantic era before tourism expanded, as though we were among the first nature lovers to exhale our emotions in this sublime moment. His paintings invite us to lonely confrontations with ancient rocks and the sea after we have climbed above the tourist villages, never far from the views that he recorded. That one could experience the view as though alone in nature is part and parcel of tourism, which is why I hope to show that the sublime cannot be separated from the picturesque. The picturesque, as we know, was the heart of the tourist experience by the late eighteenth century. First, however, let us consider the sublime.

Monet doesn't seem like a Romantic because he eliminated the storm-tossed boats, the anguished onlookers, and the panoramic extent of seascapes along the Channel coast, such as those of Eugène Isabey or Clarkson Stanfield. His compositions and technique are undeniably modern, drawing him so thoroughly into modernism that it is not recognised how much he reinstated the Romantic sublime in the 1880s. Etretat, where he painted dozens of pictures from 1883 to 1886 (plate 10), had been famous for centuries, but it was only during Monet's generation, the second half of the nineteenth century, that large numbers of tourists and vacationers went to the village to look with awe upon its three remarkable natural arches. They climbed the cliffs to savour the experiences of writers like Jacob Venedey in 1837 who wrote of the 'yawning gulphs open at our feet, out of which the agitated sea sends up tones like the voice of a bard singing the destruction of his race.'[8]

The essence of the sublime was the feeling of danger and awe when confronting nature's most powerful effects. Richard Thomson defines it as 'the sentiment of human feebleness in the face of the awesome grandeur of eternal nature.'[9] That definition, however, refers to one's experience of nature itself. For the sublime in *art* we need to expand the concept. From the days of Immanuel Kant, the sublime was treated as an elevated experience, when these exciting dangers in nature were made safe by the distance of art, which converted the raw experience to an aesthetic one. Coleridge, in his notes on Shakespeare, put it succinctly: 'Hence it is that the sense of sublimity arises, not from the sight of an outward object, but from the beholder's reflection upon it – not from the sensuous impression, but from the imaginative reflex.'[10] Nature was subjected to the controls of the poet or the painter; that is, both the boundaries of form and the evidence of technique call attention to its existence as art.

The Romantic sublime attached itself not just to natural sites and their paintings, but also to the troubled awareness of the gulf that Romanticism opened out with the past. Medieval art was championed over previously dominant neo-classical art; the Gothic, well weathered by time, could inspire deep regret for the past now under assault by rampant modernisation. Monet painted the maritime church at Varengeville several times in 1882, and poised it above a very sublime cliff, but he would not have painted a neo-classical building in the midst of a well-manicured park. The Romantics also sensed a gulf with the past in an era of constant upheavals in the concept of geological time, of which I shall write further as I turn now to the picturesque.

THE PICTURESQUE

The picturesque was not invoked in Monet's day, nor has it been associated with 'high art' since then, although the sublime, once inseparable from the picturesque, has entered prominently into current discourse about contemporary art and theory. It seems evident that by Monet's day the early-century picturesque had degenerated into an anecdotal and sentimental art that the Impressionists disdained, as we do, and so its underlying relevance to Monet has been hidden from view. In the writings

of the chief theoreticians of the picturesque, William Gilpin and Richard Payne Knight, the picturesque was a 'middle style,' neither as grand, well ordered and smooth as the Beautiful, nor as rugged and majestic as the Sublime.[11] One looked for natural settings that recalled pictures, but this invariably involved reproductions and written texts about a given site that had already made it worthy of being drawn or painted. Long before Monet went to Etretat, there was a rich literature about it that catered to the tourist trade. In 1853, three decades before Monet's campaigns there, the travel writer Morlent wrote about the cliffs as illustrations: 'Parisian painters came to ask the beautiful cliffs of Etretat for inspiration and points of view which, reproduced on canvas, exhibited in our museums, bought by these too rare Maece-nases who voluntarily exchange their gold for artistic works, carried far and wide the fame of these natural and splendid illustrations.'[12] And the American travel writer Katherine Macquoid referred to the cliffs of Etretrat in 1874 as 'constant and varied pictures'.[13]

The picturesque asked viewers to contemplate the ravages of time, the awareness of biological and geological decay, the ephemeral nature of material things. Visitors to Etretat often wrote about the marks of time on the eroded strata of cliffs and arches, that is, the wearing effects of wind and sea. They stared with awe at visible prehistory: rocks that had endured since the time of Noah. In the context of such writings, some of Monet's striking views of Etretat's arches pay attention to the way the sea had undercut the stone, an effect of nature's power visible only at low tide. And the robust but tremulous outlines of the arches and their projection over the water simultaneously inspire thoughts of the fragility of these ancient formations as we stand below them in our imagination, and yet they are safely framed and con-tained by Monet's clever compositions.

Fig. 5 Paul Sandby, *Dolbardarn Castle and Llanberris Lake*, 1764
Birmingham Museums and Art Gallery

A picture-worthy site may be sublime in itself, but it does not necessarily lead to a sublime painting. In Monet's *On the Cliff at Pourville* (plate 11) I do not see a sublime painting, as Richard Thomson does, but a picturesque one. The awe and fear that might be inspired by that setting is tamed in a picturesque manner: the lovely weather, the unthreatened boats, and, above all, the presence of the two women who are enjoying the sights. They recall the many small-scale figures who served the same purpose in the romantic picturesque, as in the works of Paul Sandby (fig.5). It is equally clear that a site which is not inherently sublime can be made so in painting. Monet's canvases of the confluence of the large and small rivers of the Creuse in central France, painted in 1889, and discussed in Richard Hobb's essay in this volume, suggest a deep and lonely river valley, yet in actuality the top of the steep slopes are a mere eighty-five feet above the water[14] and the small river can easily be forded on foot since it barely rises above one's knees. We nonetheless are in the presence of the sublime in these pictures of that rugged river valley with its lugubrious tones, seemingly remote from civilisation although the banks shown by Monet were regularly cropped by goats and sheep, and the village of Fresselines was right behind him as he painted.

From the late-eighteenth century onward, picturesque landscapes took the viewer away from the city and its cares into a country setting that freed one from the complications and tensions of urban life. Of course, like Monet's pictures years later, these picturesque landscapes were in intimate dialogue with the city's cultural and commercial markets. They were made to be exhibited and savoured in the city. In contrast to city dwellers' desires for smooth functioning order, the picturesque featured what Gilpin called 'roughness' and Knight called 'irritation'.[15] The viewer's jaded urban eye was to be energised by being rubbed against irregularities said to be the truth of nature, just as, later, Monet's rough brushwork was defended as true to natural vision.

In the picturesque, actual labour is avoided. Except for occasional figures far off in the distance, there are no humans working the land to profit from it or to control it. Instead, we see small figures subordinated to the landscapes: peasants seated by cottages, travellers along forest or country roads, gypsies, or, simply, observant tourists. Hard labour would interfere with the aesthetic response to nature, and so Monet does not show fishermen hauling in heavy nets at Etretat, or their wives working the windlasses to draw the boats on shore. He does not show heroic figures either, for they could recall history and religious painting which the picturesque had virtually outlawed. The rebellion of the picturesque against the neo-classical was recapitulated in Monet's rebellion against the Academy.

Nearly all of Monet's paintings of the coast of Normandy continue the picturesque's disassociation of landscape from urban centres. His *Cliff at Grainval, near Fécamp* (plate 12) was one of eight paintings made in 1881 from a small horizontal projection from the cliff, one of the rare locations along the cliffs where he could work in comfort before an easel. He painted four like this painting, oriented toward Le Tréport, and four in the opposite direction, toward Fécamp, all from the same

spot. An engraving from a book of the same year by the travel writer Alfred Joanne was made from this same natural platform.[16] Joanne's illustration includes two tiny figures for scale, unlike Monet who presents us with a landscape without readily understood measure, the better to induce a feeling of awe. The engraving also gives the roofs of distant Le Tréport, whereas Monet, in perfect picturesque manner, eliminates the village, except for a few indecipherable smudges, just as he all but amputated Fécamp in the other four compositions. Joanne's travel book, like the guides by the picturesque pioneers that underlay tourism, guided his readers to such specific look-out points, called 'stations' in picturesque vocabulary. They could give rise to the sublime if stormy weather co-operated or dramatic angles were invoked, or in fair weather they could subside to the picturesque. Monet's picture hovers between the two, but favours the sublime because we are threatened by our unstable perch and we have no small figures to comfort us.

In *The Beach at Etretat* (plate 13) of 1883, Monet chose a familiar 'station' on the climb up the most famous cliff, looking back over the shore toward the smallest of the port's arches. It is a decidedly picturesque view for several reasons. The village itself is all but eliminated, with only one building peeking into the composition on the right. That structure is so blended with the hillside that we hardly notice it. Tourism and its obvious signs – the casino and inns along the beach – are eliminated so that we could well imagine ourselves back in Etretat a half-century earlier. Two fishing boats approach the shore, but we don't see or sense any labour. Local figures, mostly women with white caps, are looking on but not working, conforming to the picturesque which avoids any active engagement.

Picturesque painters and travellers had not looked for an utterly new place, but instead for one made familiar in visual and written forms that could be given a new and personal response. Going to their 'stations,' picturesque painters were concerned with how to arrange the setting on paper or canvas, how to convert to a composition on canvas or paper a view that was familiar in literature. It is what Malcolm Andrews has called 'this picturesque obsession with composition and viewpoint'.[17] Modernism was not the first era to emphasize form and what we now call 'the gaze'. Picturesque women and men often recorded their impressions on the spot in watercolor on white paper, giving lessons on the virtues of white grounds for luminous colour that lay behind the innovations of the Impressionists who were seeking the same immediacy, but in oil paints.

The picturesque also proposed that the observer, poet, or painter find a solitary dialogue with nature, which Monet seems to emulate after 1878 when his earlier sociable settings disappear. Even if tiny figures appear in his pictures, they can be assimilated with locals or with city folk taking their leisure. Aesthetic pleasure and leisure were the heart of tourism, which is why the picturesque was so intimately tied to it, and why Impressionism continued this relationship, although its origins in the picturesque are never mentioned. In contrast to the sublime views of the seacoast, Monet's paintings of Giverny, where he settled in 1883, suit the rural picturesque of earlier decades. There is no regular alternation in his campaigns, but his periods of

painting near Giverny were picturesque indulgences in nature's release, in contrast to the sublime drama of so many of his Channel coast pictures.

The Romantic picturesque had given way in the middle of the century to increasing attention to 'natural' nature, so between the picturesque and Monet's Impressionism, there was the broad current of naturalism from which he sprang, and which is so clearly outlined by Michael Clarke.[18] Within the 'natural' nature of Barbizon painting, Théodore Rousseau, Diaz, Daubigny and Corot all continued the picturesque avoidance of hard work in favour of rural folk wandering peacefully along forest or country paths (which is why Millet, the painter of rural labour, stands apart from them). Although they avoided the anecdotal indulgences of the earlier picturesque, the Barbizon landscapists continued its essential features. Among Monet's contemporaries, Camille Pissarro had stronger attachments to mid-century naturalism, particularly to Millet. Nonetheless, his own modernism embraced the picturesque and never the sublime. The same is true of Renoir and Sisley. The cohabitation of the sublime and the picturesque seems unique to Monet, which is why I have been considering these terms.

My ambition here is a very modest one. I have avoided the words and the concepts of 'influence' and 'derivation'. Of course I acknowledge Monet's modernism, but instead of dealing with that here, I want to place his work of the 1880s into the broad current of landscape that originated in the eighteenth century. I think that a full appreciation of his art, like that of any other artist, requires us to see ties with the past in order to remind ourselves that art does not burst fully formed from the innovative egg, but that it grows in awareness, often unconscious of the culture of its forms and subjects. At the same time, I admit that the picturesque is a rather elastic concept, and that I have more confidence in the relevance of the sublime, now that I am buttressed by Richard Thomson's essay.

Cézanne also dealt occasionally in the sublime, as in a number of paintings of the quarry at Bibémus and of Mont Sainte-Victoire. However, the unhurried control of his brushwork and the flat patches that resulted, allowed the Cubists and later artists to praise the form which, they said, Monet had lost. As the abstract expressionists showed us by the 1950s, Monet indeed had form, it was just a different kind from Cézanne's, and one that readily transmitted febrile emotions. It is likely that the more readily grasped emotional correlatives of Monet's brushwork, both its sublime and its picturesque qualities, have given him more popular appeal than Cézanne's more contemplative and austere technique.

It was Pissarro who referred to Monet's art as 'romantic Impressionism' after he adopted Seurat's neo-Impressionism, which he called 'scientific Impressionism.'[19] It is not only the repetitive and rational brushwork of Seurat's pictures that so distinguishes him from Monet, but also his representation of seaports (Honfleur, Port-en-Bessin, Gravelines) in their contemporary, even homely, ordinariness. By contrast, Monet makes us think of the ancient associations of the sea with malediction, catastrophe, infinity, the Deluge.[20] It should be no surprise, therefore, if I conclude this essay by comparing Monet with Vincent van Gogh. Both artists were guilty of

William Seitz's 'emotional deformation,' and this is because both were aware that, much as one tried to escape the tensions of modernism and the city, they were too overpowering. These two painters are the most popular among later nineteenth-century artists, to judge from blockbuster exhibitions and books. This is because they still speak for modern city dwellers' sense of loss when confronting rural settings and nature. Both painters tried to hug nature closely to their chests, but this was a painful embrace because they were aware that they could not literally recapture the past – hence their agonised images. This is confessed in their agitated brushwork, which, like their images, is threatened with a disorder that echoes the romantic sublime.

NOTES AND REFERENCES

Monet's Neo-Romantic Seascapes 1881–1886

ROBERT L. HERBERT

1. Herbert 1994.
2. Richard Thomson, 'Looking to Paint: Monet 1868–1883,' in Edinburgh 2003, p.30.
3. Laura Gascoigne, 'Rural retreat,' *The Spectator*, 23 August 2003, pp.37–8.
4. Monet recounts his nightmarish episode in a letter to Alice Hoschedé in November 1885. See the letters in Wildenstein I-V, vol. 2, letters 631, 686, 698 and 721. At one point at Belle-Isle in 1886, Monet was trapped in a grotto – shades of the sublime! – and had to be rescued by fishermen: Monet to Alice Hoschedé, 26 September 1886 (WL. 696). Malcolm Andrews's characterisation of the picturesque tourist-painter can apply also to Monet: 'There is something of the big-game hunter in these tourists, boasting of their encounters with savage landscapes, "capturing" wild scenes, and "fixing" them as pictorial trophies in order to sell them or hang them up in frames on the drawing-room walls.' M. Andrews, *The Search for the Picturesque, Landscape Aesthetics and Tourism in Britain, 1760–1800*, Stanford 1989, p.67.
5. William Seitz (ed.), *Claude Monet, Seasons and Moments*, exh. cat., Museum of Modern Art, New York 1960, p.8. It seems to me that postwar formalism, like New Criticism in literary studies, was born of a solipsistic lack of faith in historical connections. One only knew what one saw in front of one.
6. For Levine see the following note. See also Spate 1992 and Tucker 1995.
7. Steven Z. Levine, 'Seascapes of the Sublime: Vernet, Monet, and the Oceanic Feeling', *New Literary History*, vol.16, no.2, Winter 1985, pp.377–400, and *Monet, Narcissus, and Self-Reflection*, Chicago and London 1994. Curiously, the word 'sublime' disappears from Levine's chapter title, 'Belle-Isle and the Oceanic Feeling'. Levine nowhere evokes Ossian, so the pun on 'Ossianic' may be unwitting.
8. Jacob Venedey, *Excursions in Normandy*, 2 vols., London 1841, vol. 1, p.316. (Originally *Reise und Rasttage in der Normandie*, Leipzig 1838.)
9. Edinburgh 2003, p.30. For the sublime,

Samuel H. Monk's *The Sublime*, New York 1935, is still a fundamental account. Among succinct modern studies, see Andrew Wilton (ed.), *Turner and the Sublime*, Ottawa and New Haven 1980, and Paul Mattick, *Art in its Time, Theories and Practices of Modern Aesthetics*, London and New York 2003. For widespread samples and a galaxy of different kinds of the sublime (cosmic sublime, tectonic sublime, sublime of milky paleness, etc.), see Chrystèle Burgard and Baldine Saint-Girons (eds), *Le Paysage et la question du sublime*, Musée de Valence 1997.

10. *Coleridge's Essays and Lectures on Shakespeare*, London and New York 1909, p.137, cited by John Whale, 'Romantics, Explorers and Picturesque Travellers,' in Stephen Copley and Peter Garside (eds), *The Politics of the Picturesque. Literature, Landscape and Aesthetics since 1770*, Cambridge 1994, pp.179–80.

11. For the picturesque, see Andrews 1989 and the several essays in Copley and Garside 1994. Intellectual gold can still be mined from Christopher Hussey's *The Picturesque*, London and New York 1927.

12. J. Morlent, *Nouveau guide du voyageur au Havre et dans ses environs*, Le Havre 1843, cited in Dominique Rouillard, *Le Site balnéaire*, Brussels 1984, pp.53–4.

13. Katherine Macquoid, *Through Normandy*, London (1874) 1894, p.142.

14. For this measurement I am indebted to Jeanne Pintori, Fresselines.

15. See Whale in Copley and Garside 1994.

16. For Monet's paintings, see Wildenstein I–V, w.647–50 and 653–6. I am grateful to Jacques Caumont and Jennifer Gough-Cooper for taking me to Monet's vantage point. The travel book is Adolph Joanne, *Géographie du Département de la Seine-Inférieure*, Paris 1881; the engraving is by J. Gauchard.

17. Andrews 1989, p.125.

18. Edinburgh 2003, pp.37–49.

19. See Pissarro's letters from May 1886 to February 1887, in Janine Bailly-Herzberg (ed.), *Correspondance de Camille Pissarro*, 5 vols., 1980–9.

20. For these and similar associations with the sea, see Alain Corbin's brilliant *The Lure of the Sea*, Oxford 1994 (originally *Le Territoire du vide*, Paris 1988). Jules Michelet's famous *La Mer*, Paris 1861, dealt with the sea's terrifying effects as well as its benign ones. For French paintings of the sea before Impressionism, see Marie-Antoinette Tippetts, *Les Marines des peintres vues par les littérateurs de Diderot aux Goncourt*, Paris 1966.

Fig.6 · Johan Barthold Jongkind, *Le port de Honfleur*, 1864
The Art Institute of Chicago

4

Les Peintres de Salon à la conquête de la Normandie

DOMINIQUE LOBSTEIN

Entre 1801, premier Salon du dix-neuvième siècle, et 1865, première participation de Claude Monet à la manifestation officielle, avec deux vues de Normandie (plates 14 and 15), quarante-et-une expositions 'des artistes vivants'[1] ont eu lieu à Paris. A partir de la lecture des titres portés dans les quarante-et-un livrets qui accompagnaient la manifestation, il est possible de tenter d'appréhender la place de la Normandie dans l'art et pour les artistes de ces soixante-cinq années.

Parmi les 75817 titres des sections peintures et œuvres graphiques (qu'elles aient été selon les périodes, conjointes ou séparées), il a été possible de repérer 1593 paysages de Normandie,[2] tout en excluant les œuvres relevant de la scène de genre, telle *La Fête de la Saint-Louis, dans un village de Normandie* de Auger, numéro 45 du Salon de 1824, ou le *Jeune fille des environs de Dieppe gardant des moutons sur le bord de la mer*, adressée par Julien Vallou de Villeneuve au Salon de 1834, et répertoriée sous le numéro 1865. De la même manière, ont été exclus les tableaux historiques, en ne retenant pas les précoces représentations de Jeanne d'Arc à Rouen, ni de la Guerre de Cent ans, pas plus que l'actualité contemporaine qui prenait la forme de dix tableaux évoquant les visites de la reine Victoria et du prince Albert en France, sous le règne de Louis-Philippe, puis de la reine Victoria en visite auprès de l'empereur Napoléon III.[3]

A partir de cet important corpus, qui ne se retrouve par son volume pour aucune autre région française, ni pour aucun pays étranger durant toute la période, il s'est agi de regarder combien de représentations de Normandie sont apparues lors de chaque Salon, à quels lieux et à quels types de sujets elles correspondaient, et qui étaient leurs auteurs. En exploitant ces différents renseignements, il deviendra possible de juger les envois de Monet à l'aune de la mode, et même d'évoquer les liens de ses futures vues de Normandie avec ce que nous aurons eu l'occasion de croiser.

LA PRESENCE DES PAYSAGES NORMANDS AUX SALONS

Au début de la période considérée, l'Italie, qui a été abondamment présente tout au long du dix-huitième siècle continue d'apparaître souvent, au milieu d'un étonnant mélange de sources iconographiques. Ainsi, sur 506 œuvres répertoriées en 1801,[4] peut-on compter un peu plus d'une dizaine de vues d'Italie qui en côtoient cinq de Hollande, une de Franche-Comté ou une de Blois, et deux de Normandie : une *Vue*

des environs d'Elbeuf et *Une église ruinée, près de Rouen*, deux dessins de Robert Pigeon, présentés sous les numéros 267 et 269.

En 1802, tandis que s'amenuise déjà le nombre de représentations italiennes et que stagnent les vues de villes ou de régions, la Normandie présente une timide ascension parmi les sujets préférés du Salon, avec cinq dessins et peintures sur 359. Cette ascension est bientôt arrêtée lorsque le livret n'enregistre que trois vues en 1804, aucune en 1806, deux en 1808, une seule en 1810 et encore une sur 1024 en 1812 : *Vue de Normandie près de Honfleur* de Jean-Baptiste Cazin, numéro 718 du livret.

Les chiffres évoluent à peine jusqu'à ce qu'en 1822, seize vues de Normandie apparaissent parmi les 1449 numéros du livret. Lors de la session suivante de 1824, les chiffres passent à quarante-et-un sur 1904 ; en 1827 à vingt-deux sur 1374 et en 1831 à cinquante-et-un sur 2701. Les sommets sont atteints lors des expositions suivantes de 1833, 1834, 1835 et 1836, où successivement le nombre de vues de Normandie représentera 3,05%, 4,50%, 4,46% et 4,42% du total des œuvres exposées. Bien que le chemin de fer n'existe pas encore, la Normandie se trouve en vogue au début du règne de Louis-Philippe. Deux raisons majeures peuvent être évoquées : l'une tenant au roi qui possède en Normandie le château d'Eu, et traîne derrière lui quelques peintres courtisans, et l'autre attribuable à la mode, consécutive aux multiples publications consacrées à cette région. On trouve, par exemple, à cette époque le *Voyage en Normandie*, publié par Charles Nodier, le baron Taylor et de Cailleux, qui, faisant découvrir les richesses et les paysages locaux, a certainement eu un effet d'entraînement sur l'intérêt des artistes … qui rentreront ensuite peindre dans leurs ateliers parisiens.

De 1837 à 1848, tandis que le nombre d'œuvres acceptées au Salon reste stable, les paysages de Normandie exposés tendent à diminuer : 3,75% en 1837, 3,50% en 1839, 3,13% en 1842, 2,61% en 1845, 2,54% en 1847 et 2,15% en 1848. Les facteurs qui avaient favorisé un intérêt croissant s'inversent alors: l'effet d'entraînement des publications luxueuses s'essouffle, et, même si les moyens de transport s'améliorent vers cette région, la présence royale n'y étant plus si fréquente, les artistes se retournent vers d'autres lieux ou d'autres thèmes.

Durant les débuts du Second Empire, la côte normande est abandonnée par les visiteurs, et les représentations ne cessent de décroître, tombant à 0,96% en 1857 : vingt-six tableaux et dessins sur 2715 œuvres présentées. Mais, très rapidement, la mode reprend le dessus, et les chiffres se mettent à croître à nouveau, passant de 1,67% en 1859, à 1,53% en 1863 (au même moment, au Salon des Refusés, la présence de la Normandie se faisait encore plus discrète,[5] alors qu'un nombre respectable de vues de lieux liés à l'Empire, tel Compiègne, se retrouvaient parmi les œuvres exclues, illustration supplémentaire des tensions entre l'Académie et l'Empereur que révèlent les escarmouches de cette année 1863), pour atteindre 2,25% en 1865. Les deux raisons évoquées précédemment pour l'époque de Louis-Philippe jouaient à nouveau un rôle important: le goût du couple impérial pour les côtes normandes vers lesquelles il drainait une aristocratie et une bourgeoisie qui allaient s'y faire bâtir de somptueuses résidences, et le renouveau d'une littérature de voyage, cette fois-ci, bon marché, qui décrivait à loisir les découvertes possibles.[6]

Mais la concurrence était sévère, favorisée par une plus grande mobilité des artistes, et l'hégémonie qu'avait connue la Normandie pendant longtemps, se voyait désormais battue en brèche par la réapparition de contrées oubliées, au premier rang desquelles figurait l'Italie, et par la découverte de nouveaux sites, en particulier plus exotiques, rapportés de voyages en Espagne et en Afrique du Nord.

HISTORIQUE DES LIEUX REPRESENTES

Les premières vues concernèrent Rouen, dès 1801, Caen, à partir de 1802 ; Honfleur ne fut représenté qu'après 1810, puis Cherbourg en 1814. La brusque augmentation du nombre de représentations à partir des années 1820, correspond à l'apparition de nouveaux sites : Dieppe, avec six vues en 1824, et la même année Honfleur et Le Havre (fig.6) avec quatre vues chacune, Trouville avec trois et Fécamp avec deux vues. La Pointe de la Hève (qui a depuis été intégrée à la ville du Havre), qui sera le thème d'un des deux tableaux de Monet en 1865, fait aussi son apparition à cette date. Port-en-Bessin et Le Tréport apparaîtront à partir de 1831.

A partir du moment où une nouvelle localité apparaît, elle est désormais souvent présente chaque année avec une ou plusieurs représentations. Ainsi, Rouen, qui apparaît dans trente-et-une expositions de 1801 à 1865, est représentée cent trente-six fois ; Dieppe, vingt-cinq fois sur trente Salons, donne lieu à la création de soixante-dix œuvres ; Honfleur apparaît vingt-trois fois sur trente-cinq Salons, et est représentée soixante-cinq fois. Mais des désaffections brutales sont repérables, ainsi Les Andelys qui apparaissent sur les cimaises en 1819, et en disparaîtront définitivement après une dernière peinture exposée en 1849. Une des surprises de ce recensement est l'apparition relativement tardive de Deauville, en 1861 seulement, longtemps après ses voisines de Honfleur et de Trouville, et même bien après le moins célèbre village de Touques, en 1834.

Mais, bien plus souvent que peindre et nommer un lieu déterminé, les artistes ont exposé des vues générales de Normandie, intitulées comme telles, ce qui nous oblige à émettre un doute sur la véritable connaissance qu'ils ont pu avoir de leur sujet : car, à n'en pas douter, si nous étions en mesure de voir aujourd'hui ces multiples 'vues', 'sites', 'souvenirs', etc. de Normandie, nous serions bien incapables de localiser des paysages dont le nom plus que l'image devait séduire. Ceux-ci représentent en effet, dans notre décompte, 311 œuvres, c'est-à-dire près de 20% de l'ensemble.[7] On peut, me semble-t-il, émettre le même soupçon devant les quinze vues du Calvados, les treize de l'Eure et les huit de la Manche, ou les dix-sept vues de l'Orne et l'unique représentation de la Seine-Inférieure : paysages de campagne ou bords de mer dont il était aisé de trouver l'inspiration dans les œuvres exposées par certains confrères voyageurs, ou parmi les gravures qui circulaient.

Les sujets qui séduisirent les peintres sont extrêmement variés, depuis les phénomènes naturels jusqu'aux ruines de monuments. Mais d'un site à l'autre, les types de sujets varient : Caen séduit principalement en sa qualité de ville riche en monuments, alors que c'est la mer ou les ports qui charmeront les peintres en visite à Dieppe, au Havre ou à Trouville.

Le triple croisement des lieux, des sujets et des dates démontre un glissement sensible dans le temps, de la localisation des sujets vers les côtes, et un abandon progressif des monuments, châteaux et églises, au bénéfice des champs et de la mer, symptomatique d'un éloignement du paysage historique vers 1835–1840 et d'une croissance de l'impact réaliste sur la production peinte.

Si nous prenons, par exemple, le cas de Jumièges, dans la Seine-Maritime, ville célèbre pour les ruines romantiques de son abbaye fondée en 654 par Saint Philibert, et détruite sous la Révolution, monument majeur de l'art roman de Normandie, on en trouve les reproductions peintes ou dessinées : en 1822, sous le numéro 435: François Duval, *Fragments de ruines de l'abbaye de Jumièges* ; 1824, sous les numéros 795 et 796, et sous les pinceaux de Charles Goureau, une *Vue de la grande église abbatiale de Jumièges* et une *Vue de l'abside de l'église de Jumièges* ; 1827, sous le numéro 1005, de Jules Armand Valentin, *Vue des restes de l'ancienne abbaye de Jumièges, près Rouen* ; 1833, sous le numéro 2401, par Louis Jules Frédéric Villeneuve, *Vue du village de Jumièges.*[8] 1835 permet de découvrir trois vues de Jumièges sur les cimaises du Musée Royal : sous le numéro 485, par Danvin, *Chapelle de Saint Pierre, dans l'enceinte de l'abbaye de Jumièges* (fig.7); sous le numéro 1413, par Lesaint, *Ruines de l'abbaye de Jumièges*, accompagnée d'un long commentaire aux relents monarchiques affirmés ; et enfin sous le numéro 1988, dû au pinceau de Soinard, *Vue d'une partie des ruines de l'abbaye de Jumièges.* 1837 ne révélait aucune nouvelle représentation, mais en 1839, parmi les aquarelles de A. de Ligny présentées sous le numéro 1387, figurait une *Vue des ruines de l'abbaye de Jumièges.* 1841 permettait de découvrir sous le numéro 1704, Alfred de Rivière, *Une Chaumière du village de Jumièges.* Avec ce tableau on passait du romantisme au réalisme, et de l'histoire nationale à l'anecdote ; tout comme avec

Fig.7 · Victor Marie Félix Danvin, *Ruines de l'Abbaye de Jumièges*
Musée Eugène Boudin, Honfleur

le numéro 2974 bien plus tardif, du Salon de 1848, *Moulins à eau à Duclair (Norman-die)*, de C. Lestoquoy, la ville citée étant la commune sur le territoire de laquelle a été bâtie l'abbaye de Jumièges. La seule réapparition peinte de ce site aura lieu lors du Salon de 1865, lorsque le peintre Hurault de Ligny[9] présentera une *Vue des ruines de Jumièges ; – aquarelle*, sous le numéro 2974, ultime hommage isolé à ce monument insigne de l'Histoire de France et au lieu où il était implanté.

D'autres endroits éloignés de la mer et/ou aux connotations historiques fortes, présentent la même évolution comme, par exemple, le site de Gaillon, célèbre pour le château des archevêques de Rouen construit à partir de 1501, gothique avec des décors appliqués empruntés à la Renaissance italienne, qui cesse d'être représenté après 1814 ; de même pour Falaise, où se trouvent les ruines du château fort où serait peut-être né Guillaume-le-Conquérant, que les visiteurs ont pu admirer cinq fois de 1802 à 1845, puis une fois encore en 1857, mais dépourvu désormais de sa connotation historique pour laisser place à un *Souvenir des rochers de Falaise*, par G.A. Bouet, numéro 316 du livret.

Les quelques autres repères que nous indiquent les mentions des livrets successifs sont, après l'abandon de Eu, en 1848, résidence de la famille de Louis-Philippe, un net glissement des évocations paysagères vers les bords de mer. Les peintres abandonnent le pittoresque pour les marines, aussi n'est-il pas étonnant de voir apparaître pour la première fois en 1850, la mention de *La Première leçon de natation* par Léger Chérelle, numéro 558 du livret.[10]

Après l'apogée des années 1830, les vues de Normandie vont être concurrencées par un accroissement et une diversification considérables des paysages dans les manifestations officielles : l'Italie va reconquérir la place qu'elle occupait au tout début du siècle, l'Algérie après 1835, apparaîtra souvent dans une iconographie partagée entre histoire et paysage, l'Espagne après 1845 (et le mariage prochain de Napoléon comptera certainement aussi beaucoup), et bien des régions de France seront dorénavant présentes. Il est à remarquer que si la Bretagne apparaît à partir des années 1840, elle est bientôt concurrencée par les Vosges ou les Pyrénées, comme si le goût qui s'affirmait pour la mer devait être contrebalancé par un vif intérêt pour la montagne. Les peintres qui s'étaient fait une spécialité de la représentation de Eu, de sa région et de la vie qu'y menaient le monarque et sa famille, se replient, tel Brissot de Warville, vers Compiègne, résidence impériale et vers des sites naturels de différentes régions.

LES PEINTRES DES SITES NORMANDS AUX SALONS

La mention d'un artiste tel Brissot de Warville, rencontré fréquemment lors des décomptes oblige à quelques considérations sur les créateurs de vues normandes. Comme dans toute étude thématique, il est aisé de repérer des spécialistes, c'est-à-dire des artistes qui, maîtrisant parfaitement un thème, le remettent régulièrement sur le chevalet. Dans ce cas particulier, il est aussi possible de citer Vauzelle, élève de Perrin, qui envoya des vues de Normandie en 1802, 1814, 1817, en compagnie d'un *Massacre des Abencérages*, et en 1819, en compagnie de vues de l'Alhambra de

Grenade. Parmi les artistes aujourd'hui encore célèbres, peut-être les seuls d'ailleurs, on trouve les Isabey, père et fils ; puis le fils seul, en 1824, 1827, 1831, 1834 et 1842 (fig.8). Ils sont rejoints systématiquement par Frédéric François Dandiran ou Victor Danvin à l'exceptionnelle longévité, mais qui, après 1834, laisse sa place à de quasi-obstinés de la Normandie qui ont nom Camille Flers, Louis-Auguste Lapito, Charles Mozin (fig.9) ou Louis Watelet.

Mais il est aussi possible de considérer un autre aspect de ces participations, plus lié au nombre d'envois, à une époque où aucune limite n'était fixée.[11] De 1801 à 1861 donc, à soixante-dix-huit reprises, un artiste a envoyé au même Salon au moins trois vues de Normandie. Cela arrive quarante-six fois pour trois tableaux ; vingt-six fois pour quatre tableaux ; quatre fois pour cinq peintures ; et une fois pour huit (par le sieur Jean-Isidore Bourgeois en 1844) et onze (par le peintre Charles Goureau en 1834) toiles présentées simultanément. Ces chiffres obligent à moduler l'interprétation des premiers résultats tirés du décompte des vues de Normandie aux Salons, qui s'assimilaient à un succès absolu. Ainsi, si nous retirons les envois de Goureau et de Bourgeois en 1834 et 1844, nous ne dénombrons plus que soixante-dix-sept et quarante-deux envois d'inspiration normande,[12] qui remettent sensiblement en cause la prééminence iconographique de cette région au Salon. Si ces artistes prolifiques n'avaient pas été reçus, particulièrement en 1844, d'autres villes, d'autres régions ou d'autres pays auraient pu prétendre au titre de lieux les plus représentés.

Mais tel n'est pas le cas au moment où Monet tente sa chance au milieu d'artistes et d'amateurs qui affirment un goût encore évident pour cette région. Il choisit donc de présenter pour sa première participation, deux sujets attendus, vues de sites célèbres du Havre et de Honfleur, pratiquement sans risques, si ce n'est esthétique,

Fig. 8. Louis-Gabriel-Eugène Isabey, *Vue de la ville et du port de Dieppe*, 1842
Musée des Beaux-Arts, Nancy

vis-à-vis d'un jury dont le mode d'élection et les fonctions venaient d'être revus, afin de le rendre plus conciliant, à défaut d'être plus juste. Il est difficile de se prononcer sur la présence du site de la pointe de la Hève sur les cimaises des différentes manifestations, puisque son nom n'apparaît plus après 1824, lorsque le lieu commence à être totalement intégré à la ville du Havre, date à laquelle le livret du Salon révèle une *Vue de mer, prise au bas de la Hève* de Robert Léopold Leprince, numéro 1143. Il en va tout autrement de la représentation de l'*Embouchure de la Seine à Honfleur*, la mention de ce site étant relativement fréquente. En effet, en ne considérant que les envois des Salons de 1863, 1864 et 1865,[13] il est possible de repérer parmi la dizaine de fois où cette ville est citée, au moins cinq vues du même site ou des environs proches. En 1863, J.-L. Petit sous le numéro 1472, présente une *Vue du port de Honfleur ; effet de nuit*, tandis que Mademoiselle A. Forestier, expose sous le numéro 2058, des *Vieux chênes au bord de la mer, Honfleur ; – aquarelle*. Au Salon suivant, Johan Barthold Jongkind, sous le numéro 1013, a une *Entrée du port de Honfleur* (fig.6)[14] et Thiollet, une *Embouchure de la Seine à Honfleur*, sous le numéro 1850. La version de Monet se trouve accompagnée, en 1865, de celle de E.P. Barthelemy, exposée sous le numéro 165, et le titre : *Embouchure de la Seine à Honfleur ; soleil couchant*.

Deux conclusions se font jour, applicables à la volonté du jeune Monet tentant sa chance au Salon, à travers ce recours à un sujet à la mode : premièrement, une évidente volonté de présenter au jury un sujet habituellement reçu, mais aussi, deuxièmement, le désir d'honorer ses maîtres et amis, Boudin et Jongkind, à travers des thèmes qui leur étaient chers et au moyen d'un traitement pictural fort proche. Cette déférence d'un jeune homme d'à peine vingt-cinq ans, vis-à-vis de ses aînés, qui confinait à la complicité, s'exprime avec chaleur dans la modeste

Fig.9 · Charles Mozin, *Honfleur, Marine au large de la Côte de Grâce*
Musée Eugène Boudin, Honfleur

aquarelle d'Eugène Boudin appartenant à la Galerie Schmit de Paris, justement datée vers 1864, qui, sous le titre *A la ferme Saint-Siméon*,[15] réunit de gauche à droite, autour d'une table, Jongkind, le peintre animalier Emile van Marcke, Monet et le prolifique écrivain Amédée Achard, lors d'une pause dans ce lieu célèbre entre la forêt et la mer, abondamment fréquenté par les artistes lors de leur recherche des sites pittoresques de la région, futurs sujets de leurs tableaux.

A ce premier envoi au Salon, avant les refus qui suivront 1870, ne se limitent pas les liens (qui restent cependant toujours ténus) qu'il est possible d'établir entre l'œuvre de Monet et les peintures présentées lors des Salons parisiens. Par petites touches, 'à l'impressionniste' pourrait-on dire, il est encore possible de souligner quelques convergences. A plusieurs reprises ultérieurement, Monet traitera de sujets rares mais qui avaient une ou plusieurs fois reçu les honneurs des expositions. En 1872, par exemple, il peint *Le Ruisseau de Robec* (Musée d'Orsay, Paris), sujet exceptionnel qui n'était apparu qu'une fois sur les cimaises officielles, en 1843, lorsque Pierre Marie Poulet présenta sous le numéro 1348 une œuvre inscrite au livret sous la forme : *Le Ruisseau de Robec, à Rouen ; aquarelle*. Une certitude cependant, *La Cabane des douaniers*, qu'il décline en plusieurs versions autour de 1882, n'entretient aucun rapport avec le tableau dont le titre figurait au livret du Salon de 1839, où, sous le nom d'Hippolyte Bellangé[16] apparaissait sous le numéro 117, *Un Poste de douaniers sur les côtes de Basse-Normandie*. Quatre ans plus tôt, le peintre avait réalisé une gravure de même titre qui nous est connue, et qui devait préparer le tableau du Salon, mais qui n'entretient aucun lien structurel ou plastique avec les œuvres de Monet. Mais, en ce qui concerne les peintures, qui nous sont aujourd'hui inconnues, et qui ont été exposées bien trop tôt pour que Monet puisse les voir, la coïncidence peut ne pas être totalement fortuite, et, par d'autres moyens, il a pu assister à des conversations où l'on évoquait certains sujets ou certaines compositions inspirées par les paysages normands, et ces échanges ont pu ultérieurement influencer ses créations. Il a pu, par exemple, en entendre parler par ses aînés, et peut-être par le romancier Amédée Achard, qui fut un de ses proches que nous évoquions précédemment, et qui, par exemple en 1843, participait à la rubrique littéraire[17] d'une nouvelle revue, *Les Beaux-Arts. Illustration des arts et de la littérature*, dont les premières pages s'ouvraient sur des commentaires du Salon de 1843, partie introductive d'un long feuilleton anonyme consacré aux œuvres exposées.

Evoquant les relations réelles ou supposées que Monet entretint avec les œuvres exposées aux Salons, il est encore possible d'évoquer un artiste oublié, présent en 1846, dont il n'a certainement pas vu les œuvres exposées cette année-là, mais que l'on doit à coup sûr considérer comme le premier grand ancêtre de la peinture de 'séries' à laquelle se livrera Monet à partir des années 1890. Il s'agit de Charles Louis François Quinard, demeurant 56 rue du Faubourg Saint-Denis à Paris, qui exposait sous les numéros 1499 et 1500 *Etude d'une mare entourant la ferme de La Fillatière ; effet du matin au mois d'août*, et *Etude de la même mare, vers six heures, en octobre*, premières expressions officielles d'une précoce volonté scientifique de

montrer les transformations d'un site selon des conditions climatiques ou météorologiques différentes à divers moments du jour.

Et s'il faut encore chercher une origine plus ancienne à cette démarche, peut-être pouvons-nous la trouver dans cette très ancienne volonté d'illustrer les différentes heures du jour en les liant au cycle des saisons, telle qu'elle apparaissait au Salon de 1801, où François Joseph Aloyse Doix présentait sous le numéro 103, *Les Quatre saisons aux quatre heures du jour. Le printemps, soleil levant. L'Eté, à midi. L'Automne, soleil couchant. L'Hiver, à minuit.* Quelle que soit l'attention portée à la lecture des livrets de Salon, elle ne révèle rien de plus que ce qui y est imprimé, aussi, en l'absence des œuvres originales, jamais nous ne saurons si ces quatre heures concernaient un seul et même lieu, et si quatre-vingt-dix ans furent nécessaires pour transformer cette première tentative en une révélation plastique, venant 'prouver, pour son compte, le surgissement continuel en aspects nouveaux des objets immuables, l'afflux sans trêve des sensations changeantes, liées les unes aux autres, devant un spectacle d'apparence invariable, la possibilité de résumer la poésie de l'univers dans un espace restreint.'[18]

Abstract

This essay assesses the importance of Normandy as a subject for landscape artists between 1801 and 1865, when Monet made his first appearance at the Paris Salon, exhibiting two landscapes of La Pointe de la Hève and Honfleur. At the beginning of the century the most popular landscape subjects at the Salon were Italian in origin, gradually giving way to French motifs. Norman landscapes enjoyed two main periods of popularity. The first was during the reign of Louis-Philippe, who owned the Château d'Eu in Normandy. He made the area extremely fashionable during the 1830s, when a number of publications dedicated to this region were written. The second period was in the 1860s when Napoleon III and the Empress Eugénie created a vogue for holidaying on the Normandy coast, which was then visited by aristocrats and the bourgeoisie, as well as artists. Other contributory factors included the development of the railways and the publication of popular travel guides.

The second section of the essay discusses the popularity of different locations in Normandy. The earliest views were of cities such as Rouen and Caen, but even by the 1820s artists were painting in coastal towns such as Honfleur, Dieppe and Le Havre. Some of the areas that Monet would later capture on canvas, like Fécamp and La Pointe de la Hève, were treated by artists as early as 1824. Other areas such as Deauville were apparently not visited by artists until as late as 1861. More commonly, painters presented more generalised views of Normandy, the earliest artists focusing on Romantic landmarks such as churches and castles (especially the Château d'Eu and the Château Gaillard), often in a state of ruination, while later realist artists preferred to depict open fields, seascapes and coastal views.

The final section of the essay focuses on the artists who preceded Monet in choosing Normandy as a locus and concludes that, in choosing La Pointe de la Hève and Honfleur as subjects for his first two Salon paintings, Monet was not taking any risks, but following in the footsteps of artists such as Robert Léopold Leprince and J.-L. Petit. As well as choosing a tried and tested subject, he was perhaps also consciously paying tribute to predecessors such as J.B. Jongkind and Eugène Boudin. As a final thought, the essay suggests that the Salon was of great importance to Monet when it came to choosing his subjects. Even his later series paintings may have been loosely inspired by earlier 'effets' and 'études' of different times of the day by academic artists such as Charles Louis François Quinard or François Joseph Aloyse Doix, whose works were illustrated in the Salon catalogues and contemporary reviews.

Les Peintres de Salon à la conquête de la Normandie

DOMINIQUE LOBSTEIN

1. Cette formule reprend partiellement l'en-tête officiel des livrets de Salon qui s'ouvraient sur le titre : 'Explication des ouvrages de peinture et dessins, sculpture, architecture et gravure des artistes vivants', et qui étaient suivis de l'indication du lieu, souvent changeant, de l'exposition, du Muséum Central des Arts (c'est-à-dire du Musée du Louvre sous son appellation révolutionnaire) au Palais des Champs Elysées en 1865.

2. Derrière ce terme, s'entendent les cinq départements actuels qui forment les régions de Haute et Basse Normandie, à savoir : d'une part Seine-Maritime et Eure, et d'autre part, Calvados, Manche et Orne.

3. Pour mémoire, il s'agissait des tableaux suivants : Fr. Barry, *La Reine Victoria arrivant en vue du Tréport à bord du yacht royal le 2 septembre 1843*, n° 49 du Salon de 1845; H. Bellangé, *S.A.R le prince Albert conduit par LL AA RR le prince de Joinville et les ducs d'Aumale et de Montpensier à la revue du 1er Régiment … pendant le séjour de la Reine d'Angleterre au château d'Eu (5 septembre 1843)*, n° 72 du Salon de 1845; E. Isabey, *Départ de la reine d'Angleterre (7 septembre 1843)*, n° 861 du Salon de 1845; E. Le Poittevin. *Déjeuner au Mont d'Orléans, dans la forêt d'Eu (4 septembre 1843)*, n° 1086 du Salon de 1845; H. Sebron, *La Reine d'Angleterre visite les tombeaux des Comtes d'Eu (5 septembre 1843)*, n° 1522 du Salon de 1845; T. Johannot, *Le Roi offre à la reine Victoria deux tapisseries des Gobelins, au château d'Eu (5 septembre 1843)*, n° 990 du Salon de 1846; E. Lami : *La Reine Victoria dans le salon de famille, au château d'Eu le 3 septembre 1843*, n° 1058 du Salon de 1846; Morel-Fatio, *Le 2 septembre 1844 [sic], le Roi sort du Tréport … se rend à bord du yacht … de la reine Victoria*, n° 1328 du Salon de 1846; qui seront suivis de deux évocations seulement du voyage de 1858 au Salon de 1859 : Morel-Fatio, *Episode des fêtes de Cherbourg en 1858*, n° 2206 du Salon de 1859; J. Noël : *Réception de Sa Majesté Victoria … le 5 août 1858*, n° 2260 du Salon de 1859.

4. A noter, dans le livret de ce Salon, la présence massive d'œuvres intitulées *Paysages*, sans spécification de localisation. Parfois accompagnées de compléments, tels que *d'après nature* ou *avec figures*, elles ne rentrent dans aucun cadre géographique localisée avec précision et ont été éliminées. Mais, le temps passant (sous la pression de la demande ?), de telles mentions disparaîtront progressivement des livrets.

5. On repère en effet dans les documents concernant cette exposition, publiés par Daniel Wildenstein dans la *Gazette des Beaux-Arts* de septembre 1965, n° 1160, pp.125–52, parmi 683 peintures et dessins, sept vues de Normandie qui représentent toutes des paysages, à l'exception d'une d'André Durand, *Dessin à la plume et lavis, souvenir de l'Aitre Saint-Maclou à Rouen*, partie du numéro 147.

6. Voir par exemple les opuscules de Louis Enault, *De Paris à Caen*, Paris 1856, et *De Paris à Cherbourg, itinéraire historique et descriptif*, Paris 1859.

7. Mais, comme nous l'indiquions dans notre note 4, le nombre de ces titres flous est certainement allé en diminuant pour s'adapter à la demande d'amateurs qui connaissaient les lieux dont ils acquéraient les représentations.

8. Villeneuve fut un des collaborateurs du *Voyage en Normandie*, publié par Charles Nodier au début des années 1830.

9. Qui doit être le même que le A. de Ligny

du Salon de 1837, ce qui signifierait un attachement particulier de l'artiste au lieu durant trente ans.

10. Voir : *Une Siècle de bains de mer dans l'estuaire de la Seine, 1830–1930*, Musée Eugène Boudin, Honfleur 2003.

11. Ce qui changera au début des années 1860, moment où Monet va se faire recevoir au Salon, où le nombre des envois sera limité à deux, parmi une ou plusieurs des différentes sections prévues au *Règlement*.

12. Qui se substituent aux résultats bruts qui étaient de 88 en 1834 et de 50 en 1844.

13. Voir la note-précédente.

14. Adolphe Stein, Sylvie Brame, François Lorenceau, Janine Sinizergues, *Jongkind. Catalogue critique de l'œuvre. Peintures. I*, Paris 2003, n° 341, p.164.

15. Reproduit dans : Adolphe Stein, Sylvie Brame, François Lorenceau, Janine Sinizergues, *Jongkind. Catalogue critique de l'œuvre. Peintures. I*, Paris 2003, p.37.

16. (1800–1866) Bien plus connu pour les nombreuses peintures militaires qui furent sa spécialité et lui assurèrent un renom international. Le livre de Jules Adeline, *Hippolyte Bellangé et son œuvre*, Paris 1880, mentionne le tableau du Salon de 1839 et la gravure qui l'a précédé, dans le quinzième et dernier recueil d'œuvres lithographiques édités par Gihaut à Paris, dont un exemplaire est conservé au Cabinet des estampes et de la Photographie de la Bibliothèque Nationale de France (Dc 175 Fol т.4).

17. (1814–1875) Pour cette nouvelle publication, il avait fourni un feuilleton en quatre parties, *Madame de Lastic*, dont les différents épisodes commençaient aux pages 141, 156, 173 et 189. A la page 47, de ce qui dut être le troisième numéro de la revue, figure une petite gravure d'après le tableau d'Emile Loubon, *Vue du port du Havre* (non catalogué dans le livret du Salon) qui, selon un angle différent, évoque le passage central et la forêt de mâts de l'*Impression, soleil levant* de 1872 (Musée Marmottan, Paris).

18. G. Geffroy, *Monet, sa vie, son œuvre*, vol. II, Paris 1924, p.315.

Fig.10 · Photograph of Maurice Rollinat at the piano

5 Monet, the Creuse, Rollinat:
Visual and Verbal Landscapes

RICHARD HOBBS

Claude Monet's innovations in the art of landscape painting during the 1880s led him to explore a variety of geographical locations. His preoccupation with the Seine at Vétheuil, dating from before the decade began, led directly to his life-long involvement with nearby Giverny. He visited the Normandy coast to the east of Le Havre, following the examples of Delacroix and Courbet in his paintings of the cliffs of Etretat. In 1886 he travelled to Belle-Isle off the coast of southern Brittany, whose rocky coast and seas contrasted with those of Normandy, both by their Atlantic commotion and by quite distinct regional connotations. In the same year he visited the flat polders of the Netherlands. He also travelled south to the Mediterranean, beyond the Italian border to Bordighera and on the French coast at Antibes, encountering a radically different range of climate, colour and spectacle. In all such cases, there is a relationship between the location of the landscapes and Monet's representations of them that is vital to our understanding of his paintings.[1]

Towards the end of the decade, in the late winter and spring of 1889, Monet travelled to the department of the Creuse in central France. The Creuse links the ruggedness of the Massif Central to its east with the gentler vistas of the Poitou to the west. It takes its name from the river Creuse, which originates within its borders, flowing northwest to join the river Vienne, itself a tributary of the Loire. A distinctive feature of the river Creuse is its system of valleys, formed in part by the two rivers that combine to form the main river: the Grande Creuse and the Petite Creuse. Monet would paint chiefly motifs at the confluence of these two. The area was, and remains today, sparsely populated and with a reputation for being deeply provincial. Its main town, Guéret, has long been overshadowed by neighbouring Limoges in terms of influence and power. The fundamental regional identity of the Creuse, moreover, far predating its administrative status as a department, is bound up with the old French province to which it belongs: the Berry. Although close to the prestigious and culturally rich Loire valley, the Berry, as we shall see, has long been associated with backwardness. Its inhabitants, the Berrichons, and their indigenous culture have even been considered survivors of a past era.

Monet's Creuse paintings quickly made a transition from their *berrichon* origins to Paris, a number of them being shown at his triumphant joint exhibition with Rodin at Georges Petit's gallery in the summer of 1889.[2] This was the year of the

Exposition Universelle, so that these paintings immediately became part of an international public arena and of wide critical debate. To this day, they are habitually judged in relation to Monet's practices within that broad arena, notably his growing interest in exhibiting, as well as painting, in series. Their importance, in this context, lies in being roughly contemporary with the Grainstack series and in pointing towards the originality of Monet's practices of the 1890s. This should not divert us, however, from seeking to understand the intrinsic significance of their *berrichon* motifs. Why had Monet concentrated on the Creuse, a location to which he would not later return? If motifs such as the cliffs at Etretat or the Mediterranean coast had clearly offered, physically and culturally, links with traditions of landscape painting and of the picturesque, in what ways could the Creuse be of comparable interest? I shall attempt to answer such questions here with reference both to the circumstances of Monet's journey and to the cultural practices and traditions of the Berry.

Monet's decision to go to the Creuse was initially at the invitation of Gustave Geffroy. The two had first met on Belle-Isle in 1886, where Geffroy was travelling in his capacity as journalist, and their close friendship was already flourishing by 1889, facilitated by Geffroy's championing of Monet's art since the beginning of the decade.[3] Geffroy's determination to take Monet to the Creuse, initially accompanied by Frantz Jourdain and by the journalist Louis Mullem, had been prompted in part by the proverbial wildness of the Berry region, comparable in that respect to Brittany.[4] But he also planned that Monet should meet there the writer who was then renewing landscape poetry in his representations of the Creuse region, and who had abandoned a Parisian career in order to live there: Maurice Rollinat. The initial links between Monet and the Creuse were therefore literary, and doubly so. Geffroy, a journalist and writer as well as art critic, took Monet there to visit Rollinat, a poet.

Geffroy's four decades of closeness to Monet are well known and well documented, but his connections with Maurice Rollinat are relatively obscure, as indeed are the works and career of Rollinat himself. Before taking further our consideration of Monet's Creuse visit of 1889, we need to trace Rollinat's identity as a poet and the importance attached to him by Geffroy. Geffroy was an untiring champion of Rollinat, as well as of Monet. Shortly before the publication of his critical biography of Monet, first in 1922 and then in the now standard revised edition of 1924, he had added to Rollinat's published output by compiling a posthumous collection of texts by the poet, who had died in 1903. This was *Fin d'œuvre* of 1919, a volume of verse and also of letters, some written to Monet.[5] It opens with an account of Rollinat's life and works by Geffroy, an impassioned eulogy to a poet who was already fading from public memory and was to become largely neglected.[6] Geffroy tells how he had first met Maurice Rollinat in Paris at the very end of 1882. The year 1883 was to be the one that largely determined the poet's literary reputation. Born in the Berry at Châteauroux in 1846, he had come to Paris in 1871 to pursue a literary career. In 1877 he brought out a first volume of poetry, *Dans les brandes*, containing song-like evocations of the landscapes of the Berry.[7] The appearance of this book passed unnoticed, but Rollinat soon attracted attention in quite another guise as his literary

persona developed. To his bucolic celebrations of his native region, he added a som-
bre veneration for Baudelaire and Poe, and his own eccentric brand of musicianship.
Rollinat's gift for music was so pronounced and its presence in his works is so all-
embracing that the major modern study of him, published in 1981, labels him 'poète
et musicien'.[8] *Fin d'œuvre* ends with a catalogue of his compositions. He was both
pianist and songwriter. Although largely self-taught and suffering from technical
shortcomings, he set his own poetry and that of others, notably Baudelaire, as
rondels, *chansons* and *mélodies*. He would perform his songs – many of which were
published – at the piano, in a voice that by all accounts showed more dramatic power
than control (fig.10).

These performances met with success in Parisian avant-garde circles of the late
1870s and early 1880s. Rollinat became a member of the bohemian Hydropaths, the
group of decadent neo-Baudelaireans who laid the foundations for the Chat Noir
cabaret. His fame spread quickly to fashionable Paris. The failure of *Dans les brandes*
was in this way followed by the success of Rollinat as a Hydropath performer who
seemed to typify the decadent sensibility then at the forefront of the literary avant-
garde. In 1883 he published *Les Névroses*, a second book of poetry whose overtly neu-
rotic title seemed calculated to complete his triumph in becoming a leader of the
decadent movement.[9] To this day Rollinat, where he is remembered at all, is fre-
quently aligned with neurosis and illness.[10] *Les Névroses* is assigned to the context of
Huysmans's *A Rebours*, published shortly afterwards in the spring of 1884, as an ex-
pression of the bizarre and the decadent.

Far from being the moment when Rollinat assumed pre-eminence in the Paris-
ian decadent avant-garde, however, the instant success of *Les Névroses* was the signal
for him to abandon the capital completely, after a dozen years of residence there. He
left Paris abruptly for the Berry, where he lived in rustic retreat for the rest of his life,
constantly visited by writers and artists, but only rarely emerging. These visitors were
often prestigious figures in the arts, including Rodin as well as Monet from the visual
arts, but none disturbed his self-consciously rural life-style. The reasons for this re-
treat are partly to be found in *Les Névroses* itself. *Les Névroses* is a lengthy and varied
collection, divided into five main sections. The second, 'Les Luxures', is most redo-
lent of Baudelaire and Poe. However, the longest and most substantial section is 'Les
Refuges', in which the bucolic and Lucretian Rollinat is to the fore. *Les Névroses* as a
whole, in fact, articulates tensions between neurosis and health, city and country, the
physical and the metaphysical, destiny and death. It is a network of contradictions
and dialogue. In terms of quality as well as quantity, the rural poems dominate, but
the tensions within the volume remain unresolved. In his volume of poetry that
follows *Les Névroses*, compiled after his departure from Paris, Rollinat aimed to re-
solve these tensions by thoughtful reflection of philosophical intent. This book,
L'Abîme, published in 1886, was in Geffroy's view Rollinat's finest. Geffroy places it in
the lineage of Pascal, since it sets out a dialogue between faith and doubt, between
sin and salvation, in which uncertainty proves inevitable. The spectacle of life is fun-
damentally enigmatic; personal destiny is clothed in obscurity. The workings of the

natural world, however, offer significant patterns of physical contingency and necessity. The unconscious materiality of the natural world, by virtue of its separation from the human, offers its own lessons, mysterious and even fantastic to us, but revealed through that materiality. Rollinat's *art poétique* therefore turns towards an investigation of the natural. His fourth book of poetry, published in 1892, was entitled simply *La Nature*.[11]

It is striking that Geffroy's interpretations of Rollinat in the preface to *Fin d'œuvre* express agreement with Rollinat as well as admiration for him. The outlook that he values in Rollinat's poetic works is close to the one that he himself investigated and developed over the decades of his activities as a writer. Geffroy expanded his early activities as journalist and art critic to become a novelist, short story writer, political essayist and occasional dramatist. In so doing, he developed a highly individual position in relation to contemporary literary tendencies. One of his modern apologists, JoAnne Paradise, has put it this way:

> I believe that Geffroy transformed the naturalistic aesthetic to answer the questions that were raised by the Symbolists in the late 1880s and early 1890s, that he sought to show that what he termed naturalistic art could accommodate all the values demanded by the Symbolists, but without recourse to metaphysics.[12]

Geffroy's preoccupation with social issues and with political justice, fuelled by his friendship with Clemenceau, led him to follow certain of Zola's naturalist precepts, but he also associated the creation of works of art with a quest for the mysterious truths of universal existence that lie beyond social life:

> Lorsqu'il arrive à l'homme de se dégager des menus incidents sociaux pour prendre ainsi le sens de l'ensemble, il se sent vraiment vivre, il participe à l'existence universelle. Lorsqu'après avoir connu cette ivresse de ressentir, il connaît cette autre ivresse de dire, et même d'indiquer, de bégayer ce qu'il a ressenti, il crée l'œuvre d'art.[13]

In essence, there is a universal life that transcends the material details of our lives, but not in a religious or metaphysical sense. It belongs to a kind of secular pantheism. Works of art engage with the material world, but transcend it to reveal the hitherto unknown. The contemplation of solid matter leads to the impalpable.

Geffroy would bring such criteria to bear not only on Rollinat's poetry but also on the paintings of Monet, as in this passage concerning the Rouen Cathedral series:

> Cette fois, il semble que l'obstacle matériel est disparu. Toute idée de peinture, de moyens employés, de couleurs mélangées, s'en va. Une mystérieuse opération s'est faite. L'art de Monet, épuré, dépouillé, purifié, pourrait-on dire, de tout alliage visible, conquiert un espace inconnu de lumière, et une vérité plus grande resplendit.[14]

That is, the effect of the work goes beyond its subject and even beyond its medium. Geffroy also writes of Monet's Rouen Cathedral series: 'La matière est soumise à la fantasmagorie lumineuse'.[15] Light dematerialises the object. Such an emphasis on dematerialisation as well as transcendence of the solidity of the material is indeed symptomatic of Geffroy's appropriation of aspects of French Symbolism of the late 1880s and early 1890s.[16]

Returning to 1889, we can therefore infer that Geffroy's determination to intro-duce Monet to Rollinat was on the basis that he was bringing together kindred spir-its. When he came to give his account of Monet's Creuse landscapes, he indeed claimed explicitly that they share characteristics with Rollinat's poetic evocations of the same area:

Toute cette nature est là, avec la tristesse et le songe qu'elles [ces impressions]
suggèrent, si bien pareille chez le peintre et chez le poète. L'âme de Rollinat flotte à
jamais sur ces eaux, sur ces landes, sur ces pierres, en même temps qu'y règne
l'esprit visionnaire de Monet. [17]

In short, sadness and dream characterise this land of rivers, heath and stones, haunted by the soul of Rollinat and the vision of Monet. It is clear that, for Geffroy, the transformation of nature into art as practised by Monet as painter and by Rollinat as poet had profound similarities. [18] The question immediately arises as to whether this comparison by Geffroy belongs simply to his own personal outlook and subjectivity, or whether Monet and Rollinat are indeed similar as visual and verbal landscapists. In order to answer that question, we need to consider more closely the representations of the Creuse that each of them made.

Monet first visited Rollinat in February 1889. Rollinat had settled in the village of Fresselines, his home for the rest of his life, a short distance from the confluence of the Petite Creuse and the Grande Creuse (fig.11). Monet's first visit was only brief, but immediately led to a lengthy second visit, lasting from 7 March until the middle of May, during which time he benefited from Rollinat's hospitality, conversation and music-making.[19] The time of year was vital, in that he set about representing a moment when winter was giving way to the beginnings of spring, but this was made doubly difficult by bad weather combined with the relentless coming into leaf of

MAISON DE MAURICE ROLLINAT A FRESSELINES

Fig.11 Maison de Maurice Rollinat, Fresselines

trees and plants. A notorious anecdote tells us that Monet paid to have excessive foliage stripped from a solitary tree, to which he attached particular importance, in order to preserve some of its starkness (plate 16).[20] Monet explored different motifs in the vicinity of Fresselines. Notably, he selected the bridge at nearby Vervy, a potentially picturesque location with its accompanying mill and Fontaine Saint-Julien. But it was the confluence of the two rivers to form the Creuse itself to which Monet turned most emphatically. He selected in particular one motif for repeated treatment, producing a series in which light effects vary greatly, but the dramatic folds of the river valley recur (plates 17 & 18). In these paintings, the rockiness and ruggedness of the sides of the valleys are frequently emphasised, aided by a vantage point which suggests a larger scale than the tourist of today actually discovers when visiting the scene.

This effect of ruggedness on a grand scale is perhaps taken furthest in *Le Bloc, Paysage de la Creuse* (plate 19), where Monet depicts only the outcrop of rock that figures to the left in the confluence paintings, making it rear up to a high horizon broken by just a few trees. It was this painting that Geffroy reproduced in the 1922 edition of his critical biography of Monet. The volume was richly illustrated with fifty-four plates, but *Le Bloc* is the only Creuse landscape to figure there.[21] A partial explanation for this choice lies no doubt in the fact that the painting had been given by Monet to Georges Clemenceau, who was also the dedicatee of Geffroy's book. However, it was also quite legitimate on Geffroy's part to select *Le Bloc* as typifying the tone of a number of Monet's Creuse paintings, where high horizons are typical, as are dramatic effects.

But what of Rollinat as a verbal landscapist? All of Rollinat's collections of poems contain landscapes. *Dans les brandes* of 1877 is dedicated to George Sand in these words: 'A la mémoire de Georges Sand je dédie ces paysages du Berry.' These early 'paysages' tend to contrast the Berry with Paris, implicitly or explicitly, and even the Creuse with the Seine, as in this stanza from the opening poem, 'Fuyons Paris':

> Sans fin, Seine cadavéreuse,
> Charrie un peuple de noyés !
> Nous, nous nagerons dans la Creuse,
> Entre des buis et des noyers ![22]

In *Les Névroses*, despite its title, this descriptive tendency evolves, and in a way that does invite comparison with Monet's Creuse paintings. One such poem is 'Les Rocs', dedicated to Victor Hugo, in which the seasons unleash contrasting moods on the rocky valley that contains a river, no doubt the Creuse. Here are the third, fourth and seventh stanzas in the translation of Philip Higson, the English poet who is at present one of Rollinat's few champions outside France:

The stream that roars and foams beneath their climb
Becomes their crazed and hurried looking-glass,
And, come the winter, bursting its crevasse,
Whips them with spume and slaps them with its slime.

In that month zephyrs brim with suavity
Carried abroad as fragrant flowers are swayed,
The adder's lance-blade head is here displayed
Close to some cleft or gaping cavity.
…
Like monstrous beasts in their assembled forms,
They keep sad vigil, these forbidding crags,
When sun-baked or when clawed at by the jags
Of fiery zigzags aimed by grumbling storms.[23]

The rocks or crags provide the constant motif of material objects in the scene, but they are continually transformed by successive seasonal changes and effects of light. This subject lends itself to comparison with Monet, especially since Geffroy's account of Monet's Creuse paintings is structured as an account of seasonal change throughout the year. Even if we discount this comparison as merely circumstantial, there is no doubt that 'Les Rocs' is a pictorial poem, using visual effects that ally it with painting, in common with other poems from *Les Névroses*. Here, for example, is an extract from 'Paysage d'octobre', again in translation by Philip Higson:

Woodcock are once more loitering
In copses near an outcrop's dearth;
The crows that round the ploughshares wing
Plunder the disembowelled earth,
And, faggot-lean with verdure doffed,
The poplar, stark and hung with doom,
Raises its magpie's nest aloft
Against a wan sky soaked in gloom.[24]

The poplar tree, set against the sombre sky, provides the effect of a composed visual scene, reinforced by the poem's title.

By the time of Monet's presence in the Creuse, *Les Névroses* belonged to the past, and Rollinat was writing *La Nature* (1892). This book would have been his work in progress in 1889, although the poems are not individually dated so that we cannot know if any actually coincide with Monet's visit or immediately follow it. *La Nature* is a more unified volume than its predecessors, with no division into parts and has a constant thematic focus, announced by its title. Throughout the volume, landscape and pictorial features are abundant. Rollinat had already used titles such as 'paysages', but now pictorial titles become more common, and come to include specifically the vocabulary of painting, as in the aptly named 'Esquisse', a verbal sketch. 'Esquisse' is a sonnet, of which these are the tercets:

> *Les grands arbres de chaque bord*
> *Y font une voûte qui dort ;*
> *Et, d'un coupant de besaiguë,*
>
> *Se dresse un peuple de roseaux*
> *Hérissant tout droits, par monceaux,*
> *Leurs sabres verts à pointe aiguë.*[25]

Other poems have titles that identify a visual motif and then evoke its effect, for example 'Sur l'Ecluse', on a lock or sluice gate, where the fading light of sunset is suggested:

> *Le paysage boit la lumière au déclin :*
> *Tout le sang du soleil dans l'air calme s'infuse,*
> *Du troupeau resserré – masse grise et confuse –*
> *Monte un grand bêlement qui hèle et qui se plaint.*[26]

Light conditions and their influence on colour are central to a number of poems, for example 'Matin brumeux', morning mist, of which the first verse is:

> *Sous sa vapeur laiteuse et fixe, la rivière*
> *Figure ce matin un bain de vif-argent*
> *Où les arbres penchés – le ciel se nuageant -*
> *Transparaissent brouillés ainsi que la lumière.*[27]

The melancholy that is still often prominent in Rollinat's poetry is now frequently conveyed through these colour effects, as in the pallor of the snow-decked 'Paysage Triste', a sad landscape, which begins:

> *Un ciel blanc qui sur un val gris*
> *Va pleurer des larmes de neige ;*
> *Malgré le mont qui le protège*
> *Un étang complètement pris ;*
>
> *Aux trois autres horizons sombres*
> *Un boisé vague, – une vapeur*
> *Toute blême dans la stupeur,*
> *Une espèce de forêts d'ombres.*
>
> *Ici, tout droits, sveltes et hauts,*
> *Des bouleaux qui font les délices*
> *Du regard avec leurs troncs lisses*
> *Paraissant blanchis à la chaux.*[28]

In some poems, the effects of light are dominant, uniting the scene in the kind of *enveloppe* that is associated with Monet's landscapes. In 'Le Fond de l'eau' there is a fine example of this:

Il fait une journée ardente,
Mais, sans lourdeur, torride à point :
Tout flambe, sommet, creux, recoin,
Dans une lumière fondante.

Déjà claire par elle-même,
Fourbie encore par un tel feu,
La rivière, sous le ciel bleu,
Est d'une transparence extrême.[29]

Throughout *La Nature* such visual and pictorial effects recur. They are accompanied, to be sure, by a variety of other poetic strategies, notably narrative, but they do in themselves constitute verbal landscapes. They lead the reader to wonder about possible links with contemporary painting, but, as in *Les Névroses*, no specific painters or paintings are referred to in the text, so that Rollinat's possible pictorial allegiances remain in the realm of hypothesis rather than that of certainty.

The evidence of Rollinat's poems on their own is therefore circumstantial and suggestive rather than compelling or conclusive in arriving at specific links with Monet's landscapes. Fortunately, there is another aspect of Rollinat's poetry that opens up an additional way of relating him to Monet. This concerns his identity as a poet of the Berry, inheriting a regional literary tradition that had a determining effect on his verse, including his representations of landscape.

Rollinat's background is highly revealing in this respect. The Rollinat family had been prominent in the Berry since the seventeenth century, often as lawyers and also as scientists and writers.[30] The rue Rollinat and the Lycée Rollinat in modern-day Argenton-sur-Creuse, downstream from Fresselines, refer to the family rather than a particular individual. The father of Maurice, François Rollinat (1806–1867), was an outstanding member of this family. A lawyer by training, he was a radical Republican who played a prominent role as a politician during the 1848 revolution and the Second Republic. He had a passionate interest in history and philosophy, which he imparted to his poet son. It was inevitable that François Rollinat would encounter George Sand (1804–76), in that they were compatriots and near neighbours in the Berry, and equally conversant with Parisian radical milieux. François's father, Jean-Baptiste Rollinat (1775–1839), had met her as early as 1831. The friendship that flourished between George Sand and François Rollinat, however, was unpredictably intense, and their intimate correspondence has been published.[31] The Sand and Rollinat households became enmeshed. It is no coincidence that Maurice Rollinat shares his first name with George Sand's son Maurice Sand. George Sand became the sponsor and protector of the literary aspirations of the young Maurice Rollinat.

George Sand's personal involvement in the Berry region and her commitment to describing its landscape and to representing its inhabitants in her literary works is fundamental to her career, especially in its later stages. In novels such as *La Mare au diable* (1846), *La Petite Fadette* (1849) and *Les Maîtres sonneurs* (1853), she evokes extensively the customs of the Berry in their physical settings. The region that she was

describing was rustic and economically undeveloped.[32] The living conditions of the peasantry were primitive; large numbers of Berrichons and Creusois were forced in the nineteenth century to become migrant workers. Tens of thousands left their homes for months at a time as itinerant construction labourers. Republicanism, to which Sand was sympathetic, became strong in these underprivileged circumstances. The lack of modernisation in the region meant also that it became an object of curiosity and study for those attracted by what today we might call folklore. An ancient oral tradition of uncanny and superstitious tales had survived into the modern era. For example, in 1867 the librarian of the town of Guéret, J.-F. Bonnafoux, published *Légendes et croyances superstitieuses conservées dans le Département de la Creuse*, a compilation of local Gothic tales concerning a headless woman, witches, crows and owls, diabolical hares, the clock of death, and so on.[33] Bonnafoux would have been well aware of George Sand's treatment of such tales from a living past, as in the *Légendes rustiques* of 1858, in which she collaborated with her son Maurice.[34] George Sand was championing at one and the same time the landscapes of the Berry, the plight of its people, and a culture in which the fantastic survived in a materialist age.

George Sand is the best-known literary champion of the Berry in the mid-nineteenth century, but she was not alone. In his fine survey of modern *berrichon* writers, and especially poets, published in 1902, the literary historian Auguste Théret gave almost equal weight to the now neglected figure of Henri de Latouche (1785–1851).[35] De Latouche was born at La Châtre in the Berry, and had attempted to become a successful Parisian writer. He began by writing a number of plays and novels, and achieved prominence as a literary journalist with the newly founded *Figaro*. Towards the end of his life he published volumes of poetry, which are marked by his native province. Today he has been consigned to a marginal status within French Romanticism, but his contemporaries accorded him more prestige. Théret goes so far as to refer to George Sand as Henri de Latouche's pupil. Furthermore, Théret regards De Latouche as a main catalyst in the origins of a school of modern landscape painting in the Berry that came into being during the 1850s. He states categorically that it was literary descriptions by De Latouche and George Sand that attracted painters to the region.[36] Leading the way, he tells us, was Antigna, a pupil of Delaroche, whose painting *La Descente*, exhibited at the 1859 Salon, was based on studies of peasant children made near George Sand's property at Gargilesse. Shortly after, the Lyon painter Amédée Baudit visited the Berry repeatedly in 1862–3, producing a number of landscapes, one of which was exhibited at the 1864 Salon. The Creuse river became a favoured motif early on; Francis Blin, a pupil of Picot, painted there in the summers of 1850, 1854 and 1859. Amongst the largely forgotten visiting artists, we find a more familiar one: Camille Corot in his *Etudes peintes dans le Berry*.[37]

Théret's account of Berry landscape painting continues with a list of a further twenty artists from all over France who travelled to the Berry during the Second Empire and later. For each he quotes examples of their *berrichon* work. He then points to a second phase in which artists native to the Berry, or to regions adjacent to it, followed the example of these visiting artists, creating an authentic Berry school

of painting. Théret provides precise information about these artists.[38] Their numbers were significant, and they were far from being simply amateurs. They include Stanislas Gorin, one of whose pupils in Bordeaux had been Odilon Redon. This expansion of *berrichon* landscape painting is still obvious today to tourists of the twenty-first century. The village of Crozant, whose hilltop ruined medieval castle had attracted Second Empire artists, today has a bust of Armand Guillaumin by Jean-Baptiste Paulin in its centre, a homage to an Impressionist who painted the Creuse and helped to give identity to the so-called Ecole de Crozant. Even Fresselines is today a *village d'art*, remembering artists such as Léon Deltroy and Allan Osterlind who established a local tradition of painting after Monet's visit.[39] Osterlind's fine watercolour portrait of Maurice Rollinat is now in the museum at Châteauroux, the poet's birthplace.

One further point needs to be retained from Auguste Théret's account of *berrichon* literary and pictorial landscapes. He notes, somewhat predictably, the dual identity of the Berry as a place of bucolic charm and of macabre superstition. He quotes Maurice Sand's evocation of the latter as debris of mysterious and sometimes violent folk culture, seeming to extend backwards in time to the Druids. The Berry is a place of the fantastic as well as the picturesque. Some artists, Théret asserts, sought to include this element of the fantastic, for example Baron Dudevant, who painted conventionally the classic motifs of the region but also suggested in charcoal drawings an uncanny and dark side of the region's character and tradition.[40]

Returning to Monet and Rollinat, we can now begin to construct a historical context for their encounter that goes beyond the circumstances of Gustave Geffroy's views and activities. Rollinat as a nature poet was building his practice in part on foundations created by his mentor George Sand and by her mentor Henri de Latouche. The texts and even the personalities of Henri de Latouche and George Sand had been essential in developing literary conventions for representing the Berry landscape, and they had been major catalysts in the emergence of *berrichon* landscape painting from the mid-nineteenth century onwards. Already at this stage, well before Monet's sojourn at Fresselines, there was an interaction between verbal and visual landscapes. The pictorial features of Rollinat's poetry are therefore not surprising, given this context. In addition to the pictorialist features that were growing in a general way through Parnassian and Symbolist poetic practice, he was able to respond to a specific *berrichon* version of verbal landscape. Furthermore, Monet, for his part, can be said to have been participating briefly in the development of a provincial school of landscape painting, far less celebrated than Barbizon or Brittany, but highly distinctive and in the ascendancy.

Should we then understand the encounter between Monet and Rollinat as being one of fellow travellers in a broad cultural domain? To an extent, that must be the case, but not to the exclusion of a more personal interaction between the two. We can be sure that Monet's awareness of *berrichon* culture and traditions was sharpened and mediated by living for many weeks in Rollinat's company. It is clear, to be sure, that he had reservations about the element of fantasy in Rollinat's works and

outlook.[41] He thereby distanced himself from the macabre and superstitious aspects of the Berry. However, other cultural and regional connotations of the Creuse would have been more amenable to him, for example its remoteness from modernity, or its unremitting wildness. For Rollinat's part, the *berrichon* foundations of his verbal landscapes certainly became touched, around 1889, by an increasingly developed form of pictorialism. The prominence of light and of colour in many of the descriptive poems from *La Nature*, whose very title invites comparison with Monet, points to Rollinat's growing use of a kind of verbal Impressionist palette. To read these poems is to be reminded of contemporary practice in painting, including that of Monet.

In other words, the encounter between Monet and Rollinat should be understood at more than one level. The immediate circumstances concerned Gustave Geffroy in his role as champion and interpreter of both men. This was a level of personal friendship and allegiance that depended greatly on Geffroy's skills and enthusiasms as intermediary. More generally, Geffroy was bringing together two figures who, in their respective media, shared a concern with the renewal of landscape at a time when Impressionist and Naturalist practices were being affected by new tendencies in Paris, whether through decadent or Symbolist milieux. In terms of cultural complexity, we need also to add the level of provincial location, in that the significance of their Creuse paintings and poems takes on rich connotations in relation to the regional crucible of their creation: the Berry.

Possible comparisons between specific works by Monet and Rollinat need also to be considered with these different contextual levels in mind. If a comparison between works such as 'Les Rocs' by Rollinat and *Le Bloc* by Monet might seem gratuitous, in that it begs questions about proof and chronology, it is nonetheless justified in terms of common preoccupations. To align poems from *La Nature* specifically with Monet is perhaps a speculative exercise, but it is one based on a solid foundation. Monet and Rollinat shared awareness of what representing the Creuse involved. Despite differences in emphasis and personal outlook, they both drew on the paradigms of mea-ning that the Berry offered. It is in that sense, no doubt, that we should understand Geffroy's evocation of the soul of Rollinat and the vision of Monet floating together over the Creuse landscape. It is in that sense, also, that reading Rollinat's poetry can not only remind us of Monet, but can actually help us to view and interpret his paintings of the Creuse.

Monet, the Creuse, Rollinat: Visual and Verbal Landscapes

RICHARD HOBBS

1. This underlying theme of the exhibition *Monet: the Seine and the Sea 1978–1883* (Edinburgh 2003) is stressed in a number of studies of Monet, for example Tucker 1982, and Herbert 1994.

2. In addition to information in Wildenstein III 1979, (w.1218–40), see Amédée Carriat, 'Claude Monet à Fresselines', in *Bulletin de la Société 'Les Amis de Maurice Rollinat'*, Châteauroux 1985, pp.9–16. Carriat reviews in detail archival information about Monet's Creuse paintings.

3. The principal source of information for Gustave Geffroy's involvement with Monet remains his own *Claude Monet, sa vie, son temps, son œuvre*, Paris 1922 (later published as *Claude Monet, sa vie, son œuvre*, 2 vols,1924, and republished (ed. C. Judrin) in 1980). Geffroy's account of the Creuse visit is in the 1980 edition, vol.1, chapter 31, pp.199–209.

4. Concerning Geffroy's Breton origins and preoccupations, see Robert T. Denommé, *The Naturalism of Gustave Geffroy*, Geneva 1963 (especially chp 1, 'The Life of Gustave Geffroy').

5. Maurice Rollinat, *Fin d'œuvre, préface de Gustave Geffroy*, Paris 1919. Geffroy's preface is pp.1–41. There are six letters to Monet from February 1889 to January 1891, pp.277–84, 286 and 289–93.

6. The major study of Rollinat is Régis Miannay, *Maurice Rollinat, Poète et Musicien du Fantastique*, Châteauroux 1981, which has superseded the earlier Alexandre Zévaès, *Maurice Rollinat, son œuvre*, Paris 1933. Still fundamental to the study of Rollinat are numerous publications by the poet and novelist Emile Vinchon, who was President of the 'Société Les Amis de Maurice Rollinat' from its creation in 1946 until his death in 1963. Vinchon's books on Rollinat include: *La Vie de Maurice Rollinat*, Issoudun (1921) 1938; *La Philosophie de Maurice Rollinat*, Paris 1929; *La Musique de Maurice Rollinat*, Le Blanc 1934; and *L'Œuvre Littéraire de Maurice Rollinat*, Issoudun 1936.

7. *Dans les Brandes, poèmes et rondels* was printed privately in 1877. The first commercial publication was in 1883 by Charpentier, Paris, with a portrait of the author by Jules Neige.

8. Miannay 1981 (see note 6).

9. The poet Philip Higson has recently translated the best of these poems into English in *Maurice Rollinat: a hundred poems from Les Névroses*, Newcastle, Staffs 2003. Higson (pp.xxvii-xxxv) includes an analysis of *Les Névroses* as a collection.

10. See, for example, Docteur Roger Grimaud, *Maurice Rollinat, Etude médico-psychologue. Le Poète, le musicien, le malade*, Bordeaux 1931.

11. *L'Abîme* and *La Nature* were published by Charpentier, Paris. Charpentier played a vital part in disseminating Rollinat's works, including the posthumous *Choix de Poésies de Maurice Rollinat* (1926), an anthology that draws on all his collections of poetry.

12. JoAnne Paradise, *Gustave Geffory and the Criticism of Painting*, New York and London 1985, pp.xiii-xiv.

13. 'When mankind manages to disengage himself from the tiny happenings of social life in order thereby to grasp the meaning of the totality, he really feels alive, he takes part in universal existence. When, after knowing this intoxication of feeling, he gets to know that other intoxication of expressing, and even of pointing to and stammering what he has felt, he creates a work of art.' Quoted by Paradise 1985, p.75,

from G. Geoffroy, *La Vie artistique*, vol.1, p.28, Paris 1892. The translation is mine and intended as a literal guide, as are those in the notes below.

14. 'This time it seems that the material object has disappeared. Any idea of painting, of medium, of mixing colours, goes away. A mysterious operation has taken place. The art of Monet, refined, stripped bare, purified you could say, of any visible alloy, conquers an unknown space of light, and a greater truth shines out.' Quoted by Paradise 1985, pp.298–9.

15. 'Matter is subjected to luminous phantasmagoria.' Ibid., p.298.

16. Monet had by then established contacts with literary Symbolists, notably Stéphane Mallarmé who included him in his project for illustrated prose poems conceived late in 1887. See Jean-Michel Nectoux, *Mallarmé, peinture, musique, poésie*, Paris 1998, pp.52–8. As a result of this contact, Monet gave Mallarmé his *La Seine à Jeufosse* (1884). See Nectoux's catalogue of Mallarmé's art collection, ibid., pp.202–19, where *La Seine à Jeufosse*, reproduced p.56, is item 37.

17. 'All that nature is here, with the sadness and dream that [these impressions] evoke, so very similar with the painter and with the poet. The soul of Rollinat floats forever over these waters, over these heaths, over these stones, at the same time that the visionary spirit of Monet reigns there.' Geffroy 1980 (see note 3), p.206.

18. Paradise 1985 (see note 12), pp.282–7.

19. Carriat 1985 (see note 2) analyses conflicting accounts of the exact dates.

20. Summarised by Daniel Wildenstein in *Monet, or the Triumph of Impressionism*, Cologne 1996, p.252.

21. Geffroy 1922 (see note 3). *Le Bloc, Paysage de la Creuse*, collection Clemenceau, is reproduced opposite p.233.

22. 'Endlessly, cadaverous Seine, carry along a host of the drowned! As for us, we shall swim in the Creuse, between box and walnut trees!' Rollinat, *Dans les brandes, poèmes et rondels*, Charpentier, Paris 1883, p.7.

23. Philip Higson, *Rollinat: a hundred poems from Les Névroses*, Newcastle, Staffs 2003, p.77. The original French is:

 La rivière qui hurle et moutonne à leur base
 Leur devient un miroir torrentueux et fou,
 Et, quand l'hiver la fait déborder de son trou,
 Les cravache d'écume et les gifle de vase.

 Au mois où le zephyr plein de suavité
 Emporte les parfums de la fleur qu'il balance,
 L'aspic y vient montrer sa tête en fer de lance
 Au bord de la fissure et de la cavité.

 Groupés là comme un tas de monstrueuses
 bêtes,
 Ils veillent tristement, les horribles rochers,
 Que le soleil les brûle ou qu'ils soient accrochés
 Par les feux zigzagueurs et grondants des
 tempêtes.

 From *Les Névroses*, Charpentier, Paris 1921 (first edition 1883), pp.204–5.

24. Ibid., p.95. The original French is:

 Dans les taillis voisins des rocs
 La bécasse fait sa rentrée ;
 Les corneilles autour des socs
 Piétinent la terre éventrée,
 Et, décharné comme un fagot,
 Le peuplier morne et funèbre
 Arbore son nid de margot
 Sur le ciel blanc qui s'enténèbre.
 Les Névroses, 1921 edition, p.245.

25. 'The tall trees to each side make up a sleeping vault; and, like the slicing of a double-edged blade, rises a host of reeds, bristling their green sharp-pointed sabres

in upright stacks.' *La Nature, poésies*, Charpentier, Paris 1892, pp.259–60.

26. 'The landscape drinks the falling light: all the blood of the sun is infused in the calm air; from the huddled flock – a grey and confused mass – rises a loud bleating that calls out and complains.' Ibid., p.321.

27. 'Beneath its milky and still haze, the river this morning shows a quicksilver pool where bent trees – as the sky clouds over – shine through as blurred as the light.' Ibid., pp.302–3.

28. 'A white sky which sheds snow tears on a grey valley; a completely frozen pond despite the protecting hill; at the three other dark horizons a vague woodedness, – a mist wholly pale in the stupor, like forests of shadows. Here, quite straight and slender and high, silver birches that delight the eye with their smooth trunks seem to have been washed with lime.' Ibid., pp.306–7.

29. 'The day is burning hot, but, not heavy, just scorching enough; everything is aflame – summit, hollow, nooks, in a melting light. Already bright in itself, furbished further by such a fire, the river, beneath the blue sky, is of extreme transparency.' Ibid., p.148.

30. In addition to Miannay 1981, see Jean Anatole, 'La Famille Rollinat', *Bulletin de la Société 'Les Amis de Maurice Rollinat'*, Châteauroux 1997, pp.29–44.

31. Jules Bertaut, *Une Amitié romantique. Lettres inédites de George Sand et François Rollinat*, Paris 1921.

32. See L. Vincent, *George Sand et le Berry*, Paris 1919. The second part of this has been republished as *Le Berry dans l'Œuvre de George Sand*, Geneva 1978.

33. J.-F. Bonnafoux, *Légendes et croyancées superstitieuses conservé dans le Département de la Creuse*, Guéret 1867.

34. *Légendes rustiques*, dessins de Maurice Sand, texte de George Sand, Paris 1858. See also George Sand, *Promenade dans le Berry: mœurs, coutumes, légendes*, Brussels 1992.

35. Auguste Théret, *Littérature du Berry, Poésie, le XIXme siècle, avec Henri de Latouche et Emile Deschamps*, Paris 1902. This was the second volume of Théret's study; the first, published in 1898, had covered the period 1500–1800.

36. Ibid., p.242.

37. Théret (pp.243–8) provides a detailed account of the artists involved.

38. Ibid., pp.247–8.

39. For background on artistic communities of this kind, see Nina Lübbren, *Rural artists' colonies in Europe 1870–1910*, Manchester 2001.

40. For a twentieth-century continuation of perceptions of the Creuse, see Mary Mian, *My Country-in-Law*, introduction by James Thurber, London 1947. The American author was the wife of the *berrichon* painter Aristide Mian.

41. See Geffroy 1980 (see note 3), p.202, where Geffroy quotes a letter from 24 April in which Monet complains of Rollinat's attention to strangeness in painting.

6 Monet, Atheism and the 'Antagonistic Forces' of his Age

RICHARD KENDALL

The art of Claude Monet is now so extraordinarily popular that this popularity has itself become the object of fascination, hyperbole and a certain professional weariness.[1] In broad terms, the phenomenon can be separated into two elements. The first derives from the appeal of Monet's paintings, which in recent decades have drawn enormous, record-breaking crowds to museums across the world. The exhibition in Edinburgh that prompted the present volume, for example, was the most highly attended event in the gallery's history, while the year-long show of Monet's work that opened at the Bellagio Gallery in Las Vegas in 2004 is said to have averaged 1,000 visitors a day and grossed around six million dollars in entrance fees.[2] In principle, this seems to suggest an uncomplicated success story, the kind of accolade that most artists dream of and a triumph of public engagement with high culture. The second element is manifestly interwoven with the first, while arguably leading to a different conclusion, and might be called the merchandising of Monet. The promotion and commercial exploitation of Monet's oeuvre and persona has probably exceeded that of any artist in history, expressing itself in a bewildering variety of forms that range from the innocent to the grotesque. Some of the most egregious cases are found in museum gift-shop catalogues and displays: a major institution in the United States, for example, is now offering a 'Monet Water Lilies Scarf', on which the 'shimmering reflections of Claude Monet's (French 1840–1926) "Bridge Over a Pool of Water Lilies" are artfully reinterpreted in a fluid cascade of silk chiffon', while another grand organisation proposes a '1,200-piece Jigsaw Puzzle: Challenge yourself or friends to piece together the green harmony of this beautiful Monet classic, "Le Bassin aux Nymphéas: Harmonie Verte"'.

Beyond these inanities, meanwhile, larger questions remain unasked. Why Monet, rather than Sisley or Pissarro, Morisot or Cassatt? Is Monet the most prominent because of the greatness of his paintings, or because he has proved easier to package? What are the qualities, real or generated by hype, that attract people to Monet's pictures today? And how true to the character of his art is the 'cascade of silk chiffon' of an expensive scarf, or the 'green harmony' in a jigsaw? All these issues are complicated by a further paradox. Fundamental to the modern Monet phenomenon, and widely understood by most of those engaged with it, is the knowledge that the very paintings we so admire in our own day were shunned or reviled by the many of

those who first saw them. Most famously, it was Monet's *Impression, Sunrise* (Musée Marmottan, Paris) that provoked the wrath of his contemporaries at the original Impressionist exhibition of 1874, when certain critics mocked it as 'defective' and suggested that it was made 'by the childish hand of a schoolboy who is applying colours for the first time'.[3] Monet's difficulty in selling his pictures and the penury of his early years are almost equally well-known, as is the incomprehension that accompanied him up to and beyond the period of the much abused *Le Bassin aux nymphéas: harmonie verte* (Musée d'Orsay, Paris). The gulf that separates these two estimates of Monet's achievement – 'defective' to his peers, 'classic' to the modern shopper – is, of course, characteristic of the much surveyed topography of modernism. But in Monet's case, the depth and breadth of this chasm could hardly be more spectacular, often commanding our wonder if not always our critical energies.

The initial aim of this paper is to investigate the reception of Monet's art at the Impressionist exhibitions and his early characterisation as a radical. This in turn directs our attention to the language and imagery used by Monet's critics, and their explicit association of the artist with issues related to the progressive, contrarian milieu of the 1870s. Some of these questions, including new attitudes to religion, science and evolution, were repeatedly mentioned by commentators, but have rarely, if ever, been considered in the modern Monet literature. As a case study, the role of atheism in Monet's circle will be examined and some of its significance for his painting will be explored. Implicit in this enquiry is an attempt to understand the massive shift in assessment of the artist from his day to our own, both at the specialist level and at that of the general public. Such speculation involves an unusually wide range of texts, imagery and other sources, from the abstruse to the commonplace, among them sporadic evidence of the gallery visitor's opinion in a former era, that of the late nineteenth century.

Fig.12 · Cartoon by Cham, in *Le Charivari*, Spring, 1877; reproduced in Ludovic Halévy, *Douze années comiques par Cham, 1868– 1879*, Paris 1880, p.287

— Écoute bien : tu ne sais ni dessiner ni peindre ? Eh bien, ta position est faite : tu es peintre impressionniste !

In the spring of 1877, the cartoonist Cham published in the popular journal *Le Charivari* a number of small, satirical drawings that were prompted by the newly opened Impressionist exhibition in Paris. This was the third such show and featured Monet's strongest and most extensive presentation of recent works to date, among them several marines and examples of his Gare Saint-Lazare canvases, such as the painting now in the Musée d'Orsay (plate 20). In one of Cham's vignettes (fig.12), we see an urban boulevard with a young artist at the left who carries the kind of portable oil-sketching box much used by plein-air landscapists.[4] Meeting an acquaintance who can neither draw nor paint, the landscapist announces his friend's vocation: 'you are an impressionist painter!' From the time of the first group exhibition, the Impressionists had been taunted over their perceived lack of elementary skills. Many newspaper and journal reviewers accused Monet and his colleagues of applying paint with trowels or knives, and of disguising their incompetence beneath bizarre subject matter and garish colours. In 1874, Marc de Montifaud's claim that *Impression, Sunrise* had been made by a child was typical of such barbs, as were suggestions by others that his *Boulevard des Capucines* (Nelson-Atkins Museum of Art, Kansas City) consisted of 'palette scrapings' and 'a mess of colours'.[5] Such comments had an obvious message: that in comparison with the old masters and the academic artists of their day, the poorly trained Impressionists were unworthy of being called painters at all, and were either deluded or dishonest in presenting their work to the public. Negative though they both are, however, Cham's cartoon and the remarks of these critics were essentially directed at the young artists' techniques. Despite its limitations, this has become one of the standard explanations of the response to Monet and early Impressionism, enshrined in many standard publications and still conspicuous in our classrooms and textbooks. New and uncanonical approaches to brushwork, colour and composition, in this reading, were largely responsible for the

Fig.13 · Cartoon by Cham, in *Le Charivari*, Spring, 1877; reproduced in Ludovic Halévy, *Douze années comiques par Cham, 1868–1879*, Paris 1880, p.287

— Je suis peintre impressionniste! Avant de commencer, je vous donne une impression.

outrage provoked by their canvases; the radicalism of the Impressionist venture is seen to be an internal, practical affair.

The harder we look at the early critics, the more the inadequacy of this model becomes apparent. A second cartoon by Cham from 1877 illustrates the point and carries us into new territory (fig.13). This time he shows a painter at an easel, angrily kicking a top-hatted bourgeois who may be a potential patron, sitter or some other visitor. The caption plays rather feebly on the idea of the 'impression', as both kick and visual experience, but the overall message is again clear. Not only has the smartly dressed gentleman failed to appreciate the painter's art, but violence has been directed at his person. The Impressionist's wild hair and beard tell us that he is a Bohemian, while his clothing is conspicuously sloppy when compared to that of his victim. Lacking in social propriety, the artist has put himself beyond the norms of civilised behaviour and is liable to erupt in anger, even in an assault on a respectable citizen. Other illustrations by Cham returned to this general theme, albeit sarcastically. In one, he suggests that a heavily pregnant woman would be putting herself at risk by entering an exhibition of Impressionist pictures; in another, Impressionist canvases have been acquired by the Turkish army, to be used as weapons.[6] Though intended to be comical, these drawings hint that Impressionism and the ideas associated with it might be uncomfortable, not merely for the art establishment, but for all decent people; at worst, they were a threat to life and national security.

Cham, whose real name was Amadée-Charles-Henry de Noé, was known personally to Ludovic Halévy, the longstanding friend of Monet's fellow exhibitor, Edgar Degas.[7] Though Cham's jokes appear to deal with generic figures, it is possible that they had a more pointed meaning for the celebrated *pleinairiste*, Claude Monet himself. Significant here is that some observers had already seen Monet as the leader of the 'new school', an assumption reinforced by the abusive nickname they had acquired from his *Impression, Sunrise* in 1874. A number of Cham's drawings appear to underscore this notion, showing the typical Impressionist as a tousle headed and roughly bearded individual, characteristics found in photographs and other portraits of Monet around this date. Comparable images of the other principal male Impressionists, by contrast, remove them as candidates: the older, more thick-set Pissarro hardly fits the bill and Cézanne was already prematurely bald; the formally attired and trimmed Degas, and the more petite Renoir, can also be ruled out, as can the short haired Caillebotte and the urbane Sisley. Though Monet was by no means the first unkempt, rebellious artist of his age, it must have been clear to his peers that he offered the best match for Cham's emblematic painter, and had perhaps knowingly modelled himself on the same late-Romantic archetype.

The idea that an untalented, hirsute and argumentative painter, such as Cham's 'Monet' figure, might be a real risk to society seems improbable today, but it was repeated with rising levels of seriousness in the commentary that followed the Impressionist exhibitions. It has rarely been noticed, for example, just how often Impressionist artists and their pictures were described as dangerous, whether physically, politically or in other ways. When Monet's *Boulevard des Capucines* was exhibited

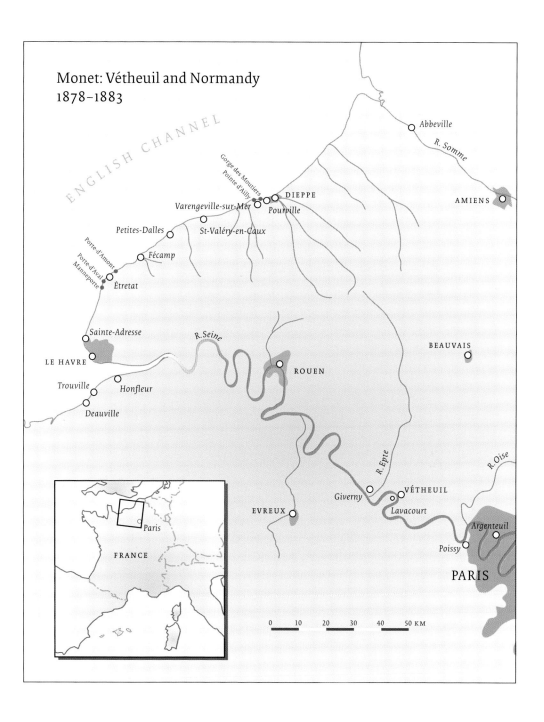

Monet: Vétheuil and Normandy
1878–1883

ENGLISH CHANNEL

Abbeville
R. Somme

AMIENS

Gorge des Moutiers
Pointe d'Ailly
Varengeville-sur-Mer
Pourville
DIEPPE

Petites-Dalles
St-Valéry-en-Caux

Porte-d'Amont
Porte-d'Aval
Manneporte
Fécamp

Étretat

Sainte-Adresse
R. Seine
BEAUVAIS

LE HAVRE
ROUEN

Trouville
Honfleur

Deauville

R. Epte
R. Oise

VÉTHEUIL
Giverny
Lavacourt
EVREUX

Argenteuil

Poissy

PARIS

FRANCE
Paris

0 10 20 30 40 50 KM

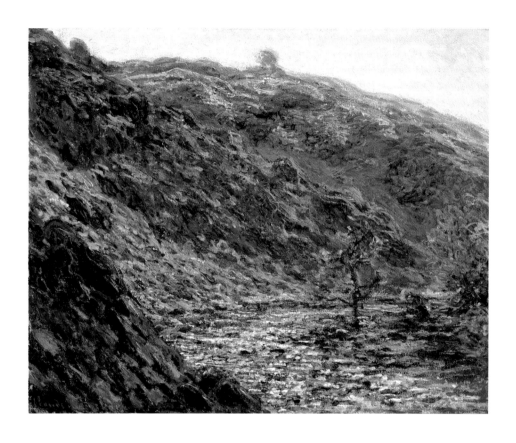

Plate 16 · Claude Monet, *Valley of the Creuse (Grey Day)*
Denman Waldo Ross Collection, 06.115, Museum of Fine Arts, Boston

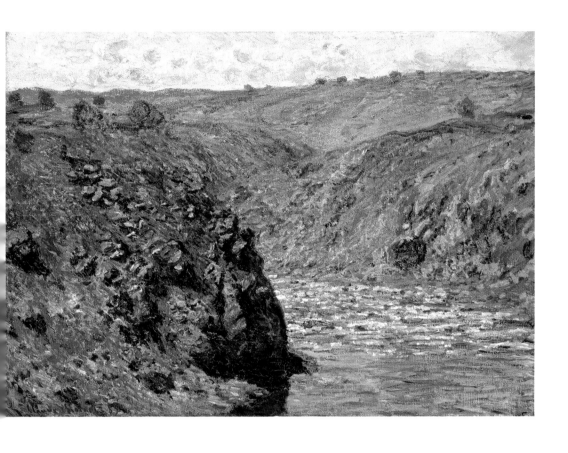

Plate 17 · Claude Monet, *Valley of the Creuse*
Juliana Cheney Edwards Collection, 25.107, Museum of Fine Arts, Boston

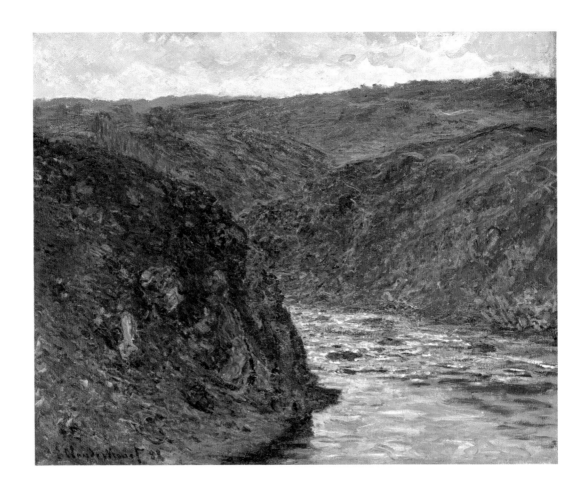

Plate 18 · Claude Monet, *Valley of the Petite Creuse*
Bequest of David P. Kimball in memory of his wife Clara Bertram Kimball, 23.541,
Museum of Fine Arts, Boston

Plate 19 · Claude Monet, *Le Bloc, paysage de la Creuse (Study of Rocks)*
The Royal Collection, Her Majesty Queen Elizabeth II

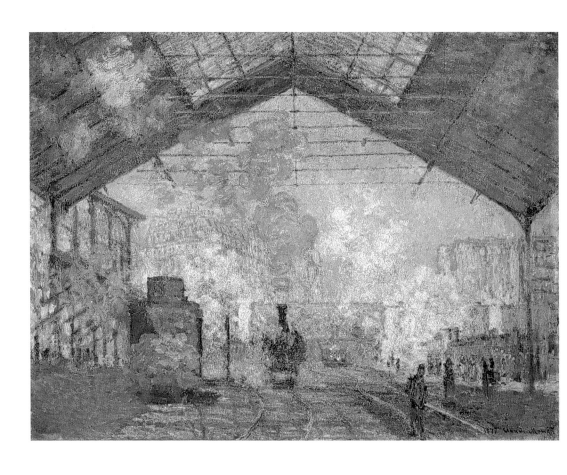

Plate 20 · Claude Monet, *La Gare Saint-Lazare*
Musée d'Orsay, Paris

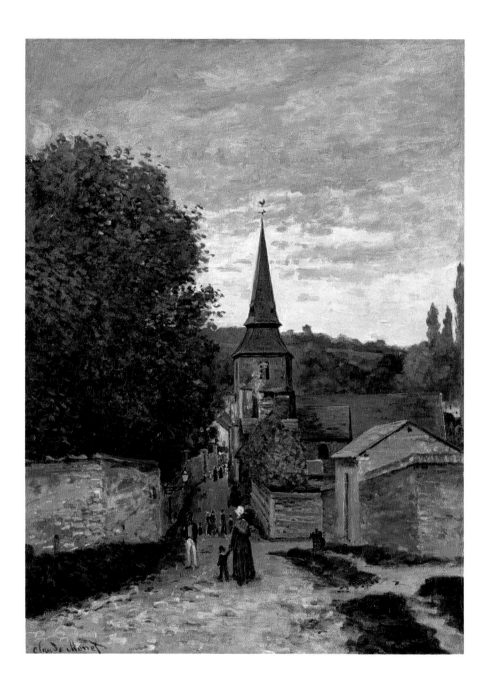

Plate 21 · Claude Monet, *Street in Sainte-Adresse*, 1868–70
Sterling and Francine Clark Art Institute, Williamstown, Massachusetts

Plate 22 · Claude Monet, *The Cliffs at Etretat*, 1885
Sterling and Francine Clark Art Institute, Williamstown, Massachusetts

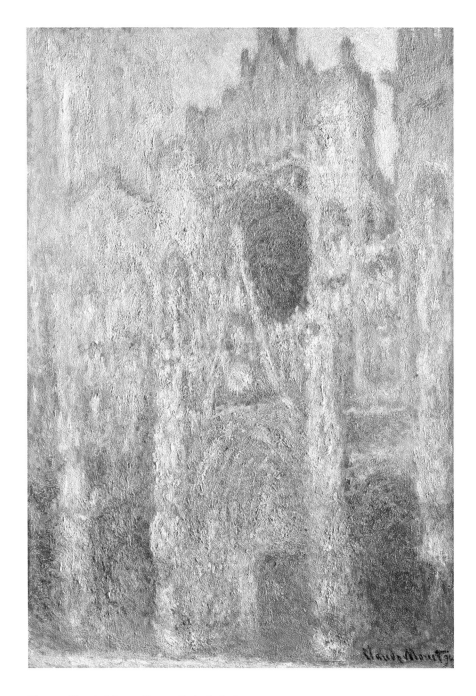

Plate 23 Claude Monet, *Rouen Cathedral*, 1894
Sterling and Francine Clark Art Institute, Williamstown, Massachusetts

121

Plate 24 · Claude Monet, *Five Figures in a Landscape*, 1888
Anonymous loan, 35.1989, The Art Institute of Chicago

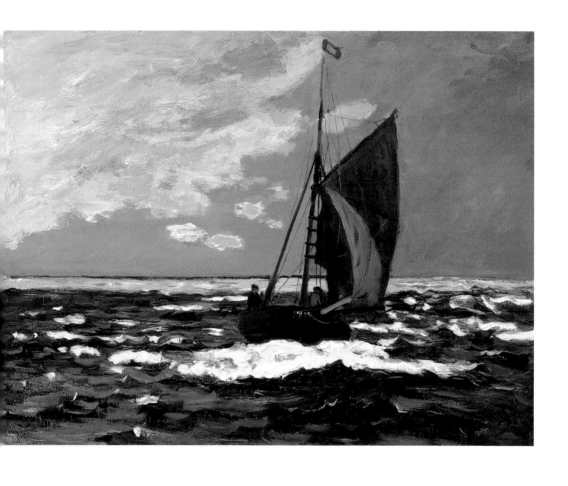

Plate 25 · Claude Monet, *A Freshening Breeze*
Sterling and Francine Clark Art Institute, Williamstown, Massachusetts

Plate 26 · Claude Monet, *A Seascape, Shipping by Moonlight*
National Gallery of Scotland, Edinburgh

Plate 27 · Claude Monet, *Lavacourt, Sun and Snow*
The National Gallery, London

Plate 28 · Claude Monet, *Grainstack (La Meule)*
Collection of Pierre Larock-Granoff, Paris

126

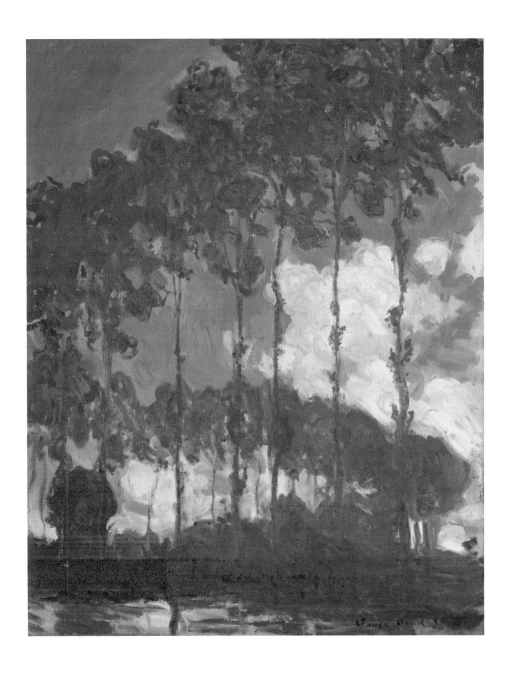

Plate 29 · Claude Monet, *Poplars on the Epte*
Tate, London

Plate 30 · James McNeill Whistler, *An Orange Note: Sweet Shop*
Gift of Charles Laing Freer, Freer Gallery of Art, Smithsonian Institution, Washington DC

in 1874, it was notoriously singled out in a review by the critic Louis Leroy. In his account, Leroy described a tour of the exhibition in the company of an imaginary academic painter, 'Monsieur Vincent', who became increasingly incensed by the Impressionists' audacity and incompetence. But it was Monet who literally finished him off: in front of this now celebrated work, the visitor is made to exclaim, 'What is represented by these numerous black lickings at the bottom of the picture?' which looked, he suggested, like random strokes of a chisel in a block of stone. 'I think I'm going to have a heart attack', Monsieur Vincent cried, and sank into a delirium.[8]

Again, the tone is ridiculous, but the message is here slightly sinister. Three years later, in 1877, Leroy conjured up another farcical visit to the current Impressionist exhibition, the same event that provoked the Cham drawings. After recoiling in horror from Monet's *Un Coin d'appartement*, and *Les Dindons* (both Musée d'Orsay, Paris), and one of his Gare Saint-Lazare pictures, Leroy's companion announced: 'I don't know why the police allow such exhibitions … when trouble arises in society, it's everywhere!' This time he collapsed dying on the gallery floor.[9] His sentiments were echoed by several other critics, who variously combined their wit with a greater seriousness. One made an extended comparison between 'these radicals of the palette' and 'the radicals of the tribune', a remark followed immediately by Monet's name; a second claimed that the Impressionists had 'planted a revolutionary banner'; and a third announced that the collective – in a ringing phrase – was part of 'the chaos of antagonistic forces that trouble our epoch'.[10] This is strong language for any art exhibition, but it allows us to take further our analysis of the reception of Monet and his fellow painters at this date. Self-evidently, these writers were not just upset by Impressionist brushwork and colour, nor by the skittish personal habits of the painters in question. Now they had identified a more serious provocation, in the subversive ideas that could be sensed behind and within these Impressionist paintings, ultimately relating them to the troubling nature of the age itself.

The possibility that the pictures of Claude Monet and his fellow exhibitors were resisted as much for their perceived links with oppositional thought as for their painterly licence deserves close consideration. The subject is vast and under-researched, yet it may shed light on the initial question raised by this essay. In recent decades, the relationship between Impressionist art and political radicalism has been urged by a number of authors, though largely as an approach to the artists' subject matter and style, and without reference to their broader interests, knowledge and beliefs. As we shall see, the 'chaos of antagonistic forces' was understood at the time in much wider terms by the Impressionists' critics, embracing not only the threat of the 'revolutionary banner' but challenges to the moral and religious fabric of French society and the intrusion of heterodox ideas from modern science. This broad spectrum of intellectual concerns, some of which had immediate and revealing consequences for the painting of Monet and his colleagues, might be thought of as the 'mental landscape' of early Impressionism. It is this environment of innovative and controversial thought, drawn from a range of disciplines and embracing many extra-artistic concerns, that has been conspicuously absent from debate about their art.

Monet's individual mental landscape, as much as the often discussed rural and ur-
ban surroundings that provided his motifs, demands our attention.

Along with most of the prominent Impressionist exhibitors in their early years,
Monet was either parsimonious with his inner thoughts or careless about preserv-
ing them. Scattered letters from the 1860s and 1870s help to trace his movements and
friendships, but do little to articulate his views about painting or his personal values
in any direct way. The huge surviving correspondence of his maturity, on the other
hand, reveals him as a man of deep emotions and intense self-awareness, with strong,
independent views on matters beyond the world of painting. We also learn some-
thing of his reading habits and his sustained intimacy with luminaries of the day,
among them novelists and musicians, poets and politicians, horticulturists and oph-
thalmologists, and leading cultural critics. Across the decades, for example, he read
the poems of Baudelaire and Mallarmé, Tolstoy's controversial *Anna Karenina*, the
novels of Zola and the stories of Poe, and was fascinated by Ibsen's plays. Other
insights emerge from his sojourns with the famous opera baritone, Jean-Baptiste
Faure, and the musician and poet, Maurice Rollinat, and his growing intimacy with
intellectuals like Gustave Geffroy and Octave Mirbeau. Illuminating though his
mature letters are, however, we are obliged to begin our brief consideration of his less
documented early mental life by grasping at incidents and isolated names, and by
leaning on more voluble contemporaries.

Monet's childhood education in Le Havre was limited and conventional, though
traces of his career as a teenage caricaturist in the late 1850s are distinctly suggestive
in the present context. Intriguingly, one of Monet's first public acts was to publish a
skilful drawing of a current celebrity in the Parisian journal *Diogène* in 1860.[11] If this
caricature was essentially innocuous, his growing identification with the political left
through this decade was implied by Monet's presence in the circles of the fire-eating
Gustave Courbet and the radical Georges Clemenceau, a future prime minister of
France and friend of the artist's old age.[12] John House has recently argued that Monet
is best seen 'as an *enfant terrible* who made no clearly articulated link between artis-
tic defiance and social critique' in these years, despite the oppositional character of
the *école des Batignolles*.[13] By 1866, however, Monet's own painting had already be-
gun to provoke the caricaturists, while finding its most serious support among lib-
eral, republican-leaning critics, such as Théophile Thoré, Jules Castagnary, Félix
Féneon and Emile Zola. The texts in which Zola welcomed Monet's submissions to
the Salon were important for many reasons, not least in his use of terms that would
soon be turned against the artist at the Impressionist exhibitions. His *Camille*, or
Woman in a Green Dress (Kunsthalle, Bremen), for example, was praised by Zola for
its 'energy and truth', while pictures shown two years later revealed that Monet was
a painter 'not content with ridiculous *trompe l'oeil*'. Summarizing Monet's moder-
nity, Zola wrote in 1868 of *Women in the Garden* (Musée d'Orsay, Paris) that 'an unu-
sual love for one's own times is required to risk such a tour de force'.[14]

Such scattered details would surely have confirmed the initial assumptions of
Cham and his journalist peers about a young artist like Monet. Here was evidence of

brazen contemporaneity and technical ineptitude, in paintings in which even an ardent admirer like Zola could find a 'wilful harshness'. [15] Writing of his marine compositions at the 1868 Salon, Zola stressed their 'frankness' and evoked with approval the water 'besmeared with patches of oil' that 'shakes off its grimy foam'.[16] Equally applicable to a work such as *A Seascape, Shipping by Moonlight* (see plate 26), these were the confrontational qualities that would soon cause the demise of 'Monsieur Vincent' and generally define Monet's stance as a disruptive outsider. Here, too, were signs of revolt and a preference for a bohemian life, led by a penniless artist who mixed in irregular society. Though his critics may not have known this, Monet was currently surviving on charitable handouts and co-habiting sporadically with his young mistress, Camille Doncieux, who gave birth to their first child out of wedlock in 1867. A quite different aspect of Monet's early radicalism, however, can be linked to these same circumstances and to the sequence of harbour views that were currently attracting praise. Around 1870, the artist gave pictures from this group to two of his friends, who acted as witnesses – along with Courbet himself – at Monet's civil wedding to Camille. The recipients were a medical doctor, Paul Dubois, and a journalist, Antonin Lafont, both belonging to the political circle of Clemenceau and described by Philip Nord as being 'well-known trouble-makers'.[17] Even more telling in Monet's choice of supporters at his wedding ceremony is the rather pointed fact that both Dubois and Lafont were 'militant atheists'.

Monet's association with atheism at this formative moment is one of many indications from his long career suggesting that he, too, was a committed non-believer and remained so until his death in 1926: his continued preference in mid-life and into old age for the company of free-thinking friends; the long years of resistance to marriage with his second wife, the strongly religious Alice Hoschedé; the complete absence of pious reflection in his numerous letters, some of which are distinctly personal and deal with tragic family events; a similar lack of sacred or devotional subject matter throughout Monet's large oeuvre; his identification as soulless or pagan by various critics during his lifetime; his cultivation at Giverny of a circle of 'liberal atheists';[18] and, perhaps most eloquent and courageous of all, the elderly Monet's instructions that he should be buried outside the rituals of the Christian church.[19] He seems to have left behind no definition of his unbelief and it is unclear whether Monet considered himself an atheist, an agnostic or simply unreligious in some imprecise way. Ill-defined though it is, this fundamental aspect of his character has typically been omitted from studies of Monet's life and art, and its implications for his painting have never been considered in detail. So profound a disjunction from the dominant values of his age, however, and so pervasive an influence on his approach to the physical world – the basis of his work as a painter – should surely be difficult to ignore. Support for this view comes from an analysis of Monet's paintings and from the thoughtful commentary of supporters who sensed their radical implications. In turn, these insights can be deepened through consideration of such factors as popular science, scientific illustration and a new understanding of the material universe in Monet's increasingly secular age.

Monet's irreligion also takes on new meaning from the discovery that his attitudes were widely shared by members of the Impressionist group, presumably adding to their intellectual cohesiveness and determining many common values. As with Monet, this theme has been little pursued among his colleagues, but the broad picture is nevertheless clear: the lives of the prominent Impressionist artists appear to have been largely untouched by religion in the years of their collective activity and – in the majority of instances – to the end of their careers. In the often intimate correspondence of Berthe Morisot, for example, we find no references to church attendance, personal piety, confession, prayer or spiritual events, even in times of crisis. When she faced her own tragically premature death in 1895, for example, Morisot left behind a deeply touching note for her daughter Julie, but it neither commended the child to God nor spoke of meeting her in the hereafter.[20] Degas's case is similar. As a young man he announced, 'I am not religious', and his subsequent notebooks and letters make no mention of observance or belief.[21] He was briefly moved when calling at the shrine of Lourdes on one of his journeys, but he was there in the role of tourist, not as a participant.[22] More equivocal in later life, Degas nevertheless castigated James Tissot when he started to paint Bible scenes, protesting to Ludovic Halévy's son, 'Now he's got religion! … I shall do a caricature of Tissot … with Christ behind him, whipping him, and call it "Christ Driving His Merchant from the Temple".'[23] The staunchly radical Mary Cassatt, who 'read and thought deeply about art, literature and politics and the state of modern civilisation', had a brief interest in spiritualism in old age, but otherwise left no evident trace of religious conviction.[24] If some members of this band, such as Alfred Sisley, seem to have shared Cassatt's neutrality toward institutional religion, others were actively hostile. In his occasional writings, Renoir was scathing about the contemporary church: 'I don't call Christianity a religion, because in your prayers you're always trying to strike a bargain.'[25] In 1876, Paul Cézanne spoke of subscribing to an anti-clerical newspaper, while his mentor, Camille Pissarro, a lapsed Jew who became an anarchist, often longed for a time 'free of all religious, mystical and unclear conceptions'.[26]

This complex story deserves much closer scrutiny, but its virtual absence from the vast literature concerned with Impressionist art remains a salutary fact. Explanations for this oversight might include the relative scarcity of confessional documents and specifically revealing memoirs by the artists in question, and the dominantly formalist or biographical character of much Impressionist scholarship. At the very least, however, we should note that such a pattern of neglect has been consistent with the sanitised view of the movement that is widely preferred in our own times. Today, there are overwhelming reasons to rethink the Impressionist achievement within the historic decline of religious adherence throughout Europe, inevitably moulding the world of these painters and influencing attitudes and institutions, language and visual forms in sweeping and intricate ways. In his recent study of the nineteenth century, the social historian Roger Magraw states bluntly of this period that 'Religion was the most divisive issue in French society', a claim endorsed by research in many related fields.[27] As Magraw and others have pointed out, the divide between Church

and State, clergy and laity, the faithful and the faithless, was a subtle and ever-shift-ing one. In the years preceding the Impressionist exhibitions, it was dramatically widened by publications such as Darwin's *The Origin of Species*, translated into French in 1862, and a work by another of Ludovic Halévy's acquaintances, Ernest Renan's *La Vie de Jésus* of 1863. It was also inflected by the creation of secular systems of knowledge and belief, such as Positivism and the so-called 'Religion of Human-ity', and was frequently re-directed by phases of revivalism, as in the Catholic resur-gence of the 1890s.

This deep-seated upheaval in traditional faith had a number of consequences for French artists, the most immediately visible being a slow retreat from religious sub-ject matter, which had begun to reassert itself at the Salon in the post-revolutionary period.[28] By the time the Impressionist generation reached maturity, the battle for a dominant, secular iconography had effectively been won by their predecessors, led by such figures as Gustave Courbet and Edouard Manet. The latter's *Jesus Mocked by the Soldiers* (Art Institute of Chicago), shown at the Salon of 1865, was the last of his con-troversial excursions into biblical themes and one of many signals to his admirers that the future lay elsewhere. In their younger days, Morisot, Degas and Cézanne made solemn copies from the Christian canon or briefly experimented with mod-ern variants on sacred themes. When they came together at the first Impressionist ex-hibition, however, it was clear that this option had effectively been abandoned. Of the 165 both famous and obscure pictures listed in the 1874 catalogue, only a tiny hand-ful could conceivably have been religious scenes and all of these were by the group's lesser known adherents.[29] Not only were biblical narratives absent, but also the pic-torial repertoire of nuns and monks, christenings and funerals, visions and acts of charity, that had a dwindling appeal at the Salon throughout these years. For Monet and his friends, even ecclesiastical buildings had become suspect: among the numer-ous landscapes on show in 1874, there was scarcely a single representation of a church.[30]

Richard Brettell has written perceptively about the actively atheistical Pissarro's approach to the image of the church in his paintings of Pontoise, arguing that the artist's 'own religion, or lack thereof, profoundly altered his perception of the Pontoise landscape. His view of the city was secular and sceptical.'[31] When churches appear in Pissarro's pictures at this period, Brettell notes that they 'are literally over-whelmed by their environment. They are pushed into corners, reduced in size, screened by layers of trees. As if in opposition to the traditional images, their forms are encroached upon and, to a large extent, designified by their context.'[32] Monet's relationship with this subject is even more extreme. He effectively avoided the church as a motif in his early years and it was not until his move to Vétheuil in 1878 that he chose to face the issues that Pissarro had already confronted. In the approximately 500 canvases produced by Monet before this date, there are just three works that fea-ture a church in any significant way, a minute percentage for such a versatile and am-bitious French landscape painter.[33] What he did depict in great numbers, of course, were the secular structures in the environments he visited during this time, from

bridges and railway stations in Paris to the parliamentary buildings of London and the canals and towers of Amsterdam. On the three occasions that he tackled a church the effect could be damning. In his *Street in Sainte-Adresse* of around 1868–70 (plate 21), the ecclesiastical monument is swamped by its banal civic setting, overshadowed by a massive, dull tree, and stripped of any trace of grandeur. Like Pissarro, Monet has boxed the church in, and transformed its meaning, just as he has separated it from the compositional modes of the past. In a work such as Corot's celebrated *Chartres Cathedral* (Musée du Louvre, Paris), the great Gothic building is set apart and rendered awe-inspiring, with a pronounced verticality that – in the approved manner – carries our eyes heavenward. Monet's *Street in Sainte-Adresse*, by contrast, insists that we look down on an unbeautiful village church that is plunged in shadow. Adding insult to injury, the backstreets of Sainte-Adresse were described by one contemporary as 'noisy' and 'dirty', and the edifice itself was so decrepit that it was demolished within a decade.[34] Here Monet shows us religion in decline.

For the first visitors to the pioneering exhibitions of Monet and his fellow non-believers, the absence of piety, as well as the dominance of worldly motifs and attitudes, were clearly apparent. Indeed, the number of specifically religious phrases and associations among the critics' remarks is yet another strikingly overlooked aspect of the group's early reception. Adopting a wry tone at the 1874 show, Philippe Burty wrote of the event that, 'from the governmental point of view, it is heretical, worthy of the dungeon, torture and the stake'.[35] Less humorously, Pierre Véron invoked the threat of the new secular organisations in France, suggesting that the Impressionist painters were a 'small sect' that aimed to build 'private temples' in opposition to the Salon, 'heretics of the brush' who were 'following the wrong way'.[36] Variants of these statements appeared frequently at subsequent exhibitions and a bizarre, quasi-biblical rhetoric soon achieved its own momentum. The Impressionists' gatherings of 'less than a dozen of the faithful' were repeatedly compared to the 'Last Supper', while various individuals became 'apostles' who issued 'prophecies', with Pissarro as their 'High Priest' and Degas one of several aspirants for 'Pope'.[37] Directly attacking the breakaway group, one writer went so far as to claim that they were founding 'a new religion' that was 'more or less heretical, separated from the great Church of Art'.[38] A more sympathetic voice noted parallels between the modernity of the Impressionists and the secularising approach of Renan himself, and a colleague imagined new, topical pictures that would show 'the Virgin travelling in a sleeping car' or a Calvary in which Christ had been shot, rather than crucified.[39] Conceivably aware of Pissarro's views, a supercilious critic suggested that he 'has never had the good fortune to contemplate the great spectacle of nature, which God offers to man, to delight his vision and enchant his soul'.[40]

Complicit in most of these outrages, Monet was listed among his 'co-religionists' in 1877 and seen by one critic to have 'definitively become the pontiff', adding that 'this young master (the word is admitted in the sect) appears to have burned his own Gods here and there'.[41] One of the strangest and most aggressive reviews that year was by Gonzague Privat, who almost lost himself in metaphors from the worlds of

evolution, religion and nationalism, and invoked martyrdom, rebellion, war and the names of Christ and Judas, before evoking the moment of creation, the 'sublime chaos from which God disdainfully plucked the earth'. Mentioning in his text most of the principal contributors, Privat seemed unwilling to spell out Monet's name, writing instead, 'in this chaos we placed railway stations, to show that human fantasy has no limits, trains that blow rocks from their chimneys … The impressionist school was born'. [42] Paradoxically, this almost surreal passage assigns the role of divine Creator to the unspeakable Monet, the master of chaos who makes art from the void and gives birth to an entirely new order. Meant dismissively in 1877, almost the same image would be used of Monet several decades later by one of his most perceptive and loyal supporters.

Looking back over the artist's long career, Georges Clemenceau compiled a series of reminiscences that recalled their shared friendship with the 'militant atheists' Dubois and Lafont in the early Paris years. [43] Attempting a characterisation of Monet's mature achievement, Clemenceau imagined the 'divine monster' that drove him to paint and the 'divine light' that became his subject, and explicitly claimed that Monet 'following the Creator, made something out of nothing'. [44] Within his effusive prose, Clemenceau was remarkably acute about the larger issues that Monet and his peers inherited, including the 'incredible poverty' of religious subject matter. [45] Trained as a doctor, Clemenceau wrote subtly and at length about the originality of Monet's visual project and argued that 'science and art … had a common point of departure, an intense culture of sensory response'. [46] He also drew freely on wider concepts, proposing that Monet's series paintings represented 'an evolution that confirmed a new way of seeing, of feeling, of expressing: a revolution'. [47] The progression from the art of 'the stone age … to the Cathedral of Monet', according to Clemenceau, 'allows us to appreciate in summary the phases of vision through which our race has passed.' [48]

Such links between atheism, contemporary thought and progressive art were self-evident to Clemenceau, one of the principal confidants of Monet's last years. Two further paintings allow us to touch on his later Impressionism in this shared 'mental landscape'. The first is *Cliffs at Etretat* of 1885 (plate 22), an exquisite product of Monet's long-standing fascination with the rocky promontories of this small Normandy resort. Already immortalised by Delacroix, Courbet and a host of minor artists, the spectacular arches of Etretat seemed richly symbolic to the Romantic generation, one of whom echoed a more general sentiment when he wrote 'this is the temple of God, built by God himself'. [49] Robert Herbert has pointed out that, by 1861, a more pragmatic interpretation of the same landscape was also available, citing Michelet's attention to the patterns in the cliff face formed by superimposed strata, where 'the accumulated centuries freely open the book of time'. [50] At almost exactly this date, Michelet's rational approach to such questions was given a historic boost by Darwin's *The Origin of Species*, where the detailed studies of sedimentation by Sir Charles Lyell were among a number of insights from modern geology offered in support of the great antiquity of the earth. [51] Seen by many of his contemporaries as an

incitement to atheism, Darwin's book argued for the slow modification of animal and vegetable life through natural selection, in contrast to the biblical view of creation. Darwin's writings caused an intense debate in the specialist and popular press in France, as a further drawing by Cham illustrates (fig.14). They were also known to some of the Impressionists, including Morisot, Degas and Cézanne, though there is no direct proof that Monet read them.

What we can argue from *Cliffs at Etretat* and many related canvases, however, is that – like Pissarro at Pontoise – Monet's non-religious views and perhaps a layman's awareness of scientific matters had 'profoundly altered his perception' of the French countryside. This possibility received endorsement from an unlikely quarter a year after the painting was completed, when a group of his landscapes was shown in New York and discussed by the previously unknown, pseudonymous critic, Celen Sabbrin. Welcoming Monet as a 'philosopher', Sabbrin saw his materialist vision in the bleakest terms, noting of one painting that it was 'an expression of hopelessness, of the unattainableness of absolute truth, and a confirmation of science's teachings … the end of the struggle of the human race; all work and thought have been of no avail: the fight is over and inorganic forces proclaim their victory.'[52] In the development of Monet's Etretat scenes, a less apocalyptic but still strongly empirical view of nature can gradually be discerned. Where his youthful compositions showed a storm-lashed, sunset-gilded or simply picturesque location, the Porte d'Aval and adjacent 'Needle' in the Clark Art Institute picture seem almost matter-of-fact in their brightly lit isolation. Carefully defining the stratifications of the cliff that spelled out its great age, a feature largely overlooked by his predecessors, Monet also emphasized the crumbling margins of the rock that revealed the slow ravages of time. Deserted except for tiny sails in the distance, this could almost be a scene from 'the stone age' envisaged by Clemenceau, long before 'the Cathedral of Monet' had been conceived.

Any discussion of Monet's private beliefs and their impact on his art must eventually come to terms with the Rouen Cathedral series, a haunting cluster of thirty

Grâce à M. Darwin, la recherche de la paternité n'est plus interdite.

Fig.14 · Cartoon by Cham, in *Le Charivari*, Spring 1877; reproduced in Ludovic Halévy, *Douze années comiques par Cham, 1868–1879*, Paris 1880, p.331

canvases that were begun in 1892 and partially exhibited in 1895 (plate 23). The artist himself gave no reasons for this choice of motif and in his letters from Rouen spoke only of an infatuation with the light and frustrated attempts to 'convey what I feel'.[53] Other factors have been proposed, from Monet's personal links with the city and its convenient access from Giverny, to the importance of the cathedral as a Gothic structure and its resonance as a national symbol. Paul Tucker's detailed, persuasive account of this context also reminds us that Monet's pictures were made at a time of vigorously revived concern for the Catholic faith and self-consciousness about its monuments.[54] The commitment made by Monet to painting this major ecclesiastical building in the early 1890s is thus doubly challenging, even provocative. Less clear is the nature of his interpretation on canvas of the extraordinary structure itself. While acknowledging its multiple significances, Tucker argues that Monet's handling of the subject tended 'to suggest its humbler, organic qualities', resulting in a painted façade that 'appears to be moving' and portals that 'are flexing according to their own wills'.[55] This success in transforming the cathedral from an inert object into a vital pictorial entity became a persistent theme among Monet's admirers: 'Isn't it curious, a man taking such materials and making such a magnificent use of it?' asked the American painter Theodore Butler; while others commented on the way the masonry now resembled an ancient cliff or a 'phantasmagoria of light'.[56] After seeing the series at the Durand-Ruel gallery, Clemenceau exclaimed: 'The marvel that is Monet's sensation is to see the stone vibrate and to give it to us, vibrating, bathed in luminous waves that collide in splashing sparks.'[57]

Given Monet's personal history, we might be led to assume that his activity in Rouen was an essentially visual one. But when he 'animated the Cathedral', in Tucker's words, Monet chose to go beyond its massive, factual solidity and perhaps even further in disregarding the historic building's meaning.[58] His lack of concern for its religious importance is apparent in other ways: we learn from a letter of March 1893, that Monet did not set foot in the cathedral itself until he had been in Rouen for several months, and then it was specifically to hear a performance of music.[59] Disrespectfully exclaiming as he worked, 'dear God, this cursed Cathedral is hard to do!', Monet's acts of painting suppressed certain elements of the fabric, purposefully or otherwise, including those that had articulated its message to the faithful over the centuries. His impastoed, rainbow-hued brushwork, for example, made 'the gargoyles and statuary seem more arbitrary' and swallowed up such features as the huge carved reliefs above the doors, dense with Christian iconography.[60] These and other implications in the Rouen canvases were quickly apparent to both supporters and opponents. In Clemenceau's essay on the front page of the newspaper *La Justice*, he eulogized the recently opened exhibition. 'Skilfully chosen, the twenty states of light, the twenty paintings are ordered, classified, completed in an achieved evolution', he explained. He continued: 'Looking closely at Monet's Cathedrals, they seem to be made of I-don't-know-what multi-coloured masonry, crushed on the canvas in an attack of fury. All this savage impulse is no doubt made of passion, but of science as well.'[61] Clearly transported and somewhat echoing Sabbrin, Clemenceau combined

an awareness of Monet's modernity with something close to universal pantheism: 'Light explodes, it invades the being, it imposes itself as conqueror, it dominates the world.'[62] Among the doubtful and the frank were those who noted Monet's concern with the 'decay' of the structure and his determination to see it 'as a fragment of nature, according to reality, not according to religion … From his canvases, life spills out, stripped of every symbol, of every kind of artifice or lie.'[63] As one writer put it more simply, 'Gothic art, the cerebral art par excellence' had been used as a motif by an artist who was 'pagan'.[64]

If Monet effaced some elements of Rouen Cathedral and was indifferent, even dismissive, towards many of its traditional roles, he also claimed the motif for a new kind of painting that was radical, ecstatic and dense with promise for a more secular time. Developing as an artist within Impressionism, he shared with his largely non-believing colleagues an exceptional experiment in modern creativity, caught between the collapse of earlier religious conventions and a resurgence of piety in *fin-de-siècle* Symbolism. The godlessness of the Impressionist interlude has been conveniently forgotten in our own day, as has much of the abrasive, intellectually informed character of these artists' views of the physical world. When the critic Charles Bigot 'looked in vain for a thought and a soul' in Monet's pictures of the Gare Saint-Lazare, he too missed the multitude of real qualities that these pictures had to offer and which still wait to be fully articulated today.[65] Living in a post-Darwinian world, Monet painted 'the poetry of railway stations', in Zola's phrase, and what Clemenceau called the 'the perceptible vibrations of light' and the 'fury of live atoms', all understood from within the 'culture of sensory response' that defines the epoch.[66] These claims are grand and complex, but by removing them from our presentation and our understanding of Monet's art – in favour of fashion accessories and childish games – we do him, and ourselves, a disservice.

NOTES AND REFERENCES

Monet, Atheism and the 'Antagonistic Forces' of his Age
RICHARD KENDALL

1. This issue was first raised in a short paper delivered at the Clark Art Institute in 2001. It was subsequently developed in the 2003 George Heard Hamilton Lecture at the Clark Art Institute and, with much of the material that follows, will form part of a forthcoming book, *Painting without God: Impressionism in the Age of Darwin*, Yale University Press.

2. *New York Times*, March 30, 2005.

3. Berson 1996, vol., I, p.40 (Silvestre), p.29 (Montifaud).

4. The three works by Cham discussed in this paper are reproduced in Ludovic Halévy, *Douze années comiques par Cham, 1868–1879*, Paris 1880, pp.287 and 331.

5. Berson 1996, p.18 (Chesneau), p.40 (Silvestre). The version of this painting, now in the Pushkin Museum, Moscow (w.292); may have been exhibited.

6. Ibid., pp.196–7.

7. Halévy's familiarity with Cham is evident, among other places, in his introduction to the 1880 compilation of the cartoonist's drawings; see Halévy 1880, pp.5–16.

8. Berson 1996, p.25 (Leroy).

9. Ibid., pp.160–1 (Leroy).

10. Ibid., p.67 (Chaumelin), p.91 (Maillard) and p.139 (Chevalier).

11. Wildenstein v, no. D.511.

12. See Clemenceau 1928, pp.73–4.

13. House 2004, p.42.

14. Emile Zola cited in Stuckey 1985, pp.34 and 39.

15. Stuckey 1985, p.39.

16. Ibid., pp.38–9.

17. Nord 2000, p.30. The paintings in question were numbers 88 and 118 in Wildenstein, vol. II.

18. Nord 2000, p.95.

19. For a description of Monet's funeral, see Jacques-Emile Blanche, 'Claude Monet', *Revue de Paris*, vol.I, 1927, p.562.

20. Kathleen Adler and Tamar Garb (eds.), *The Correspondence of Berthe Morisot*, London 1986, p.212.

21. Theodore Reff, *The Notebooks of Edgar Degas*, New York 1976, notebook 11, p.75.

22. Marcel Guérin (ed.), *Degas Letters*, Oxford 1947, p.148.

23. Daniel Halévy, *Degas Parle*, Paris 1960, p.117.

24. Nancy Mowll Mathews, *Mary Cassatt: A Life*, New York 1994, p.70.

25. Robert L. Herbert, *Nature's Workshop: Renoir's Writings on the Decorative Arts*, New Haven and London 2000, p.134.

26. John Rewald (ed.), *Paul Cézanne: Letters*, London 1941, p.104; John Rewald (ed.), *Camille Pissarro: Letters to his Son Lucien*, London 1943, p.163.

27. Roger Magraw, *France 1800–1914: A Social History*, London 2002, p.159.

28. Bruno Foucart, *Le renouveau de la peinture religieuse en France (1800–1860)*, Paris 1987, p.77.

29. Several of these works remain unidentified or somewhat unclear in their subjects, but candidates for this category include Zachary Astruc's *Le Bouquet à la Pénitente* (no.1); Edouard Brandon's *Première Lecture de la Loi* (no.29) and *Exposition du corps de Sainte-Brigitte à Rome* (no.32).

30. See note 29. Exceptions may have been Pierre-Isidore Bureau's *Le Clocher de Jouy-le-Comte* (no.33) and Léon-Auguste Ottin's *Après le messe à la campagne* (no.129), both of unknown location.

31. Richard R. Brettell, *Pissarro and Pontoise*, London 1990, p.50.

32. Brettell 1990, p.46.

33. The paintings are nos.35, 84 and 98, in Wildenstein II.

34. Joanne Adolphe, *Itinéraire générale de la France: Normandie*, Paris 1866, p.105.

35. Berson 1996, p.10 (Burty).

36. Ibid., p.42 (Véron).

37. Ibid., p.60 (Bigot); p.90 (*La Liberté*); p.87 ('A. de L.'); p.139 (Chevalier); p.60 (Bigot); and p.54 (Baignères).

38. Ibid., p.123 (Argus).

39. Ibid., p.73 (Duranty); p.158 (Jacques).

40. Ibid., p.82 (Enault).

41. Ibid., p.163 (de Lora); p.142 ('C. D.').

42. The critic's surname was Gonzague-Privat, but he signed himself Gonzague Privat; see Berson 1996, pp.149–50.

43. Clemenceau 1928, p.74.

44. Ibid., pp.21, 105 and 140.

45. Ibid., p.43.

46. Ibid., p.44.

47. Ibid., p.110.

48. Ibid., p.107.

49. Herbert 1994, p.64.

50. Herbert 1994, p.143, n.25.

51. For example, see Charles Darwin, *The Origin of Species*, London 1859, chapter x.

52. Cited in Michael Leja, *Looking Askance: Skepticism and American Art form Eakins to Duchamp*, Berkeley 2004, pp.99 and 102–3.

53. Letter 1201 in Wildenstein III.

54. These issues are discussed in Tucker 1989, chapter VI.

55. Ibid., pp.157 and 188.

56. Cited in ibid., p.192.

57. Stuckey 1985, p.179.

58. Tucker 1989, p.188.

59. See letter 1196 in Wildenstein, vol. III.

60. Tucker 1989, p.188.

61. Cited in Stuckey 1985, p.179.

62. Cited in ibid., p.176.

63. Robinson and Bazalgette, cited in Tucker 1989, pp.192 and 199 respectively.

64. Mauclair, cited in ibid., p.192.

65. Berson 1996, p.134.

66. Ibid., p.191; Clemenceau, cited in Stuckey 1985, pp.178–9.

7 Making Money out of Monet: Marketing Monet in Britain 1870–1905

FRANCES FOWLE

The French dealer Paul Durand-Ruel began exhibiting Monet's work in England in 1871, and yet by 1900 he had failed to make any real impact on the British market. In the late 1880s and 1890s, when Monet's pictures were commanding high prices in Paris, Berlin, Boston and New York, the response in London and Glasgow was still decidedly lukewarm. This, despite the fact that these two cities were among the most important economic centres in the world and had recently spawned an entire generation of entrepreneurial collectors who had built up vast collections of specifically French nineteenth-century art. Why, therefore, did dealers such as Durand-Ruel and his contemporaries have so much trouble in establishing a market for Monet and Impressionist art in Britain?

In this essay I shall investigate this question, specifically in relation to Monet, and from two angles: first, by examining the strategies adopted by dealers attempting to sell Monet's work in Britain in the late nineteenth century; and second, by analysing the types of pictures which were being bought and the nature of the collections they were entering.

DURAND-RUEL: THE FIRST CAMPAIGN (1870–1875)

It was really by chance, rather than by design, that Durand-Ruel began marketing the work of the Impressionists in England. In 1870, forced to flee Paris at the outbreak of the Franco-Prussian war, he took refuge in London, along with, among others, François Bonvin, Gustave Ricard, Camille Pissarro and Claude Monet. He chose London because he had certain contacts there, most importantly Alphonse Legros, who had been living in the capital since 1863 and who introduced the dealer to a group of British *amateurs*, including James Staats Forbes, Constantine Ionides and Louis Huth.[1] Another important contact was the French baritone and collector Jean-Baptiste Faure whose London house was next door to Durand-Ruel's in Brompton Crescent. Durand-Ruel shipped his stock of nineteenth-century French pictures across the channel on 8 September 1870,[2] with the aid of the London dealers Wallis & Son, who specialised in French paintings. The pictures he brought with him included almost exclusively works by the *Ecole de 1830* and it must be stressed that during these early years it was the work of these artists that he sought to promote, rather than that of Monet and his contemporaries.

In London Durand-Ruel met Monet for the first time through the artist Charles-François Daubigny, who had also taken refuge in the capital.[3] (Durand-Ruel had admired Monet's work at the Salon but they had never been introduced.) According to the dealer's memoirs he immediately bought a selection of Monet's recent London paintings, for which he paid 300 francs apiece.[4] During these early years Durand-Ruel did not attempt to market Monet and the Impressionists either individually or as a group, but included one or two examples of their work in mixed exhibitions of French nineteenth-century art. Between 1870 and 1875 he organised eleven exhibitions of what he called the 'Society of French Artists' at the rather inappropriately named German gallery at 168 New Bond Street. These early exhibitions included not only a few works by Monet and Pissarro – whom he also met in London – but paintings by Manet, Degas, Renoir and Sisley, which he showed alongside works by Corot, Millet, Dupré, Diaz, Daubigny, Courbet and others.[5]

From the point of view of marketing the *Ecole de 1830*, the exhibitions were entirely successful and Durand-Ruel attracted collectors from London and further afield. Among them was James Duncan of Benmore, who built up one of the earliest collections of Barbizon pictures in Scotland. The Impressionists, on the other hand, fared less well, and the dealer recalled that the works of Monet, Renoir, Sisley and Pissarro 'went almost unnoticed by almost all the visitors to our galleries … In London we sold very few and when I wasn't there to support their cause, the rare collector that risked purchasing a few pictures resold them one after the other.'[6]

The first painting by Monet to be shown at Durand-Ruel's gallery was *Entrance to Trouville Harbour* (Szépmüvészeti Múseum, Budapest), a Boudinesque seascape, which was exhibited at the second hanging of the first exhibition of the Society of French Artists in 1870.[7] This kind of subject would have blended easily with the rest of the nineteenth-century pictures on display and Durand-Ruel might have had more success with Monet's pictures had he exhibited more of this genre and taken into consideration from the outset the relative conservatism of the British amateurs.

His strategy throughout this early period was to show pairs of pictures by Monet, initially exhibiting a French subject alongside an example of the artist's most recent London pictures, which he might reasonably have expected to appeal to his British clients. In common with many dealers, he deliberately hung slightly inferior or perhaps more conventional pictures close to better or more challenging images in order that the one might enhance the other.[8]

At the fifth (winter) exhibition of 1872, for example, he included the sketchy and recently executed *Green Park* (Philadelphia Museum of Art) as a contrast to the earlier, larger and more 'finished' *Saint Germain l'Auxerrois* of 1866 (Nationalgalerie, Staatliche Museen zu Berlin),[9] presumably to enhance the latter. He was also deliberately juxtaposing a London subject with a French one. The following year he tried a different tactic, introducing the British public to a selection of extremely challenging industrial landscapes from Monet's recent campaigns in Rouen and Argenteuil. These included *The Robec Stream* (Musée d'Orsay, Paris) exhibited at the seventh exhibition in the summer of 1873 (206), depicting the factories at Déville, to the east

of Rouen. The following year he showed *The Goods Train* (private collection, Japan), catalogued as 'The Railway', and offering a rather different view of the industrial landscape of Déville.

It must be born in mind that Durand-Ruel was not obliged to show such difficult and problematical images. He had ready access to Monet's latest work and at Nadar's studio that spring Monet had shown far more obviously marketable images such as *Poppies at Argenteuil* (Musée d'Orsay, Paris). Perhaps Monet was anxious to keep his apparently less challenging pictures for a French audience, since we know he later objected to Durand-Ruel shipping his work to the United States before it had been seen in Paris. Perhaps, too, Durand-Ruel believed that these darker-toned images of industrial modernity would appeal to the new class of mercantile buyer emerging in Britain at that time. Whatever his aim, the British public was far from receptive. Indeed, a reviewer for *The Times* detected a 'spirit of anarchy at work' in the landscapes of Monet, 'Pissaro' [*sic*] and 'Sisbey' [*sic*]. But he criticised them not so much for their subject matter as for their lack of 'completeness and thoroughness of workmanship'.[10] In the end both the Rouen pictures remained in stock until 1877 when they were acquired by Monet's stalwart supporters in Paris, Ernest Hoschedé and Théodore Duret.

In 1875 Durand-Ruel held a further exhibition of French nineteenth-century painting in which only four Impressionist works were included: paintings by Degas, Sisley, and Pissarro, but none by Monet. A critic for the *Art Journal* was struck by the large number of landscapes in the exhibition and above all by their unity of style and subject: 'The pictures grouped together on the walls have a certain *collective harmony*, and we feel in their presence that the painters have something of a *common system and purpose*.'[11]

This concept of 'collective harmony' was of fundamental importance to the reception of nineteenth-century French painting in Britain. It is the kind of feeling one gets from walking into an exhibition or private house where all the pictures appear to talk to one another, and I believe it was also at the basis of the reluctance of British collectors to invest in the work of Monet. As Anna Robins's essay demonstrates, Monet's work was constantly criticised during the 1880s and 1890s for its 'difference' – difference in technique and difference in colour – from the work of the previous generation. Some critics, writing in support of Monet, attempted to explain his technique in terms of the English landscape tradition. His use of colour, some said, derived from a careful and sustained observation of Turner,[12] and his 'neglect of individual form' was inherited from Constable.[13] Nevertheless, British collectors expected to see detail in their pictures, not landscapes where, as the critic for the *Art Journal* put it, 'all minute things are slurred over quickly' and 'the different parts of the landscape are reduced into a single effect'.[14]

It is therefore not surprising that, initially, the most popular Impressionist artist with British collectors was Degas, whose concern with form and line was more developed than that of his contemporaries. Monet had less immediate appeal, and, as far as we can tell, only one of his paintings was sold as a result of Durand-Ruel's

initial London campaign. The buyer was Henry Hill (1812–1882), whose collection at 53 Marine Parade, Brighton, was discussed in three separate articles published in the *Magazine of Art* in 1882. Hill was one of the earliest and most important British collectors of nineteenth-century French art, and his collection included works by Bonvin, Vollon and Degas. Most of his purchases were made in the 1870s, and by 1876, when he was sixty-four, he owned seven works by Degas, six of which were acquired from Durand-Ruel. The other was the notorious *L'Absinthe* (Musée d'Orsay, Paris) which he probably bought directly from the artist.[15]

However, despite his extremely advanced tastes in French art, Hill acquired only one work by Monet, which remained in the collection until his death in 1882. It was described by a contemporary observer as 'a charming garden-orchard scene … full of blossoms and spring feeling' with 'a pretty, delicate distance, poplars and a tender sky'.[16] Although not included in the catalogue raisonné, it is possible from this brief description to identify Hill's painting as *Apple Trees in Blossom* of 1872 (fig.15), painted at Argenteuil and exhibited at the second Impressionist exhibition at Durand-Ruel's gallery in 1876.[17] As a regular client of Durand-Ruel's, Hill presumably continued to patronize his Paris gallery even after the London branch had closed and he must have acquired this picture some time in the late 1870s.

DURAND-RUEL: THE SECOND CAMPAIGN (1882–1884)

Durand-Ruel closed his London gallery in 1875 and Monet's work was not shown again in Britain until 1882. This second British campaign was initiated by Durand-Ruel with a small exhibition of French art at 13 King Street. By this date the market for Impressionism in France was still far from buoyant and Durand-Ruel was trying to find new outlets for the Impressionists' work. The previous year he had made an informal agreement with Monet whereby the artist would sell all his pictures through

Fig. 15 Claude Monet, *Apple Trees in Blossom*
Union League of Chicago

the dealer in return for regular financial support. In April 1882 Monet brought him twenty-three pictures, three of which he showed in London alongside the outstandingly beautiful *Banks of the Seine at Argenteuil* (Courtauld Institute, London). In comparison to the pictures that Durand-Ruel had shown in London in the early 1870s these later works were, to our eyes, extremely marketable examples of Monet's work. They included, for example, *Low Tide at Varengeville* (Thyssen Bornemisza Collection, Madrid) and *The Douanier's Hut* (Museum of Fine Arts, Boston). Durand-Ruel continued his practice of showing Monet's works in pairs but, thanks to the artist's latest working methods, was able to refine his strategy by showing repeated images side by side, such as two versions of *The Douanier's Hut*. Richard Thomson has commented that Georges Petit and Theo van Gogh also employed what he describes as 'the replica tactic', a particularly appropriate strategy for a company such as Goupil, who were so used to marketing art through reproductions.[18]

In January 1883 the first important English article devoted entirely to the Impressionists appeared in the *Fortnightly Review*. It was written by the artist Frederick Wedmore, who named Degas, Renoir and Monet as 'the really powerful men of the new movement'.[19] However, the critics continued to be drawn to Degas's figurative works as opposed to Monet's sketch-like landscapes, vivid palette and unorthodox use of colour. Furthermore, there was still a tremendous ignorance of the main protagonists of Impressionism and some critics even failed to differentiate between Monet and Manet because of the similarity of their names.

In 1883 Durand-Ruel widened his net, exhibiting Impressionist pictures not only in London, but in Berlin and Boston. He had just held a solo show of Monet's work in Paris and as soon as the exhibition closed he made for London, where he mounted a large exhibition at Dowdeswell's Galleries at 133 New Bond Street.[20] He included six works by Monet, most, if not all, of which had been included in the one-man show. The majority were recent landscapes painted at Pourville, including *On the Cliff at Pourville* (see plate 11), which was paired with *Edge of the Cliffs at Pourville* (private collection, Switzerland).[21] Durand-Ruel was wary of both the press and the public reaction and the catalogue warned that the exhibition was aimed, not at the general public, but at the 'English connoisseur'.

The following year he showed five more Monets at the Dudley Gallery in Piccadilly. This time he included examples of Monet's recent work at Etretat, as well as two works that had been exhibited on previous occasions: *Low Tide at Varengeville* from the 1882 exhibition and the Courtauld's *Banks of the Seine*. This may have been a deliberate strategy to show familiar images alongside new ones, or it may simply have been an attempt to shift works that had been in stock for some time. Whatever the motive, once again no sales of Monet's work resulted from this or indeed from any of these exhibitions of the early 1880s. Thereafter, Durand-Ruel seems to have lost interest in promoting his work (and indeed that of the Impressionists in general) in Britain. Instead, lured by the promise of richer pickings on the other side of the Atlantic, he travelled in 1886 to New York, where he quickly realised the potential for marketing Impressionism in the United States.[22]

There are several reasons for the slow response of British collectors at this time. You need only consult the catalogues of the international exhibitions of 1886 and 1888 to understand that the predominating taste in Britain at this time was for the Hague School and the work of the Barbizon School. Among the numerous examples of pictures by Corot, Diaz, Dupré and Daubigny that were shown at these exhibitions, only one Impressionist picture featured, Degas's *The Lobby of the Opera on the Rue Lepeletier* of 1872 (Musée du Louvre, Paris) which was owned by Louis Huth. The sketch-like handling and vivid palette of Monet's work constituted an enormous leap of taste. And even though collectors in Boston and New York were apparently able to adjust almost overnight from the sombre tones of Barbizon art to the brilliance of Impressionism, this was not the case in Britain. Several major collectors of this period such as Alexander Young, Sir John Day and W.A. Coats, even though they specialised in French nineteenth-century art, failed to buy a single Impressionist painting, simply because their taste was for the darker colour and smoother technique of an earlier generation. Durand-Ruel's mistake was to show mainly recent works by Monet, rather than introducing these collectors gradually via Monet's pre-Impressionist pictures.

BOUSSOD & VALADON IN LONDON: THE GOUPIL GALLERY EXHIBITION

Towards the end of the 1880s the market for Monet's pictures in France took a sharp upturn and, while Durand-Ruel was focusing on the American market, other French dealers, namely Georges Petit and Boussod & Valadon (with Theo van Gogh in charge of the modern paintings section) began to take an interest. Monet was more than willing to be courted by his dealer's rivals.[23] He did not like being tied to one dealer and he rightly gauged that the public would gain more confidence in the Impressionists if their work were more widely available.[24] Furthermore, collectors would be more inclined to make an investment if more than one dealer were to demonstrate confidence in their commercial value.

By the late 1880s Monet's work was beginning to command reasonable prices and, whereas in 1881 Durand-Ruel had paid him only 300 francs per picture, by 1887 Theo van Gogh was paying him an average of 1,400 francs or more for each work.[25] In June 1888 Monet entered into an agreement with Boussod & Valadon, whereby Theo would have the right of first refusal on all new works, but Monet would received 50% of all profits on his paintings once they were sold.[26]

It was around this date that Boussod & Valadon, spurred on by the increasing market value of Monet's work and also by the establishment of Durand-Ruel's New York branch, began to think in terms of marketing Impressionism abroad. Initially they contemplated sending Theo to the United States to set up a rival branch to Durand-Ruel.[27] Almost concurrently, Vincent van Gogh was trying to persuade his brother to set himself up as an independent dealer of Impressionist pictures in Paris. Vincent would set up a dealership in Marseilles and a third agent 'would have a permanent exhibition of the impressionists in London.'[28] This third agent would be one of three people: either Hermanus Gijsbertus Tersteeg, Goupil's agent in The Hague,

Elbert van Wisselingh, who had galleries in London and Amsterdam, or Alexander Reid, a Glasgow dealer who had been working alongside Theo at Boussod & Valadon.

In the end the plan came to nothing, due first of all to Vincent's indecision about who to employ as the London agent; secondly, because Theo apparently never seriously addressed himself to the project; and thirdly as a result of Reid and the Van Gogh brothers having a major disagreement, which caused the break up of their friendship.[29] Despite this, it was only the following year that Boussod & Valadon had their first foray into the London market.

Whereas Durand-Ruel had shown Monet's work in mixed exhibitions of Impressionist art, Boussod & Valadon took the decision to commit themselves wholeheartedly to Monet by holding his first one-man exhibition in Britain. The venue for the exhibition, which opened in April 1889 and ran for one month, was the London branch of Boussod & Valadon, still known as the Goupil Gallery. The show included some twenty works by Monet, of which seventeen have been identified by Wildenstein, including thirteen which appear on the Goupil ledger. According to David Croal Thomson, then manager of Goupil's in London (and editor of the *Art Journal* from 1893 to 1902), it was René Valadon who had put forward the idea for the exhibition, although the initial suggestion for the show presumably came from Theo van Gogh. Croal Thomson recalled how thrilled he was 'to receive so novel a proposition from [his] chief,'[30] who was apparently a neighbour of Monet's in Giverny.

In fact, this was the third one-man show of Monet's works that Boussod & Valdon had held in the past year. Two months previously, Theo had held a small exhibition of Monet's work in the Paris gallery. The exhibition was reviewed by Cecil Nicholson, a Scot resident in Paris, for the *Scottish Art Review*, the voice of the Scottish avant-garde. Nicholson's article was designed to underline Monet's reputation as the leader of the Impressionist school. In stark contrast to the reviewer of Durand-Ruel's 1874 London show, he praised Monet for being 'an Independent in the full force of the term', one who had 'escaped the teachings of Cabanel, Bouguereau and other impeccable Academicians', and someone who 'may to some extent have been influenced by Courbet, Manet and Pissano [*sic*]' but who had 'struck out a line for himself.'[31] The article was published in the April edition of the *Scottish Art Review*, coinciding with the opening of the London Goupil Gallery exhibition.

Despite Nicholson's enthusiasm, the national press reviews of the Goupil exhibition were generally unfavourable or simply baffled. *The Times* remarked that Monet's works would 'severely strain the faith of the ordinary British visitor', were 'unlike anything he has seen before in art' and possibly 'unlike anything in nature'.[32] The general feeling was still that the work of the Impressionists was accessible only to a small section of the population and that 'le gros public, even in Paris, where artistic quality is generally so readily recognised, would as soon think of dining off caviare as of satisfying itself with these strange and wayward productions.'[33]

David Croal Thomson recalled that 'this exhibition had no success whatever, and after the private view day, when it was filled with complimentary visitors, no one came at all. For three long weeks the collection remained open and was well

advertised, yet during that time only one visitor paid for admission.'[34]

What was it about the exhibition that the public found so problematical? Like Durand-Ruel, Theo showed mainly recent works by Monet. The majority of pictures exhibited had been painted in the past three years, including three paintings of Antibes painted the previous year and two of the Normandy coast from 1886.[35] The few earlier works exhibited had been bought from Durand-Ruel, and dated from about 1873. These included the *Orgemont Windmill in Snow* of about 1873,[36] very close in style to *Thaw at Argenteuil* (Virginia Museum of Fine Arts) of about the same date.[37] Monet also persuaded Goupil to exhibit *Vétheuil in Fog* of 1879 (Musée Marmottan, Paris), which Faure had previously rejected as being 'too white'. Perhaps Monet thought that Londoners, accustomed to pea-soupers, would have a readier appreciation of the subject!

Goupil used similar strategies to Durand-Ruel, showing several pictures in pairs, and even employing the replica tactic. For example, both w.1203, *Taking a Walk in Grey Weather* of 1888 (private collection) and w.1204, *Five Figures in a Landscape* (plate 24) from the same year,[38] showed Monet's children and step-children at Giverny. Perhaps this particular strategy worked, since, according to the Goupil ledger, *Five Figures in a Landscape* (then described as *Landscape with Figures, Giverny)* was the only picture that was bought shortly after the exhibition. It was acquired by the artist John Singer Sargent on 20 September for a good price – 3,000 francs.[39] However, it may well be that Sargent missed seeing the picture in London and actually saw it in Paris, when he visited Petit's enormous Monet/Rodin retrospective that July. Indeed, a number of pictures from the Goupil show were sent straight on to the Petit exhibition.

Between 1887 and 1891 Sargent acquired four pictures by Monet.[40] However, American by birth, he scarcely qualifies as a British collector, and as an artist closely acquainted with Monet, he was not seduced by the market, but rather by a personal and professional admiration for the artist's work. Similarly, when the artist Arthur Studd bought one of Monet's Grainstack pictures (w.1217 – now destroyed) in 1891, he was already acquainted with Gauguin and was fully aware of Monet's significance for his own work.[41] Another early collector, the Irish playwright Edward Martyn, was introduced to Monet by the critic George Moore who was a distant cousin. He bought *The Seine near Argenteuil* (National Gallery of Ireland, Dublin) directly from the artist in the 1890s.[42]

EARLY COLLECTORS OF MONET IN BRITAIN: THE ENTREPRENEURS

Sargent, Martyn and Studd all moved in artistic circles and, with the possible exception of Studd, were closely acquainted with Monet, but the majority of early collectors in Britain were industrialists, merchants and businessmen who, to a certain extent, were willing to be guided by the market in matters of taste. And it was on those men that the dealers were aiming to make an impression.

Since the majority of pictures in the Goupil exhibition were full-blown Impressionist works, they failed to excite the interest of these entrepreneurial collectors,

whose eyes were still accustomed to the dark tones of the *Ecole de 1830*. However, it is possible that there were two paintings in the catalogue that were more immediately to their taste. These were two seascapes listed as numbers 12 and 15 in the catalogue, one of which has never been identified and one which may have been misidentified. The first was a seascape described as 'Marine (Tempest)' (cat.no.12). It has neither been identified by Wildenstein, nor appears in the Goupil ledger. However, the title is strikingly close to that of the picture now in the Clark Art Institute, Williamstown, originally titled *Marine, orage,* but now known as *A Freshening Breeze* (plate 25). We know that this picture was in the collection of a Scots industrialist, Andrew Bain, by 1901, when he exhibited it at the Glasgow international exhibition, but there is no trace of its earlier provenance. A second seascape, catalogued as *Port du Havre (Effet de Nuit)* (cat. no.15) was identified by Wildenstein as a picture now in a private collection (w.264). This painting was sold by Monet to Georges Charpentier in 1876 or 1877 and was back with Durand-Ruel in 1897. There is no record of it having passed through Boussod & Valadon and Wildenstein's attribution is presumably based on the fact that it is apparently the only nocturne that Monet painted at Le Havre.

However, this second seascape could just as easily have been *A Seascape, Shipping by Moonlight* (plate 26), now in the National Gallery of Scotland, Edinburgh, which, like the Clark picture, was also bought by a Scottish industrialist, Duncan McCorkindale. The location has since been identified as Honfleur, but when the picture came into the National Gallery of Scotland's collection in 1980 it was thought to be a view of Le Havre (as is still indicated on the frame). A close inspection of the picture out of its frame has revealed an intriguing inscription on the lining canvas in pencil, as follows: *Marine tempe[s]t/ Port du Havre effet de nuit,* the exact catalogue titles of the two seascapes in the Goupil exhibition. If this inscription does relate to these two pictures, it is probable that they were shipped to London in the same consignment, and they may even have hung side by side. Alternatively, they were shipped to a separate location after the show had ended, possibly even to Scotland.

The exact date of purchase for both pictures is unknown but it seems certain that Andrew Bain bought his picture less for its style than for the subject – a two-man dinghy on a choppy sea under a lowering sky. As a keen yachtsman, owner of four racing yachts and living on the west coast of Scotland, such a scene could not have failed to capture his imagination. In 1888, he had been elected commodore of the prestigious Royal Western Yacht Club and may well have chosen to mark this achievement and simultaneously demonstrate his modernity of outlook by purchasing an example of the leading French Impressionist painter, albeit an example of his pre-Impressionist period.

The nautical subject of the picture must also have motivated McCorkindale's purchase, since he, too, came from the west coast of Scotland.[43] McCorkindale lived in Rothesay on the Isle of Bute and made his fortune as an iron founder. Bain, too, had made his money from heavy industry. Indeed, the two men were co-founders (in 1870) of the Clydesdale Iron & Steel Company, which made huge profits from manufacturing steel in the 1880s. (In 1890 the company merged with A.& J. Stewart Ltd.)

The two not only knew each other but almost certainly influenced each other's purchase.

McCorkindale had an important collection which was sold in 1903. It included Whistler's *Nocturne in Black and Gold: The Fire Wheel* (Tate, London), which he bought from the artist in 1894. It may even have been through his knowledge of Whistler that he developed an interest in Monet – and certainly this moonlit scene, with its dark, almost monochrome palette and dramatic light effects, although closer to Courbet in technique, is reminiscent of Whistler's 'nocturnes'. The link with Courbet is important, since this artist's broad handling and sombre colour range was more immediately acceptable to these entrepreneurial collectors than the luminosity and divided brushstrokes of Impressionism. And although a number Monet's pictures were absorbed into British collections during the 1890s, they were frequently early works which showed some kind of stylistic debt to the previous generation of French painters.

Like Bain and McCorkindale, the majority of these early collectors were Scots industrialists, who had made their fortune from the recent economic expansion of cities such as Glasgow, Aberdeen and Dundee. Many of them had built up important art collections, with a strong emphasis on nineteenth-century French painting. Of these, the most significant was the Aberdonian collector James Staats Forbes (1824–1904) who from 1861 was general manager of the London Chatham and Dover Railway Co. His vast collection of mainly Barbizon and Hague School paintings was divided between his house on the Chelsea embankment and his rooms at Victoria Station (and featured in three separate articles by E.G. Halton in *The Studio* in 1905). But despite the fact that this collection of over 4,000 items included works by Courbet, Daumier, Bastien-Lepage, Lhermitte and Harpignies, Forbes bought only two Impressionist pictures: Degas's *Woman with a White Headscarf* (National Gallery of Ireland, Dublin) and Monet's *A Lane in Normandy* of 1868–9 (fig.16), which he acquired in 1892. With its Corotesque resonances, this picture would have harmonised well with the rest of his collection which included no fewer than 160 works by Corot. Halton even hinted as much when he commented on the picture's 'beautiful tints of green, brown and blue … softened by the grey mist into a subtle harmony palpitating with atmosphere.'[44]

The importance of creating a harmonious collection was remarked on by critics such as R.A.M. Stevenson, writing on Sir John Day's collection in the *Art Journal* in 1893. Stevenson commented on the importance of preserving a 'principle of decorative unity', adding, 'It is better to weed out pictures that disturb the harmony of your effect.'[45]

Sir John Day's collection of French nineteenth-century art included almost exclusively artists of the *Ecole de 1830*. Day invested in no single example of Impressionist art, and Stevenson praised him for his forbearance: 'I would not disparage the later Impressionist work' (by which he means the work of Monet and his contemporaries) 'but I feel that the real lover of pictures preserves them from dangerous encounters. He will not toss them, as it were, into a pit to fight it out like dogs and cats … he

jealously guards his pictures from improper companions and riotous debauches of untramelled colour.'[46] By contrast, Robert Walker, writing in the *Magazine of Art* in 1894, commented on the comparative brightness of Monet's *Effet de Neige à Vétheuil* (private collection, Switzerland), which was in the collection of the Glasgow iron and steel merchant, Andrew Maxwell: 'Light blues and greens and yellows in separate touches make, on the canvas, wonderful combinations with white, and, as the result, the picture – "winter" though it be – positively lights up the wall on which it hangs.'[47]

Like Forbes, Maxwell's taste was predominantly for the work of the Hague School – especially Jacob and Matthijs Maris – and Corot, as well as Scottish artists of the Scott Lauder school. In general, the Vétheuil snowscene must have sat rather uneasily among its darker-toned companions and it is perhaps not surprising that Maxwell made no further purchases of Impressionist pictures, although the Monet did remain in his collection until his death in 1926.

Forbes had acquired his Monet from Boussod & Valadon in Paris, but Maxwell bought his directly from the Scots dealer Alexander Reid who had returned from Paris in 1889 and set up his own gallery, La Société des Beaux-Arts, in Glasgow. In December 1891, two years after the Goupil show, Reid fulfilled Vincent van Gogh's ambitions and exhibited pictures by Monet, Degas, Sisley and Pissarro in a mixed exhibition of forty-six nineteenth-century French pictures in London at Arthur Collie's gallery in Old Bond Street. The exhibition, entitled 'A small collection of Degas and others', closed on 8 January 1892 and reopened in Glasgow the following month. From the outset Reid was more interested in marketing Degas than Monet,

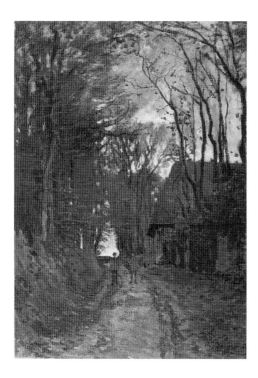

Fig.16 Claude Monet, *A Lane in Normandy*, 1868–9
Matsuoka Museum of Art, Tokyo

and even earned himself the sobriquet 'Degas Reid'. However, he recognised the importance of Monet, and although Degas was the main focus of the show, the first pictures to greet visitors to the exhibition were two snowscenes by Monet and Sisley, which Reid hung side by side. The pictures did not go unnoticed and George Moore devoted an entire article to a discussion of these two paintings.[48]

Maxwell's Monet came from Durand-Ruel who probably let Reid have it on commission, since he did not pay for it until March 1892, after the exhibition had closed. One can infer from this that Reid had already found a buyer by this date. Certainly, in November that year a contemporary periodical, the *Bailie*, reported: 'Among the latest additions to the gallery of one of our chief Glasgow collectors is an example of Claude Monet, a picture distinguished by all the more distinctive characteristics of the great impressionist … '.[49] The Vétheuil picture cost Reid 4,500 francs, as opposed to 3,000 francs for Degas's *Woman at the Window* (Courtauld Institute, London) and only 1,200 francs for the Sisley snowscape.

There are no records of any sales that Reid made prior to 1899 – both then (and later), like Durand-Ruel, he kept his books in a haphazard way. It is therefore difficult to say whether or not he marketed Monet's work with any enthusiasm during the 1890s, although we know that he included works by Monet and Manet in an exhibition of French nineteenth-century painting at his Glasgow gallery in December 1898.

Since he succeeded in selling the Vétheuil painting to Maxwell, it seems more than likely that Reid stocked further examples of Monet's work, despite the fact that it was so expensive in comparison to Sisley, Pissarro and even Degas. He may well have sold the early seascapes to Bain and McCorkindale, but there is no documentation to prove this either way. In 1897 he may also have sold a Monet landscape to the Glasgow chemical merchant Andrew Kirkpatrick who was a regular client. Like the majority of collectors, Kirkpatrick specialised in the work of the Barbizon and Hague Schools. However, through Reid he was introduced to Whistler, Boudin and Jongkind, and it was through developing a taste for these artists that he quickly adapted to Impressionism, adding works by Sisley and Manet to his collection just before he died in 1900.[50]

Another British collector, Sir Edmund Beckett, later Lord Grimthorpe (1816–1905) – best known as the designer of 'Big Ben' at Westminster – also began taking an interest in Monet towards the end of his life.[51] He acquired his only painting by Monet sometime between April 1901, when it was bought by Bernheim-Jeune at the Depeux sale, and his death in 1905. Once again, like the majority of his contemporaries, he was conservative in his choice of image, acquiring *Le Phare de l'Hospice* (Kunsthaus, Zurich), a fresh view of Honfleur painted in the summer or autumn of 1864.

Like Grimthorpe, a number of the collectors we have looked at acquired their paintings by Monet towards the end of their lives, and like him they died just after the turn of the century: Kirkpatrick in 1901, McCorkindale in 1903, Staats Forbes in 1904 and Maxwell in 1909. Without exception they had formed their collections when the predominating taste was for dark-toned Hague School and Barbizon paint-

ings and very often their purchases were restricted to a single example of Monet's work, almost as if they had deliberately acquired a 'token' painting by the leading Impressionist artist. This was certainly the case with Andrew Bain, Duncan McCorkindale and Andrew Maxwell. Others such as Henry Hill, Constantine Ionides, T.G. Arthur, Arthur Kay and George Burrell limited their brief association with Impressionism almost exclusively to Degas. As we have seen, the introduction of Impressionist pictures severely threatened the unity of their collections and with individuals such as Forbes and McCorkindale, they were careful to choose pictures that had stylistic resonances with other works.

Given all of these factors, it was clearly necessary for a new generation of collectors to emerge in Britain before a successful market for Monet and the Impressionists could be established. It was also necessary for another British dealer, apart from Alexander Reid, to take an interest in the Impressionist market. As Durand-Ruel himself once said, exhibitions were all very well for showcasing a new artist, but most sales were made in the gallery from stock. And no British dealer was yet prepared to stock Monet's work in any quantity.

DURAND-RUEL: THE FINAL CAMPAIGN (1901–1905)

It was almost certainly Monet's painting campaigns in London from 1899 to 1901 that prompted Durand-Ruel to renew his interest in the British market. In 1901 he sent four Impressionist pictures to the Glasgow international exhibition, including *Stormy Weather at Etretat* (National Gallery of Victoria, Melbourne). Earlier that year he had exhibited nine works by Monet at the Hanover Gallery and for the first time the exhibition was not merely a mixed exhibition of nineteenth-century French painting, but was entitled 'Pictures by French Impressionists.'

Monet too, after painting for three consecutive years in London, was becoming interested in marketing his work in England. In December 1904 he wrote to Durand-Ruel asking him not to include any of the Thames series in his exhibition of Impressionist pictures which was to open the following month at the Grafton Galleries. Instead, he planned to hold a separate exhibition of his London pictures in the capital two or three months after Durand-Ruel's show. In the end this never took place, due to Monet's own delay in preparing the pictures for exhibition, and most of these pictures ended up in American collections. However, it explains why, among the fifty-five works by Monet exhibited at the Grafton Galleries, and spanning his career from 1871 to 1901, there was not a single example of those pictures which, because of their subjcts, one might have expected to have most appeal for the English public.

The exhibition was well received and Durand-Ruel was particularly pleased with the glowing eulogy it received in *The Athenæum*.[52] Nevertheless, only thirteen works sold, mostly to non-British buyers. These included only four Monets but, in contrast to the early pre-Impressionist works favoured by the previous generation of collectors, three of these were recent works. *Cliffs at Pourville, Sunrise* (Magnani Rocca Foundation, Parma) was bought by Baron Adolf de Meyer, the German fashion photographer who had moved to London in 1895.[53] And two Scots, A.B. Hepburn and

Sir Hugh Shaw Stewart bought, respectively, *Grainstack in Sunlight* (Kunsthaus, Zurich) – one of three Grainstack pictures exhibited – and *On the Cliff near Dieppe* of 1897 (w.1463).

However, Meyer can hardly count as a British collector and the other two purchases appear to have been 'one-offs' – Sir Hugh's collection at Ardgowan, Inverkip, was certainly better known for its eighteenth-century portraits than for its Impressionist pictures. It was therefore the fourth purchase, *Lavacourt, Sun and Snow* (plate 27) that was the most significant. Frank Rutter opened a private subscription to present the Monet landscape to the National Gallery, London; but according to the National Gallery's consititution, it was not allowed to accept work by a living artist. In the end the picture was bought by Sir Hugh Lane on 8 April 1905. Lane had held an important exhibition of French paintings the previous year at the Royal Hibernian Academy in Dublin. It included 164 works from the Staats Forbes collection as well as works by Monet, Manet, Sisley and Renoir, which he had borrowed from Durand-Ruel. Apparently inspired by Staats Forbes's example, Lane's aim was to establish a collection of such quality that it would form the nucleus of a modern paintings collection at the National Gallery in Dublin. Eventually, after Lane's untimely death on the *Lusitania*, the collection, including the Monet landscape, was bequeathed to the National Gallery in London.

Despite this important purchase by Lane, the number of sales of Monet's work at the Grafton Galleries exhibition was unimpressive, and thereafter Durand-Ruel appears to have turned his attention away from the British market. In May 1909 he briefly suggested showing a recent exhibition of Monet's Waterlily paintings (held jointly with Bernheim-Jeune) in London, but Monet refused to cooperate and it seems that the decision to abandon the British market was not entirely that of the dealer.[54]

The problem was that, apart from Boussod & Valadon in 1889 and Alexander Reid in the 1890s, no other dealer had made a serious attempt to market Monet's work in Britain, and this was to remain the case until after the First World War. Furthermore, apart from Lane and William Burrell, whose tastes were comparatively conservative, no serious collector of Impressionist art had yet emerged in Britain. For the first two decades of the twentieth century even Reid appeared to give up on the Impressionists and concentrate instead on artists such as Boudin who had a more immediate appeal for his clients. And even if some London dealers stocked one or two examples of Monet's work, it was in Paris that the best choice of pictures was to be found. When the Davies sisters made their innovative purchases of Monet's Venice and Waterlily paintings in 1912 and 1913, they went to Bernheim-Jeune and Durand-Ruel in Paris. Only one picture was bought through a London dealer. This was *Charing Cross Bridge* which had been in the collection of the Duke of Malborough since 1910 and which they bought in May 1913 from Wallis & Son, the same dealers who had helped Durand-Ruel all those years ago when he moved his stock of French paintings to London during the Franco-Prussian war. The director of the gallery at that time was David Croal Thomson.

As Monet himself had predicted, it was only once a selection of dealers had shown their confidence in Impressionism that the public was prepared to buy, and in Britain this did not happen until 1923, well after Roger Fry had held his Post-Impressionist exhibitions. In this year Alexander Reid in Glasgow and Lefevre, Knoedler's and Agnew's in London all held exhibitions of Impressionist art. In 1926 Alexander Reid and Lefevre amalgamated, creating a prestigious gallery that specialised in Impressionist and Post-Impressionist art. During this period important collections of Impressionist paintings were formed, including those of Courtauld, the Workmans and the Cargill brothers. All of these collectors bought works by Monet and all were clients of Reid & Lefevre in London.

Nevertheless, when Monet died in 1926 no great interest was shown in Britain. In 1927 memorial exhibitions were held in Boston and Philadelphia, and Durand-Ruel, still regarded as Monet's dealer, organised an exhibition in New York. The following year retrospectives were held in Berlin and Paris (the latter again organised by Durand-Ruel), and a major retrospective was staged at the Orangerie in Paris in 1931. But it was not until five years later that a British dealer, Arthur Tooth, was to follow suit. And so, in 1936, Monet was given his second solo exhibition in London, ten years after his death, nearly fifty years after the Goupil exhibition and sixty-six years since Durand-Ruel first set foot on British soil.

NOTES AND REFERENCES

Making Money out of Monet: Marketing Monet in Britain 1870–1905

FRANCES FOWLE

1. L. Venturi, *Archives de l'Impressionisme. Lettres de Renoir, Monet, Pissarro, Sisley et autres. Mémoires de Paul Durand-Ruel*, Paris 1939, vol.2, p.177.
2. John House, 'New Material on Monet and Pissarro in London in 1870–71', *The Burlington Magazine*, October 1978, p.636.
3. House dates the meeting to soon after 21 January 1871. House 1978, p.637.
4. None of these purchases appears to have been recorded until 1872. See ibid., p.638, note 16.
5. Venturi 1939 (see note 1), p.176.
6. Ibid.
7. Catalogue no.36.
8. Caroline Durand-Ruel Godfroy, 'Paul Durand-Ruel's marketing practices', *Van Gogh Museum Journal 2000*, pp.83–9.
9. Catalogue numbers 131 and 9 respectively.
10. Unsigned review, *The Times*, 27 April 1874, p.14; reprinted in K. Flint (ed.), *Impressionists in England: The Critical Reception*, London 1984, pp.34–5.
11. 'Society of French Artists', the *Art Journal*, 1875, p.57.
12. E.M. Rashdall, 'Claude Monet', *Artist*, vol.ix, 2 July 1888, pp.195–7; reprinted in Flint 1984, pp.305–9 (see especially p.307).
13. 'Society of French Artists', the *Art Journal*, 1875, p.57.
14. Ibid.
15. R. Pickvance, 'Henry Hill: An Untypical Victorian Collector', *Apollo*, vol.LXXVI, 1962, pp.789–91.
16. Alice Meynell, 'Pictures from the Hill Collection', *Magazine of Art*, 1882, p.82.
17. Catalogue no.163.
18. See R. Thomson, 'Trading the visual: Theo van Gogh, the dealer among artists', *Van Gogh Museum Journal 2000*, pp.30–2.
19. Frederick Wedmore, 'The Impressionists', *Fortnightly Review*, vol.xxxiii, January 1883,

pp.75–82; reprinted in Flint 1984, pp.46–55.
20. The exhibition ran from 10 April to 7 July.
21. Others included w.751, *Edge of the Cliff at Pourville* and w.762, *The Path at la Cavée, Pourville*.
22. J. Rewald, 'Theo van Gogh, Goupil and the Impressionists', *Gazette des Beaux-Arts*, vol. LXXXI, 1973, p.9.
23. Ibid., pp.21–2.
24. He later(1892) told Durand-Ruel that it was 'absolument néfaste et mauvais pour un artiste de vendre exclusivement à un seul marchand.' (Monet to Durand-Ruel, 22 March 1892, Venturi 1939, p.344).
25. On 17 February 1881 Durand-Ruel paid Monet 4,500 francs for fourteen paintings. Theo van Gogh paid 20,000 francs in 1887 for fourteen pictures. This was more than the profit that Durand-Ruel made that year on his Impressionist sales in New York.
26. Rewald 1973, p.22.
27. Ibid., pp.26–7.
28. *The Complete Letters of Vincent van Gogh*, 3 vols., London, 1958, letter 465.
29. See F. Fowle, 'Vincent's Scottish Twin: the Glasgow art dealer Alexander Reid,' *Van Gogh Museum Journal 2000*, pp.90–9.
30. W.T. Whitley (ed.), *The Art Reminiscences of David Croal Thomson*, vol. 1, unpublished text, Barbizon House 1931, p.68.
31. Cecil Nicholson, *Scottish Arts Review*, April 1889, p.315.
32. Unsigned review, *The Times*, 18 April 1889.
33. Ibid.
34. Whitley 1931, p.54. The visitor in question was the Scots artist John Robertson Reid (1851–1926) who paid the one-shilling admission.
35. Catalogue no.1 *Pyramids at Port-Coton*, 1886 (w.1087, Fondation Rau, Zurich); IV *Trees by the Seashore, Antibes*, 1888 (w.1188, private collection); VII *Antibes, View from the Cap d'Antibes, Mistral Wind*, 1888 (w.1174, Rhode Island School of Design, Providence); V *The Mediterranean, Mistral Wind*, 1888 (w.1181, private collection); XVIII *Etretat in the Rain*, 1886 (w. 1044,

Nasjonalgalleriet, Oslo).

36. Catalogue no.x: acquired by Boussod
 &Valadon from Durand-Ruel, 9 April 1888
 for 1,200 francs; sold to Heilbut, 4 August
 1893 for 3,000 francs.

37. Catalogue no.xiv; acquired by Boussod &
 Valadon from Durand-Ruel, 9 April 1888
 for 1,200 francs; sold to Faure, 14 April 1894
 for 2,000 francs.

38. Catalogued as 'Prairie and Figures (Temps
 couvert)' (no.vi) and 'Prairie and Figures'
 (no.x).

39. Bought by Boussod & Valadon from
 Monet, 31 December, for 1,300 francs
 (profit to be split 50/50).

40. Sargent already had two pictures by Monet
 which he had acquired directly from the
 artist in 1887. These have been identified as
 Rough Seas at the Manneporte, 1886
 (w.1036, private collection, USA) and
 Bennecourt, 1887 (w.1126, private collection,
 USA). The second picture is remarkably
 close to *Trees in Winter, View of Bennecourt*
 (Columbus Museum of Art, Columbus,
 Ohio) which was one of four pictures by
 Monet exhibited at the Royal Society of
 British Artists in Suffolk Street in
 December 1887 and bought by Boussod &
 Valdadon in April 1888. It was sold in the
 same year to a Mr Richardson for £160
 (more than most of the other works in the
 exhibition). This could have been the same
 J. Richardson described by Vincent van
 Gogh as 'The travelling representative for
 Goupil & Co' based in England (letter 239).
 In 1891 Sargent went on to acquire w.867
 Gardener's House, 1884 (private collection)
 from Durand-Ruel.

41. The artist Arthur Studd studied at the
 Slade under Alphonse Legros and at the
 Académie Julian in 1889. In 1880 he had
 stayed at Le Pouldu and met Gauguin.
 From 1894 onwards he fell under the spell
 of Whistler. (Three of the Whistlers in the
 National Gallery, London, were
 bequeathed by Studd). The Monet
 Grainstack painting was destroyed in the
 San Francisco earthquake in 1906 along
 with the Crocker Collection.

42. See Madeleine Korn, 'Exhibitions of
 modern French art and their influence on
 collectors in Britain 1870–1918: the Davies
 Sisters in Context', *Journal of the History of
 Collections,* vol.16, no.2, 2004, Appendix 2
 (Collectors of Impressionist art in Britain
 1870–1913), p. 215.

43. McCorkindale was from the west coast of
 Scotland – at the time of the Monet
 exhibition he was living in Rothesay, but
 later moved to Carfin Hall in Lanarkshire. I
 am very grateful to Anne Dulau for her
 assistance with research on McCorkindale.

44. E.G. Halton, 'The Staats Forbes Collection',
 The Studio, vol.36, no.153, 15 December
 1905, p.231.

45. R.A.M. Stevenson, 'Sir John Day's Pictures',
 the *Art Journal,* 1893, p.261.

46. Ibid., p.262.

47. Robert Walker, 'Private Picture Collections
 in Glasgow and West of Scotland. II. – Mr
 Andrew Maxwell's Collection', the
 Magazine of Art, 1894, pp.226–7.

48. George Moore in *The Speaker,*
 26 December 1891.

49. Megilp in *The Bailie,* 9 November 1892, p.7.

50. See *Illustrated Catalogue of the Very
 Valuable Collection of Pictures, the Property
 of the Late Andrew J. Kirkpatrick Esq.,*
 Waring & Gillow, sold on the premises at
 No.5, Park Terrace, Glasgow on Wednesday
 1 April 1914. See also Robert Walker,
 'Private Picture Collections in Glasgow
 and West of Scotland. Mr A.J. Kirkpatrick's
 Collection', the *Magazine of Art,* 1895,
 pp.41–7.

51. On Lord Grimthorpe see Martin S. Briggs,
 Men of Taste, New York and London 1947,
 pp.205–13.

52. *Athenæum,* 4 February 1905.

53. Later that year (November) he also
 acquired w.1587, *Waterloo Bridge, effet de
 soleil* (McMaster University, Hamilton) –
 also from Durand-Ruel.

54. Venturi 1939 (see note 1), vol.1, p.422
 (10 May 1909).

8

'Slabs of Pink and Lumps of Brown': The Critical Reaction to the Exhibition of a Monet Grainstack Painting in Britain in 1893

ANNA GRUETZNER ROBINS

The title of this essay, 'slabs of pink and lumps of brown' is composed from words used by Charles Whibley, who was describing the surface effect of a Monet painting, one of three works on exhibition at *The 10th Exhibition of Modern Pictures* at the New English Art Club in April 1893.[1] Whibley was not the first critic to make gastronomic and sexual associations with the surface of Monet's paintings, nor would he be the last; but what is surprising is that Whibley was part of an inner circle of critics, known as the New Art critics, who were thought to be sympathetic to French Impressionist painting. Whibley's remarks come at the end of over a decade of some very perceptive comments by British critics about Monet's painting. The purpose of this essay is to put Whibley's ideas about Monet's painting into context, and in doing so, to throw further light on its exhibition in London.

Early in 1893, the annually elected committee of the New English Art Club (NEAC) approached Monet about sending work to their next exhibition. Several of the NEAC artists, including Walter Sickert, had been part of Whistler's inner circle at the Royal Society of British Artists when Monet exhibited four pictures at its winter exhibition in 1887–8.[2] Two years previously, the committee had approved the exhibition of two pictures by Monet, owned by John Singer Sargent, at the club's winter exhibition.[3] An invitation to Monet to send work to the club was a natural next step. The committee, which included the London Impressionists Walter Sickert and Philip Wilson Steer,[4] must have been delighted when Monet 'promised' to contribute.[5] In the end, Monet sent three works from Giverny, the maximum number allowed under the club rules in any one exhibition.[6] All three were recent pictures: *Peupliers des bords de l'Epte, Giverny* (51); *De la série des meules* (74); and *Le Pont de Vervit, Creuse* (77). This last picture has been tentatively identified by Daniel Wildenstein as *Le Pont de Vervy* (Musée Marmottan, Paris),[7] and various descriptions in the press confirm this to be the case.[8] Neither the Grainstack nor the Poplars picture has been identified. The knowledge that all three NEAC pictures were in Monet's possession until the time of exhibition, and the numerous descriptions of these pictures in the press, allow us to consider the possibility of identifying both of them.

Several critics pointed out that the Grainstack painting represented a single stack.[9] Of the eleven single Grainstack pictures listed by Wildenstein,[10] six of these were bought by Durand-Ruel before 1893.[11] The descriptions in the press enable us

to narrow the remaining five down even further. The *Morning Post* wrote that the contour of the stack in question 'is edged with rosy light, defining its bulk against the clinging blue mists, entering the distant hills and woods, above which the sky is resplendent with the glories of sunrise.'[12] In addition, D.S. MacColl's description of the 'dead-blue distance against the dark primrose and flushed orange and red of the sky'[13] suggests to me that the Grainstack of 1890–1 (plate 28), a picture that remained with Michel Monet until around 1972 and is now in the collection of Pierre Larock-Granoff, Paris, must be the picture that Monet sent to the NEAC in spring 1893.[14] The Poplars picture was the best liked of the three NEAC Monets. After piecing together the numerous descriptions of it, I am suggesting that the Tate's *Poplars, Banks of the Epte* of 1891 (plate 29) is the strongest contender of those listed by Wildenstein.[15]

We can assume that Monet would not have selected these recent pictures unless he had hopes of finding an appreciative audience in London. He must have known that the artist and Whistler collector, Arthur 'Peter' Studd, had purchased a Grainstack picture from Durand-Ruel shortly after the showing of fifteen of them in Paris in April 1891. Through his friendship with Whistler and Sargent, Monet would have been aware of the keen support for him within the club. Steer and George Thomson, another London Impressionist, who was part of the inner circle that was running the club, were keen acolytes of Monet's painting methods. Rather surprisingly, given the support for Monet, the committee took the eccentric decision to hang the Creuse picture and the Grainstack painting on either side of an equestrian portrait by Charles Furse, a juxtaposition that was bizarre to say the least.[16]

Earlier in 1893, the exhibition of Degas's *Au Café* or *L'Absinthe*, as it was christened at the newly opened Grafton Gallery, had sparked an extraordinary debate in the press. Two other critics in Whibley's circle, D.S. MacColl and George Moore had sprung to Degas's defence. During the ensuing debate, when MacColl made his memorable remark that it was the 'treatment not the subject' that the art critic should address, the term 'New Art Criticism' was coined. Hence the New Art critics, who included MacColl, Moore, Whibley and several others.[17] I will refer to their reaction later in this essay but first Whibley's extraordinary comments about Monet's Grainstack paintings merit quoting at length:

> Approach that ingenious *Study of a Haystack* and you see nothing but blobs of discordant and unpleasant colour – slabs of pink suggesting cheap confectionary, lumps of brown sluiced at the canvas as it were in pure wantonness. But get far enough away, and the vice of colour is purged, the coarse and ugly handling disappears. There is revealed a haystack wrapt in the haze of evening. The planes are indicated with astonishing precision. It is evident that every touch of paint holds its place inevitably upon the canvas. What seemed a hideous puzzle turns out not an inelegant presentation of a completely commonplace fact. The result is achieved by a sort of legerdemain: and if the human eye were differently focused, if the conditions of life were such that an impassable barrier were set at a distance of over thirty feet before every picture, much might be said in favour of Monet's methods. But before you arrive at that deliberate effect, you must distress yourself with the contemplation of

ugliness, and when you have suited your eye to the distance a feeling of wonder at the man's ingenuity quarrels with your pleasure.[18]

It would appear that Whibley's conundrum was that it was all a matter of where you stood when looking at Monet's picture. The 'slabs of pink' and 'lumps of brown' were only visible if you stood close to the picture surface. But get far enough away as he explained and the 'vice of colour is purged' and the 'coarse and ugly handling disappears.' His speculation that 'if the human eye were differently focussed' and 'an impassable barrier' kept the viewer 'at a distance of over thirty feet' from every picture, then 'much might be said in favour of Monet's methods' illustrates his dilemma. As MaryAnne Stevens has observed, 'Whibley maintains that the progress from close-up scrutiny of an inevitably ugly surface through to wonderment at the final unified composition creates a conflict between acknowledgement of man's technical "ingenuity" and the appreciation of the achievement of an ultimately beautiful effect.'[19] But the question remains. If Whibley was more comfortable standing thirty feet away from Monet's pictures, then even without the 'impassable barrier' why did he feel compelled to stand so close to Monet's *Grainstack*? Although it is tempting to suggest that Monet's 'wanton' surface gave him more visual pleasure than he willingly admitted, looking at close range was an uncomfortable sensation.

Whibley's assessment of the *Grainstack* painting, seen near and far, reflects a sophisticated and informed way of viewing pictures which the New Art critics shared. It was their practice to stand close to a picture and whether pleasurable or not to experience some sort of a visual sensation. For example, Moore expected to see a pleasing surface effect, explaining that he would like to weave 'the net of his sensations so close' that nothing would escape his close attention.[20] Here Moore uses sensation in the French sense, meaning the role of the subjective in perception, or the act of seeing. Looking closely at the surface of Monet's pictures brought a new evaluation of Monet's art that broke with an earlier critical tradition that willingly accepted Monet's landscape pictures. When five Monet landscapes, including *On the Cliff at Pourville* (see plate 11), were shown in London in 1883,[21] a writer in *The Artist*, in a typical reaction, delighted at the effects of light and movement in these pictures of coast and sea: 'How remarkable in them all is the expression of nature! We seem in one to feel the breeze which bends the long grass on the cliff and ruffles the surface of the sea below; in another we almost perceive the quiver of the leaves which cast a flickering shadow on the sun-scorched ground; while in a third we can fancy how great is the heat which keeps the shimmering haze over that sultry down.'[22] The pleasure the critic in *The Artist* takes in looking at these vibrant images of the sea is not so very different from what the majority of people today expect to feel when looking at Impressionist landscape painting.

By the late 1880s British critics were applying different criteria when looking at a Monet landscape. They no longer necessarily expected to see a transcription of natural effects. Of course, the surface effects of Monet's painting became more visible and dramatic in the 1880s, but this does not entirely explain why British critics were creeping towards Monet's pictures. The extensive writing on the four pictures that

Monet sent on Whistler's invitation to the 1887 winter exhibition of the Royal Society of British Artists (RBA) heralded a change in critical thinking. All four Monets were recent works, painted within the last two years. All four were priced at £160, and one has been positively identified – *Village of Bennecourt* (w.1125 Columbus Museum of Art, Ohio).[23] A sampling of these reviews shows that the earlier liking for sunlight and colour is there, but some critics had decided that Monet's brush techniques required careful scrutiny. However, they had not acquired the critical skills needed for comment of this sort. The critic for *The Spectator* liked the pictures by Monet who 'makes his light and shade through colour' because 'light is always swimming with colour'.[24] But when it came to describing Monet's technique, he admitted that he could 'not give ... any description worth the having of this most strange and powerful painting.'[25] What is clear is that the exhibition of these Monets marked a change in attitude concerning the distance from which they were to be scrutinised. Sargent did not say how far away he was standing when he reached his state of 'voluptuous stupefaction' when looking at them at the RBA, but such intense sensuousness suggests that he must have been standing pretty close.[26] Equally, the sceptical critic of the low-brow *Land and Water*, when looking at the surface effects of *Coast of Belle-Isle, Bretagne* – almost certainly *Port-Domois à Belle-Ile* (w.1109) – must also have been standing quite close[27] when he commented that it resembled 'a study of ripe Gorgonzola seen under a microscope.'[28]

I want to suggest that the change in thinking about where to stand when looking at a painting by Monet can be connected to Whistler's own ideas about the viewing of pictures. When Whistler hung his first solo exhibition in 1874, he arranged the works in such a way that the hang of vertical portraits was punctuated by etchings and dry points hung at eye level.[29] As Kenneth Myers observes, the viewer was encouraged 'to proceed around the room while alternately moving close to the wall in order to examine the prints and drawings, and then stepping back to look at the larger paintings.'[30] In the 1880s, when Whistler was making and exhibiting small works in oil and watercolour, he had a fully developed aesthetic which demanded that the viewer stand close to these works. Whistler encouraged this practice at the RBA exhibitions and his solo exhibitions, and commanded his followers to instruct visitors to the galleries about this viewing practice. In Whistler's sketch of his 1886 London exhibition, published in the *Pall Mall Gazette,* the people we see looking closely at the small scale works carefully arranged on the gallery walls would have been acting under Whistler's instructions. It is hardly surprising that British critics would apply the same criteria when looking at Monet's pictures at the RBA, since it would have been well known that he exhibited there as Whistler's invited guest, hence the remark of the *Land and Water* critic about Gorgonzola cheese.

There are clear indications that British critics adopted these viewing habits when visiting *Impressions by Claude Monet*, a solo exhibition of twenty works, at the Goupil Gallery in New Bond Street, London, which opened to the public on 15 April 1889.[31] Of the twenty pictures on show, at least twelve had been painted in the previous two years, so there was plenty of opportunity to see the highly variegated brushwork

and distinctive colour range that characterise Monet's painting of the late 1880s.[32]

David Croal Thomson, the manager of the London branch of the Goupil Gallery, prepared for any hostile criticism of the show by inserting the following note in the catalogue: 'Messrs. Boussod, Valadon & Co., being desirous of presenting the various phases of French art to the English public, have arranged this exhibition of the works of M. Claude Monet in order to show the latest development of the Impressionist movement in France.' Croal Thomson also prefaced the catalogue with the translation of an article on Monet's work taken from *Le Figaro* of 10 March 1889, explaining that 'This is a fair specimen of enthusiastic art criticism dealing with a certain tendency in art scarcely known to, and not recognised by, the connoisseurs of England. As these works differ so entirely from anything hitherto shown in London, they should be considered for some time before a final opinion on their merits is formed.'[33]

The additional catalogue preface was the article which Octave Mirbeau had published on the front page of *Le Figaro*[34] in connection with the small Monet show at the Goupil Gallery, Paris, in February-March 1889. The article had been critical to the success of the Paris show.[35] Mirbeau's romancing of Monet as a keen lover of nature, who worked alone, in the open air, appealed to British sentiment, and many critics were sympathetic to these aims. The critics who took Thomson's advice to consider pictures by Monet for a short time before forming an opinion, saw that the real issue was where to stand in the gallery. All the pictures were hung in one 'small room',[36] and there must have been some juggling for space at the private view, as the critics moved near and far, to find an optimum viewing position. *The Scotsman* advised: 'All his pictures have to be looked at from the opposite side of the room … Most critics with open minds … will … admit that M. Monet is an artist of amazing power. He simply revels in colour.'[37] The *Illustrated London News* shared this opinion, appreciating the poetic effects of colour in nature, like the 'rose-tipped mountains' in *Antibes, vue du Cap, vent de Mistral* (w.1174) and the 'poplar-surrounded pool … bright with the delicate touch of early spring' in *Bend in the River Epte* (w.1209). This is not sophisticated criticism; neither is it hostile. But then these two critics were standing at a safe distance from the pictures, believing that 'two-thirds of the width of the gallery [was to be] placed between the spectator and the canvas' before the pictures could be appreciated.[38]

On the other hand, the more informed critics were creeping closer and closer to Monet's pictures. Marion Spielmann was not exactly part of the circle of critics with privileged access to Whistler's circle, but he had his finger in a number of 'art' pies, and would have been privy to what was in and what was out when it came to Monet. Referring to the 1887 *Alfalfa and Poppies* (w.1146) Spielmann advised: 'Come near and see brush stroke after brush stroke, bold, hurried, mingled … a cross-net of emerald green and scarlet, in rough splashes about half an inch long … a sort of Scotch plaid'.[39] 'Stand back', he continued, 'it is a meadow of long grasses thickly poppy sown bending before the breezes, alone in the sunlight.'[40] Spielmann was doing his best here to express what he felt, but a failure of language let him down.

Spielmann's remarks can be compared to those by R.A.M. Stevenson, former painter, and future New Art critic, who is best know for his 1895 *Velasquez*, a magnificent study of the surface effects of Velázquez's painting. Stevenson was used to looking closely at pictures, and frequently used the surface effect of a picture as the basis of his critique, but he was slightly at a loss when it came to Monet. Darting to and fro in front of *Alfalfa and Poppies*, he advised his readers that unless they retire 'to a distance of twelve or fifteen feet' from the canvas, they would not 'begin to comprehend' it. Stevenson continued: 'At that distance, the aerial perspective begins to assert itself. And what seemed a perpendicular wall of yellowish grey, dotted with scarlet, begins to appear horizontal, to assume the character of dry herbage, and to let poppies be seen through the interstices of its stalks.'[41]

This brief discussion of the 1889 show brings me back to 1893, and the comments of the other critics about Monet's Grainstack painting. Taking account of the press criticism, a noticeable difference emerges between the opinions of the so-called less enlightened critics – the 'Old Art Critics', as the anonymous critic who took over the *Star* column for the purpose of reviewing the Monet show described them – and the New Art critics.[42] Consider, for example, the comments of the critic of the gossip magazine *Talk*, who thought the picture was 'superb', and who may have been repeating 'truthful' gossip when he claimed that this picture was one of the Grainstack paintings recently exhibited in Paris;[43] or the *Weekly Dispatch*, which thought that Monet's 'glowing landscapes are the most striking works in the room' and that the Grainstack painting had 'rare qualities of colour and atmosphere.'[44] Spielmann must have decided to keep his distance, because he said nothing about the surface effect of the painting, but advised that it demonstrated 'how little the subject had to do with picture-making, and what infinite variety exists in a single subject when studying [it] under varying atmospheric conditions.'[45]

On the other hand, a handful of New Art critics homed in on the painting. Possibly the reductive shape of the grainstack itself, pushed forward, with little depth of field, made them think long and hard about its surface effects. The oil panels of shop fronts that Whistler first exhibited in the 1880s had trained them to look at flat paintings. There is no clear proof that looking at Monet's close-up view of a grainstack triggered memories of looking at Whistler's shop fronts, but something made the New Art critics take up the viewing position that Whistler had commanded them to take, and look closely at Monet's painting with its motif pushed close to the picture surface.

I argue elsewhere that Hermann von Helmholtz's ideas on the perception of space can be linked to the pictorial solutions for representing flatness that Whistler tried out in the 1880s. [46] Admittedly Helmholtz warned that the 'representation' of flatness was as impossible as the 'representation' of colours would be to one born blind but this did not stop Whistler from trying.[47] Moreover, Helhmholtz's dictum that 'in a painting close at hand, the fact that it is a flat picture continually forces itself more powerfully and more distinctly on our perception', undoubtedly also influenced Whistler's ideas about the viewing of a picture.[48] I suggest that Whistler

adapted Helmholtz's theory of binocular vision, which he illustrated by referring to a stereoscope and its ability to give the illusion of the third dimension by combining two flat images. Helmholtz's suggestion that the perception of the third dimension was largely an illusion, and his postulation that 'binocular vision turns against the painter' because it shows 'unmistakably the flatness of the picture' was particularly influential for Whistler.[49] Although Whistler worked from memory when painting the Nocturnes, he painted on the spot when painting *An Orange Note: Sweet Shop* (plate 30). He took extreme steps to eliminate his depth of field by standing a few feet away from the motif of the shop window with its jumble of oranges and sweets. This viewpoint eliminates the roofline, and the edges of the façade, and increases the painting's flatness. Monet also stood very close to his motif when painting the Grainstack picture. I am suggesting that possibly Whistler and Monet had a shared interest here. These shop front pictures were an important part of Whistler's output during the period when he and Monet were in closest contact. There are important differences between *An Orange Note: Sweet Shop*, where all depth of field has been eliminated around the opening of the doorway, and Monet's painting, which suggests spatial depth behind the stack. However, Monet's restricted depth of field when painting the stack has something in common with the position Whistler adopted when painting the shop front.

At this point, it is worth reviewing what the other New Art critics had to say about Monet's painting of a grainstack. D.S. MacColl was an intelligent and perceptive critic who appreciated Monet's skill in building up the dense and varied colour in the painting. MacColl, like many other New Art critics, saw that his mission was to place the French Impressionists within a tradition of old master paintings, and in this review he compared Monet with Turner:

> In the haystack picture … what he has succeeded in rendering with rare justice and beauty is the colour-value of the haystack against the distance … No one probably has ever done it so well. Turner, who perhaps set him on the track, is left behind; compared with this unity of effect, the Temeraire splits into arbitrary lights, false values and crude colour, however delicate some of its local gradations may be. But Turner would have been uneasy over the composition of forms in the haystack picture. He would hardly have allowed so awkward a shape to call attention to itself … It would be absurd to say there is no drawing in Monet; for one of the biggest parts of the drawing is putting things in their places, and that he does by noting the colour-values of things.[50]

This is a sophisticated response, but MacColl was uneasy about the overall textural effect of Monet's painting. 'His handling goes to build up colour' but the result is 'a handling which is a colour-building expedient', a characteristic which MacColl thought all the Monet pictures shared, including *Le Pont de Vervy*, which had a 'woolly look'.[51] There is an uneasiness here in MacColl's terminology. Recognising that the effects of colour and texture in the painting had their own autonomy, independent from the thing represented, he nevertheless lacked, and perhaps was unwilling to find, a descriptive language to describe them adequately. Stevenson waited

until seeing a Grainstack painting in Liverpool, later in 1893,[52] before giving his opinion of 'this exquisite work'.[53] Stevenson knew something of the history of the series,[54] telling his readers that Monet started the series 'at the beginning of August … carrying on the work till March, so as to obtain every variety of summer and winter lights and shadows.'[55] He then launched into a rather garbled account of Monet's use of colour which he confused with neo-Impressionist colour theory, while confessing that 'it is a little difficult to express the system, based as it is on the theories of colour held by modern men of science'.[56]

Stevenson was not the only critic to make a connection between Monet's methods and science. There was a suspicion that his brush techniques were based on a scientific method, and as such they were easily repeated. Mirbeau may have sowed the seeds for this view by claiming in the Goupil 1889 preface that Monet's painting methods were based on 'a methodical and rational plan of mathematical precision and inflexible vigour'.[57] At the next showing of Monet in London, when two paintings were included in the 1891 NEAC autumn exhibition, the connection between Monet's art and science was bandied about by several critics. Monet was 'preoccupied with science rather than with art' said Whibley.[58] MacColl made a similar claim about Monet and science. Monet 'stands for effort to push further the analysis of visual effect, to render the force and vibrating colour of sunlight', but he was often a 'more experimentalist than successful artist', MacColl claimed, and *Orange and Lemon Trees* (now know as *Maison de Jardinier*) 'would be more in place in some museum of painting research than in a gallery of pictures.'[59]

There was a suspicion that, because the Grainstack painting was part of a series (it was after all so described by Monet in the NEAC catalogue), it was a mechanically produced picture. George Moore sowed the seeds of this belief when he claimed, late in December 1891, after the exhibition of Grainstack paintings in Paris earlier that year, that 'at undetermined intervals … Monet returns from the country with thirty or forty landscapes, all equally perfect, all painted in precisely the same way.'[60] As painting, Moore claimed, it was 'eternal decoration', its 'touch, so much more precious than profound' with a 'vision, so rapid that the intimate note is lost', and that it had an 'ever-changing but ever shallow, brilliant appearance'.[61] Moore repeated this wisdom about Monet's 'unceasing production' and 'an almost unvarying degree of excellence' the following year, when he wrote about Monet in an article for *The Speaker*, entitled 'Decadence'.[62] Monet's 'broken brushwork' signalled the 'separation of the method of expression from the idea to be expressed', and was 'the sure sign of decadence.'[63] By the time he saw the Grainstack painting at the New English Art Club, Moore had lost all serious interest in Monet's recent painting, claiming that 'they are as brilliant as they are superficial, an externality and very little else.'[64]

Moore's swingeing attacks on Monet, whom he linked with the neo-Impressionists in his articles 'Decadence' and 'The Division of the Tones', both published in September 1892, must have fuelled the suspicions of the other critics in his circle about Monet. Both essays reveal Moore's growing distrust of what he perceived to be the manufactured aspect of modern painting, or the mechanical touch of the similar-

looking 'series of minute touches like mosaic', as he described neo-Impressionist pictures.[65] 'All methods that are not part and parcel of the pictorial intuition – are equally puerile and ridiculous', Moore claimed. 'The separation of the method of expression from the idea to be expressed is the sure sign of decadence ... the man of the hour is he who has invented the last trick in subject and treatment ... France is now all Decadence.'[66]

Underlying Moore's criticism was a deep distrust of the many new pictorial styles that were emerging from France. Moore was a notorious plagiarist and it is telling that his close associate, the poet and critic Arthur Symons, provided a similar definition of decadence in his 1892 'The Decadent Movement in Literature'.[67] Most of the article was devoted to recent French writers, and while Symons is hardly a hostile critic, he was suspicious, nevertheless, of what he called 'the restless curiosity in research', meaning new forms of writing which he thought were 'a new and beautiful and interesting disease'. Symons is quite clear that 'the very disease of form' that characterises recent French literature is symptomatic of a decadent civilisation. Symons traced this collapse of style back to Impressionist painting that had discarded traditional means to find a visual equivalent in painting to an impression, so that a blob of paint stands for a way of seeing. Symons had no objections to what he called 'a new way of saying things', the verbal equivalent as it were, to 'a new way of seeing things', but he did have reservations about new forms of writing which seemingly had no basis in a phenomenological response. Symons cites Stephane Mallarmé and Jean Moréas 'who has brought nothing into literature but an example of deliberate singularity for singularity's sake.' And dismissing the fashionableness of the search for novelty Symons wrote: 'These people have nothing to say, but they are resolved to say something and to say it in the newest mode.' Symons spelled out the reasons rather well as to why British critics did not develop a critical terminology to describe the surface effects of Monet's Grainstack painting at the New English Art Club in April 1893.

'Slabs of Pink and Lumps of Brown': The Critical Reaction to the Exhibition of a Monet Grainstack Painting in Britain in 1893

ANNA GRUETZNER ROBINS

1. A copy of the catalogue of the exhibition is in the National Art Library, Victoria & Albert Museum, London. The exhibition was held at the Dudley Gallery, Piccadilly, and opened in April 1893.

2. These were: (212) *Coast of Belle-Isle, Bretagne*, w.1109; (375) *Meadow of Limetz*; (384) *Village of Bennecourt*, w.1125 , Columbus Museum of Art, Ohio; (391) *Cliff near Dieppe*, w.708 or w.719.

3. These were: *Orange and Lemon Trees*, now known as *Maison de Jardinier*, 1884, w.867 and *Early Spring* now known as *Bennecourt*, w.1126. Sargent bought w.1126 in August 1887; sold Sotheby's, New York, 18 November 1986 (14).

4. The 1893 Executive Committee consisted of Francis Bate, the Honorary Secretary and Treasurer, the critic and painter Alfred Lys Baldry, Frederick Brown, Professor of the Slade, J.E. Christie, Moffat P. Lindner, London Impressionist George Thomson, Sickert, Steer and Robert A. Bell. Steer, Bate, Brown, Sickert, and Charles Furse formed the Selection Committee, and they were joined by Lindner, Christie, Bernhard Sickert, Arthur Thomson, George Thomson and Mark Fisher on the Hanging Committee.

5. W.P., 'New English Art Club II', *Artist*, 1 May 1893, pp.151–2, wrote: 'From Mr. Bate I learned that Claude Monet had promised to contribute to the exhibition, now Mr. Monet does not strike even a journalist as an English painter, but he is a welcome guest at all times, and why quibble about nationality in art, seeing that art only just manages to exist in spite of nationality.' W.P. was not hostile to the Monets, adding that they 'are all worth much study'.

6. Monet was listed as follows in the list of 'Exhibitors – Non Members' in the catalogue: 'Monet, Claude, Giverny, Eure, France'.

7. Wildenstein III, w.1234.

8. For example, the *Morning Post*, 18 April 1893, wrote: 'A few white-walled houses are grouped irregularly at the base of a lofty wooded hill, up the steep sides of which climbs … a winding road. There is no sky visible in the picture, but its joyous line is indicated in the luminous tints of the rippling stream.' *Land and Water*, 8 April 1893, wrote: 'You look down on a purple but barren valley, and you see a blue river foaming through its centre, and white houses clustering one of its banks.' All NEAC reviews are taken from the NEAC Press Cuttings /TG /Tate, unless otherwise stated.

9. For example, the *Morning Post*, 8 April 1893 and the *Star*, 7 April 1893, both pointed out that it was a single stack.

10. These include: w.1280–90.

11. These include w.1280, w.1281, w.1282, w.1286, w.1287 and w.1288, all purchased in 1891.

12. *Morning Post*, 18 April 1893. There was difference of opinion, however, about whether it was sunrise or sunset. *The Globe*, 12 April 1893, thought it was a 'misty sunset'.

13. D.S. MacColl, 'The New English Art Club and the Meissonier Exhibition', *The Spectator*, 22 April 1893.

14. Of course, there is always the possibility that it was a picture not listed in Wildenstein.

15. w.1300, *Peupliers des Bords de l'Epte,* was described as 'a large canvas' with 'a long line of poplars rising in a snake-like curve into the blue summer sky', but the 'sky dappled with clouds' was thought to be 'hard, untransparent, and wanting in aerial

perspective.' The scheme of blue was very pronounced with 'blue trees, blue water, blue sky, blue grass'. *Land and Water* thought it was 'a beautiful piece of decoration' and described it as 'a long line of poplar trees winding in serpentine behind each other, the bushy tops of the tall trees in the first curve standing high against the pale sky, those in the second curve coming lower, and in the third still nearer the ground.' The *Pall Mall Gazette* admired 'the exquisite breath of dawn, the tall elegance of the winding row of trees, the still water, the point of chill freshness in the air'. The *Echo* confirmed that it was 'an early morning sky' and that 'in the foreground is a pool of water, vaguely repeating opalescent hues.' Finally, the *Saturday Review* doubted whether it was a recent picture.

16. This was *Portrait of R. Allison Johnson, Master of the North Hereford, on his horse Bendigo, with his hounds 'Gaylass', 'Flourish', 'Spangle', etc.* This information comes from the 'The New English Art Club', *Graphic*, 15 April 1893. The Furse was no.76 while the Monets were nos.74 and 77 which suggests that the hang followed the sequence of numbering in the catalogue. *Poplars* (no.51) must have hung between James S. Hill's *Near Deal* (no.50) and Sickert's *Portrait of Miss Geraldine Blunt* (no.52).

17. For the New Art critics, see Kimberly Jones, 'The New Art Criticism in Britain 1890–95', unpublished Ph.D. thesis, University of Reading, 2003.

18. 'New or Old', *National Observer*, 15 April 1893 in K. Flint (ed.), *The Impressionists in England. The Critical Reception*, London 1984, p.313. The review is unsigned; however, all evidence indicates that

Whibley was the author, as Flint suggests.

19. I am grateful to MaryAnne Stevens for providing the original English text of her essay which has only been published in Italian translation. See M.A. Stevens, 'Monet e Londra: le esperienze del luogo', in *Monet: I luoghi della pittura*, Casa dei Carraresi, Treviso 2001, pp.307–25.

20. G. M[oore], 'Mr. Burne-Jones', *Speaker*, 7 January 1893, p.16.

21. Also included were: (16) *Petit Bras a Argenteuil*; (30) *Cabane de Pecheurs*, w. 732 or w.805 ; (32) *Promenade sur la Falaise*, w.758 ; (34) *Chemin de la Carée* ; (39) *Bateaux Voiliers*; (40) *Faisans* (*Nature Morte*).

22. *Artist*, 1 May 1883; in Flint 1984, p.61.

23. Descriptions in the press suggest that another was almost certainly *Port Domois à Belle-Ile*, w.1109.

24. 'The Royal Society of British Artists', *The Spectator*, 10 December 1887, p.1705.

25. Ibid.

26. Sargent wrote to Monet: 'It is only with great difficulty that I am able to tear myself away from your delightful painting. I have remained there before it for whole hours at a time in a state of voluptuous stupefaction, or enchantment.'
E. Charteris, *John Sargent*, London 1927, cited in S. Olsen, *John Singer Sargent: His Portrait*, London 2001, p.97. Sargent had bought two Monet pictures, *Bennecourt, Spring*, 1887, w.1126 and *Vagues à la Manneporte*, w.1036, earlier in the year, and had added two more, *Paysages avec Figures*, 1888, w.1204 and *Maison de Jardinier*, w.867 to his collection by 1891.

27. This picture and two other versions of the picture, w.1107 and w.1108, which Monet sold earlier in 1887, best fit the description. The Brittany picture is described as a

'comparatively small work' , as 'brilliant as colour and sunshine can make it' and with a 'powerful … contrast of golden cliffs with purple and green sea … dashing against and between great masses of rock and cliff.'

28. *Land and Water,* 3 December 1887, p.699.

29. See R. Spencer, 'Whistler's First One-Man Exhibition Reconstructed', in G.P. Weisberg and L.S. Dixon, *The Documented Image: Visions in Art History,* Syracuse 1987, pp.27–48.

30. K.J. Myers, *Mr. Whistler's Gallery: Pictures at an 1884 Exhibition,* Washington 2003, p.5.

31. The private view invitation read: 'Messrs. Boussod, Valadon & Co. request the honour of your presence at a Private View of Works by the well-known Impressionist.'

32. Wildenstein identifies the following pictures: (I) *The Pyramid Rock, Port Coton,* w.1087; (II) *Field of Poppies,* w.1146; (IV) *The Pines at Juan Les Pins,* w.1188; (VI) *Prairie and Figures (Temps Couvert),* w.1203; (VII) *Antibes,* w. 1174; (IX) *Chrysanthemums,* w.1212; (X) *Prairie and Figures,* w.1204; (XI) *Maisons de* Villageois, w.975; *Vétheuil (Fog),* w.518; (XVII) *Un Tournant de L'Epte,* w.1209; and (XVIII) *Marine (Rainy Weather),* w.1044. In addition, Frances Fowle has identified XII *Marine (Tempest)* and XV *Port du Havre (Effet de Nuit).* See her essay in this volume.

33. The preface, entitled 'Note', is unsigned. However, I am assuming that D.C. Thomson, who is well-known for his writings on the gallery artists, was the author.

34. O. Mirbeau, 'Claude Monet', *Le Figaro,* 10 March 1889, p.5.

35. For a discussion of this preface, see P.H. Tucker, *Monet in the '90s: The Series Paintings,* New Haven and London 1989, pp.59 and 288, n.27.

36. This information comes from John Gray, *Comedy,* 4 May 1889, New English Art Club Press Cuttings Book, TGA 7310, Hyman Kreitman Research Centre, Tate, and all references to 1889 Goupil Gallery reviews thereafter, unless otherwise stated.

37. *Scotsman,* 15 April 1889.

38. 'Monet at the Goupil Gallery', *Artist,* 1 May 1889, in K. Flint 1984, pp.311–2.

39. 'Art in London', *Echo,* 15 April 1889.

40. Ibid.

41. 'An Impressionist', *Saturday Review,* 20 April 1889.

42. Not A.U., 'A Chance for the 'Old Art Critics', *Star,* 7 April 1889.

43. 'Pictures', *Talk,* 12 April 1893.

44. *Weekly Dispatch,* 16 April 1893.

45. 'S', 'New English Art Club', *Echo,* 12 April 1893. 'S' was M.H. Spielmann.

46. I examine this point at length in my forthcoming study 'A Fragile Modernism: Whistler and his Impressionism and Followers' to be published by Yale University Press.

47. I hardly need to point out that Helmholtz's comment about the impossibility of representing colour 'to one born blind' might be one source for Monet's comment that 'he wished he had been born blind and then suddenly gained his sight'. Monet reported this wish to Lilla Cabot Perry. See 'Reminiscences of Claude Monet from 1889 to 1909', *The American Magazine of Art,* vol.XVIII, no.3, March 1927, p.120; cited by C. Stuckey, 'Monet's art and the act of vision', in J. Rewald and F. Weitzenhoffer (eds.), *Aspects of Monet: a symposium on the artist's life and times,* New York 1984, p.106. Stuckey suggests Ruskin was a source for this idea.

48. H. von Helmholtz, *Popular Lectures on Scientific Subjects,* second series, London

1881, p.82.

49. Ibid., p.135.

50. *The Spectator*, 22 April 1893.

51. Ibid.

52. It is not clear whether this was the same picture that was shown at the NEAC. It was exhibited as (1030) *De la série des meules* in the *Autumn Exhibition of Modern Pictures in oil and watercolour*, at the Walker Art Gallery, Liverpool, in September 1893. The picture was listed in the catalogue as not for sale.

53. 'The Liverpool Autumn Exhibition', *Manchester Guardian*, 2 September 1893, p.9. The review is unsigned, but Stevenson is known to be the author.

54. Philip H. Rathbone, 'The Liverpool Autumn Exhibition', *Sphinx*, vol.1, 1893–4, p.66, also stressed this point, writing: 'It is one of a series representing a haystack at different times of the day, illustrating the play of light under different conditions. A haystack is a very uninteresting subject, but it has probably been chosen because, from its shape and natural colour, the effect of the rays of the sun is not likely to be interfered with by shadows caused by corners or irregularities of form. It is a study of sunlight pure and simple.' I am grateful to Edward Morris for this reference.

55. *Manchester Guardian*, 2 September 1893, p.9.

56. Ibid.

57. O. Mirbeau, 'Claude Monet', *Impressions by Claude Monet*, Goupil Gallery, London 1889, p.6.

58. 'The New English Art Club', *National Observer*, 12 December 1891, New English Art Club Press Cuttings Book, Hyman Kreitman Research Centre, Tate. The review is unsigned, but Whibley is known to have been the art critic for the paper at this date.

59. D.S. M[acColl], 'The New English Art Club', *The Spectator*, 5 December 1891.

60. G. M[oore], 'Two Landscape Painters', *Speaker*, 25 December 1891, p.776.

61. Ibid.

62. G. M[oore], 'Decadence', *Speaker*, 3 September 1892, p.285.

63. G. M[oore], 'The Division of the Tones', *Speaker*, 10 September 1892, p.316. Moore made this observation in a concluding article where he included the neo-Impressionists in his attack.

64. G. M[oore], 'The New English Art Club', *Speaker*, 15 April 1893.

65. G. M[oore], 10 September, 1893, p.316.

66. Ibid.

67. A. Symons, 'The Decadent Movement in Literature', *Harper's New Monthly*, January 1892, p.512.

Selected Bibliography

BERSON 1996
Berson, Ruth (ed.), *The New Painting: Impressionism 1874–1886; Documentation,* vol. I, San Francisco and Seattle 1996

CLEMENCEAU 1928
Clemenceau, Georges, *Claude Monet,* Paris 1928

EDINBURGH 1994
Thomson, Richard (with Michael Clarke), *Monet to Matisse: Landscape Painting in France, 1874–1914,* exh. cat., National Galleries of Scotland, Edinburgh 1994

EDINBURGH 2003
Clarke, Michael and Thomson, Richard, *Monet: the Seine and the Sea 1878–1883,* exh. cat., National Galleries of Scotland, Edinburgh 2003

FOWLE AND THOMSON 2003
Fowle, Frances and Thomson, Richard (eds), *Soil & Stone : Impressionism, Urbanism, Environment,* London 2003

HERBERT 1994
Herbert, Robert L., *Monet on the Normandy Coast, Tourism and Painting, 1867–1886,* New Haven and London 1994

HOUSE 1986
House, John, *Monet: Nature into Art,* London 1986

HOUSE 2004
House, John, *Impressionism: Paint and Politics,* New Haven and London 2004

LONDON 1995
House, John *et al, Landscapes of France: Impressionism and its Rivals,* exh. cat., Hayward Gallery, London 1995

NORD 2000
Nord, Philip, *Impressionists and Politics: Art and democracy in the nineteenth century,* London and New York 2000

SPATE 1992
Spate, Virginia, *The Colour of Time, Claude Monet,* London 1992

STUCKEY 1985
Stuckey, Charles (ed.), *Monet: A Retrospective,* New York 1985 (Leicester 1988)

THOMSON 1998
Thomson, Richard (ed.), *Framing France: The representation of landscape in France, 1870–1914,* Manchester and New York 1998

TUCKER 1982
Tucker, Paul Hayes, *Monet at Argenteuil,* New Haven 1982

TUCKER 1989
Tucker, Paul Hayes, *Monet in the '90s: The Series Paintings,* Boston 1989

TUCKER 1995
Tucker, Paul Hayes, *Claude Monet, Life and Art,* New Haven and London 1995

VENTURI 1939
Venturi, Lionello, *Archives des Impressionnisme,* 2 vols., Paris and New York 1939

WILDENSTEIN I–V
Wildenstein, Daniel, *Claude Monet: biographie et catalogue raisonné,* 5 vols, Lausanne and Paris 1974–1991 (vol.III, 1979)

WILLSDON 2005
Willsdon, Clare, *In the Gardens of Impressionism,* New Haven and London 2005

Index